Authenticity in Art:

The Scientific Detection of Forgery

Stuart J Fleming

foreword by Professor S A Goudsmit

Crane, Russack + Co Inc New York

Authenticity in Art:

The Scientific Detection of Forgery

The Institute of Physics London + Bristol

Copyright © 1975 Stuart J Fleming

Published by The Institute of Physics
47 Belgrave Square, London SW 1X 8QX, and
Techno House, Redcliffe Way, Bristol BS1 6NX

ISBN 0 85498 029 6

Published in the United States in 1976 by
Crane, Russak & Co Inc
347 Madison Avenue, New York NY 10017

ISBN 0 8448 0752 4

Library of Congress Catalogue Card Number 75-27303

Designed by Roydon Jenkins MSIA
Set in 11/12 'Monotype' Bembo 270
Printed and bound in Great Britain by
W & J Mackay Limited, Chatham, Kent

Preface

This book is a departure from a long-established tradition in discussion of authenticity problems in the art world. At regular intervals over the past century attempts have been made to survey the forger's ways and achievements. Some, like that of George Savage in *Forgeries, Fakes and Reproductions*, was directed at the academic world, with a thorough review of stylistic criteria in art judgement. Others, by far the majority of contributions in this field, are mainly anecdotal, providing the historical background to the major art scandals of our times. Perhaps each of these books served an important purpose, to 'freshen the air' in the art market, in some way purging the system. Yet behind many of the sensational headlines there has been a hard-core background of forensic science. It is the methodology and conclusions of this scientific work that I have attempted to elucidate here.

I have little time for those who believe authenticity judgement is possible solely by eye and regard scientific analysis in this field as superfluous. History speaks against their confidence (and arrogance?), in the recognized errors of fine art historians such as Abraham Bredius and Gisela Richter and of highly respected archaeologists such as Smith Woodward. But a blind confidence in technical evidence would also be misplaced. From my own experience in thermoluminescence dating of ceramics I believe that one near-successful attempt has been made to artificially simulate physical as well as visual features of antiquity, a plot interestingly 'veneered' by a detailed, though quite implausible, provenance and history of purchase elegantly presented by one of the most beautiful young Italian ladies I have had the pleasure to encounter! Most of my colleagues can surely recall similar tense moments of near deception.

I have tried to avoid an elementary pitfall in my writing: to concentrate only on the latest forgery revelations, so that they would appear to stand apart in some way from the history of authenticity problems which stretches back some two thousand years. True, the 'scientific snowball' is now gathering sufficient momentum to provide plenty of such fresh material, but one of the pleasures I gained from preparing this text lay in 'library-scavenging', unearthing many elegant papers which I feel deserve much fuller recognition. In this respect my favourite topics would include

Tasso Margaritoff's x-ray study of icons, Thomas Brachert's revelation of fingerprints in the paint layers of several da Vinci works and Stephen Guglielmi's structure-stripping of the spurious Princeton *p'ou* bronze.

Certain stories of fakery are not included, such as that of Lothar Malskat's turkey fresco in Schleswig Cathedral and Francis Lagrange's 'Fra Lippi' triptych that gained an honoured place in Rheims Cathedral, mainly on the grounds that these affairs contain no scientific features in their denouement. I have also chosen to leave out a report of the Glozel affair which currently clutters the pages of *Antiquity* in a science versus archaeology controversy: a report on this matter could, at present, only be incomplete and unresolved. I have no doubt that another author a decade from now will have some fascinating new tales to recount.

Response to my requests for illustrative material was so great that much has had to be excluded: I only hope that my presentation of my colleagues' work does it justice. In particular I would like to single out the generosity and help of three American scientists, Pieter Meyers, Bernard Keisch and Robert Feller, whose wide-ranging experience in authenticity analysis proved indispensable. Also I would like to pay tribute to the tolerance of the photographic department of the National Gallery of Art, in London, and of the Heberden Coin Room of the Ashmolean Museum, in Oxford, in bearing with some of my more bizarre requests. Finally, I must express my gratitude to the editorial staff of The Institute of Physics for the effort they have put into this book, during the early stages of preparing the text as well as in the actual production work. They, and the designer Roydon Jenkins, can take a good deal of credit from its final appearance.

S J Fleming
Research Laboratory for Archaeology and the History of Art, Oxford

Foreword

I must begin by confessing that I have always had some admiration for art forgers and their products. This is in sharp contrast with the opening statement in Dr Fleming's book in which he quotes a blanket condemnation of all forgeries by a museum's director. Forgers, like one's enemies, have to be respected if one wants to engage them in combat. In the case of forgers against experts it is a veritable 'battle of wits'.

Forgeries have unmasked some of the false pretences in the evaluation of art objects. It is not true that the value of a painting depends upon its artistic quality or upon the skill of the master who painted it. Today the value is primarily determined by its authenticity and not by its aesthetic merits. The forger, van Meegeren, created original paintings which the art critics accepted as true Vermeers. Only detailed laboratory tests, described in this book, revealed differences which cannot be detected by the eye of the most experienced connoisseur. If the artistic value of some of van Meegeren's products is equal to that of Vermeer's, why is there such an enormous difference in monetary value?

Many forgeries are made so skilfully that the art expert can easily be misled. The application of the scientific methods described in this book is often the only objective means of detecting these forgeries. As the title implies, these tests can determine authenticity, but they have, of course, no bearing on the artistic merit of the object.

The motivation of most forgers is to deceive buyers into paying more for an object than it is worth. There are a few exceptions. For example, van Meegeren initially wanted to fool the art critics because they did not like his own original work. He did succeed. Later van Meegeren used his skill to deceive high Nazi officials who stole and collected art. It was an admirable achievement. There are also forgers whose purpose is to confuse historical and scientific interpretation. Their motivation is revenge on colleagues or it could be the manifestation of a psychopathological disorder. Such forgeries are very dangerous because they are usually unexpected.

There have also been forgeries which were merely cases of mistaken identity. Many years ago I read the story of a small stone with a runic inscription found in the 1860s in the United States. Scholars had made tentative translations. But when the inscription was later shown to a designer of printing fonts, who happened also to be a Kipling fan, he read it at once in English: 'This is Bill's stone'. The crude carving had made the letters angular, thus resembling runes. The inscription had something to do with a contemporary story by Kipling.

Another interesting case concerns large Egyptian scarabs found among the estate of an eminent Egyptologist. Coming from that source they were accepted as genuine. However, some linguistic discrepancies in the historically important inscription aroused suspicion. An investigation revealed that the Egyptologist had designed them and had planned to present them to a few colleagues for amusement; the inscription told about the circumnavigation of Africa. At the time of his death he had not yet given them away. I knew an orientalist who amused himself during a rainy vacation on Cape Cod by carving a Coptic inscription on a stone slab and burying it. After fifty years this hoax has not yet been discovered.

My own interest in these problems goes back to my schooldays. Influenced by adventure books of that time, I shared with many others the ambition to become an expert in unravelling mysteries. I wanted to decipher ancient inscriptions, solve crimes and penetrate the secrets of nature. In my case the childhood – or should I say childish – ambitions never quite subsided. I later found out that my lack of linguistic talent limited me to the status of a minor amateur in Egyptology. My crime detection studies were restricted too, because I dislike corpses. I concentrated on document forgeries, the tools then available being only the microscope and the newly developed ultraviolet lamp. Luck, rather than talent, helped me in becoming a physicist. The subject matter of Dr Fleming's book is a true synthesis of all the areas of my childhood interest. It combines the challenge of historical and archaeological problems with the solution of crimes and with the most advanced discoveries in science. This must be one of the reasons why this kind of research has such a wide appeal.

I am a very minor collector of Ancient Egyptian objects and have been sold forgeries a number of times. I am surprised at my own reaction to these occurrences, namely that I find these fakes instructive and interesting. I once bought a limestone ostrakon with strange writing on it. The merchant in Luxor, Egypt, claimed that it had been in his shop for many years, that his deceased father had obtained it long ago and that he did not know what it was. It looked like a really interesting find, fulfilling one of my childhood ambitions. I showed it to a very knowledgeable dealer of high reputation. He remarked that he knew the boy across the Nile who makes these stones. I also own a very nice small pot of brown baked clay with a decoration placing it during the Roman domination of Egypt. A museum's director believes that it is not authentic, but may be a sample of pottery made in the 1890s. The above-mentioned dealer, on the other hand, is convinced that it is genuine and provided some corroborative evidence. The modern method of thermoluminescence described in this book can easily decide who is right. However, it would be unwarranted in this case to use an expensive technique on an object for which I paid a digger at a Roman

temple in Egypt only a few piastres. The little pot has no historical value and no monetary value even if genuine.

In the past, the principal buyers of art were museums and those private collectors who had acquired a thorough knowledge of their narrow field of interest. In recent decades a new kind of general collector has come upon the scene. He usually does not specialize, but wants a few samples of the art of all historical and geographical areas—a French Impressionist painting, an Ancient Persian tile, and more. This type of collecting has greatly contributed to the fantastic increase in the price of art objects, especially for those of lesser quality and interest. For example, Ancient Egyptian artifacts, which have merely some minor archeological significance, are now treated as art. Unfortunately, this has completely eliminated me as a collector of such items. Objects presented to me by highly respectable dealers some fifty years ago, because they were not good enough for the art trade, are now of considerable value.

This development has resulted in an increase in the forgery of minor objects, which is easier than forging important works of art. Most of these minor fakes are crude and sold to tourists but some are made so expertly that even experienced dealers are sometimes the victims.

It is fortunate that at the same time that forgers have improved their skills a great variety of scientific techniques have been developed to test authenticity. Dr Fleming's book describes these modern methods and their implications in detail, illustrated with case histories. This fascinating field is still very new and growing. Improved techniques and new applications are steadily being added to the basic ones treated in this book. These have made the forger's endeavours more difficult. However, I therefore expect an increase in the appearance of two types of forgeries. The first is the skilful alteration of an authentic object of moderate value into one of higher value. The second is a flood of faked minor objects which appeal to the general collector but which do not warrant technical analysis because they have neither historical importance nor significant monetary value.

Dr Fleming's lucid treatment of the subject will be of value, not only to the technical expert, but also to the art dealer and collector. In addition, the general reader can consider it as a collection of fascinating true detective stories. It will, of course, also be of very great interest to the forgers who can learn how to avoid mistakes and pitfalls. As I stated at the beginning, it is a 'battle of wits'.

Samuel A Goudsmit
formerly Editor-in-Chief of the American Physical Society

1 Introduction, 2 Paintings,

3 Ceramics,

4 Metals.

I

Introduction,

1 Introduction,

The art historian and the scientist/Early examples of forgery detection/The forger's technical approach: different kinds of fake/The first line of defence: errors and stylistic anachronisms in forgeries/Surface examination: the microscope and the ultraviolet lamp.

'Don't hesitate to use derogatory adjectives in describing forgeries. They should not be given any sort of adulation, despite the fact that at certain times in the history of art they have been collected for their own sake' [1]. Such a clear-cut attitude, expressed by Thomas Hoving, Director of the Metropolitan Museum of Art, seems hard to fault. Nevertheless it is difficult to define the breadth of the term 'forgery' for many of the examples in this book. An innocent imitation in the hands of a fraudulent art dealer can assume a fake pedigree which boosts its sales price multi-fold. Original paintings, heavily and wrongly restored, might well be rejected even though the alterations were introduced unintentionally. It would also seem essential that we are absolutely certain that the label 'forgery' is firmly established before we think of adding any adjectives, derogatory or otherwise.

The direction of this text at this point might seem obvious; to show how scientific techniques offer the means by which labelling of this kind can be substantiated. But should we exclude visual stylistic judgement? Certainly not. An art historian relies on a mental 'data-bank' to relate an object to other cultures, periods and artists, and this, in itself, is a scientific approach.

Yet there are some reasons why the latter approach has been liable to error to an extent that creates consternation in both the scientific and lay community. Two factors, in particular, are easy to explain and illustrate.

First, a data-bank is only as reliable as the quality and amount of information it contains. A private buyer or museum curator is often called upon to decide whether an object is authentic only a short time after reference material becomes available. In 1965 a number of leading museums, including the Ashmolean and the British Museum, purchased various double-headed anthropomorphic vases with inlaid obsidian eyes. These vases were supposed to have come from an obscure cemetery close to the recently-excavated site of Hacilar in Turkey. The remarkable affinity of these vessels to one another and their contrast in surface texture with other similarly decorated fragments of pottery excavated from the site eventually led to criticisms. These remained muted until 1970 when formal publication of the genuine Hacilar

material firmly underlined the dubious nature of the purchased objects. By then scientific dating of their pottery fabric (by the thermoluminescence technique) was already indicating their recent date of manufacture [2].

 Second, the history of authenticity studies indicates that natural 'blind-spots' exist in our vision and that these allow stylistic mistakes which happen to be in keeping with contemporary taste to pass by largely un-noticed. It is not realistic to try and discover what the present generation accepts in this sense but, with hindsight, we can often see the errors in nineteenth-century judgement. The bust of Lucrezia Donati (plate 1) has a sentimentality much more in sympathy with the ideals of the late-Romantic writers than of the *Quattrocento* era. As handiwork of the nineteenth-century forger Giovanni Bastianini (of whom much more will be said in later pages) it stands as an outstanding example of Italian art of the last century.

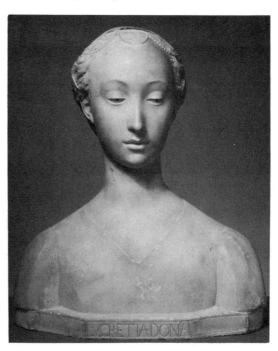

Plate 1/Lucrezia Donati/Marble bust in *Quattrocento* style by Giovanni Bastianini (1830–1868). Photograph: courtesy of the Director of the Victoria and Albert Museum.

 There is also the problem that jargon is just as prevalent among art historians as it is in the scientific community. Words like 'characterless', 'over-ornate', 'pedantic' and 'cold' all carry a subjective air which must be somewhat suspect. Again present-day taste colours our emotional response to these terms and fashion is sufficiently fickle to equate concepts like 'austere' with 'simple' and 'colourful' with 'gawdy' in the space of a decade.

 There is no question that a scientific data-bank has to be very comprehensive to be of value in art historical studies. It has to be vetted for quality just as

rigorously as any stylistic analysis. There is a cautionary tale from the author's own experience. A dealer produced documentary evidence that a terracotta in his possession agreed in composition with a similar piece in a leading museum. Unfortunately, although the documentation was genuine it was also quite old. The museum piece had since been removed from display. It was a forgery with a clay-type which proved to be quite a good 'fingerprint' in its own right for a particular modern workshop.

Methods of direct age determination are, for obvious reasons, of major importance in the solution of authenticity problems. Tree-ring counting has been used with some success to date the oak panels which were used extensively in early European paintings. The technique of thermoluminescence analysis enables us to pin-point the date when a piece of pottery was fired in the kiln. Radiocarbon measurements have been used to date materials as far apart as parchments and (by examining the carbon inclusions in the metal) cast iron. There is, however, a much more general approach that looks for anachronisms in the technology of a piece as evidence of the forger's hand. This depends, in part, upon construction of a chronological framework based on the artist's palette or the first appearance of a new ore-refining process. Amongst pigments, traditional techniques of x-ray crystallography and wet chemistry still play a major role in bulk composition identification while metal alloy assays are now usually made using x-ray fluorescence. Trace impurity evaluation in many media is generally obtained by neutron activation analysis though other forms of radiation (like protons or high-energy photons) have some additional advantages in specialized conditions.

Ageing effects (or, in the case of fakes, the lack of them) can be detected by a number of visual methods. The high-power optical microscope is particularly useful in studying metal corrosion. Surface restoration of paintings can be revealed by examination in ultraviolet light. There is also a variety of photographic systems in which an image is produced by more exotic forms of radiation. X-rays or infrared excitation are used extensively in studies of the sub-surface of paintings. In order to look at the construction details of bronzes a more penetrating source, such as high-energy x-rays or gamma-rays, is required. Even more sophisticated techniques—scanning electron microscopy and mass isotope spectroscopy—can sometimes contribute that little extra piece of evidence overlooked by the forger.

The general recognition, by art critic and layman alike, of the power of technical examination in the study of art works probably dates back to the trial of Otto Wacker, in 1932, for his forgery of 'Van Gogh' paintings [3]. The Berlin court gave great weight to x-ray photographs which illustrated Van Gogh's technique of modelling the surface with bold strokes of thick paint laid on over a heavy foundation impasto. Wacker omitted that foundation and concentrated on superficial aspects. Such analysis might seem trivial today but the Wacker case marks a transition from earlier, crude methods of examination to the more thorough-going modern approach. Perhaps we should feel sympathy for the nineteenth-century scientists who tried to combat forgery with little more than spot-test chemistry and a magnifying glass in an era when the public taste for imitations of all things ancient created halcyon times for the unscrupulous artist or dealer.

The history of forgery and imitation goes back many centuries before this. The Roman appreciation of Greek Classical sculpture in stone and bronze prompted extensive imitation that is extremely difficult to detect now [4] while blatant forgery of early silver from many cultures in the Empire was recorded in verse by Phaedrus during the reign of the Emperor Augustus. Coinage has always been a prime target for debasement because of the immediate financial rewards that result. We find early examples of counterfeiting amongst the subject peoples of the Roman Empire, particularly in Britain. Around AD 198, during the reign of Severus, the silver *denarius* was already debased by the addition of about 42% copper, but imitators took the devaluation much further [5]. We also know from excavated clay moulds impressed from original coinage that the folk of Whitchurch in Somerset, during the last quarter of the third century AD, produced their own silver *antoniniani* once official minting in the area had ceased. The alternative to direct alloying, the surface coating of a precious metal onto a less valuable core, is a common practice. It was employed officially in Roman imperial issue between AD 274 and 294 when an argentiferrous coin was silver-dipped to improve the appearance [6] while fifteenth-century forgery is evidenced by a gold-coated *Noble* of Henry VI from the Fishpool hoard; this coin was produced by mercury gilding of a silver core [7].

Attitudes to fakes and the reasons for their existence have changed many times in the past. Roman materialism seems to have been very akin to that of our present generation while in the Medieval era there was a greater interest in an item's subject matter than its age. (A growing rejection of modern-day 'investment' buying of art works may well cause a similar philosophy to develop again before the end of this century.) During the Renaissance new social standards emerged. Michelangelo achieved fame early in his career when his statue 'Cupid Asleep' was sold in 1496 as a Classical work, at which time he proudly explained his methods of creating its antique appearance. However, the early seventeenth-century painter, Terenzio da Urbino, was dismissed by his patron, Cardinal Montalto, for forging a Madonna and attributing it to Raphael. The reverence shown for the antique seems to have been sufficiently extreme for a bronze 'Bellerophon' by Bertoldo, a fine sculpture in its own right, to have been wax-coated in the region of the artist's signature so that it could be sold as a Classical work.

By the second half of the nineteenth century a different morality again had developed as the art market as we understand it to-day, with its echelon of dealers and fluidity of object movement, grew in size and stature. Enthusiasm for art collecting, in evidence at many social levels, was stimulated by the growth of archaeological excavations, particularly in Etruria (the region north of Rome bounded by the Tiber and the Arno) where tomb complexes yielded up the burial treasures of a hitherto unknown civilization. In 1828 the unearthing of vast numbers of Attic black- and red-figured vases at the cemeteries of Vulci led to that material first being attributed to Etruscan rather than Greek craftsmen, while later excavation of Cerveteri and Tarquinia revealed a sombre local art-form in wall-painting and sarcophagal decoration. The impetus was certainly maintained by Schliemann's opening of the rich royal graves of Mycenae in 1876 while Egyptology flourished for a whole century before the startling breach of the entrance of Tutankhamun's tomb by Lord Carnarvon in 1922.

The exposure of each new civilization brought with it a rash of fakes upon which the Victorians frowned. However, they vaunted imitation to the heights to the extent of awarding medals and running special exhibitions. Few cultures were spared but the predilection of collectors and museums for terracottas in the Renaissance style is most noteworthy. The nineteenth century was also the period of widespread fabrication of pseudo-Gothic ivories which frequently gained excellent pedigrees by their inclusion in French cathedral treasuries. At the same time, it is known that many important ivories were sold by convents and replaced by exact copies without any fuss or formal record.

The year 1524 marks the earliest documentation of forgery amongst paintings, in Pietro Summonte's discussion of the activities of a Neapolitan artist, Colantonio, some seventy years earlier. A portrait of the Duke of Burgundy was so well reproduced that the merchant-owner from whom the original had been borrowed accepted the return of Colantonio's version without suspicion.

A little more than a century later there began a saga that remained untold until 1871. A work commissioned from Hans Holbein, the Younger, in 1525, 'The Madonna as Protectress of Jacob Meyer, Mayor of Basle, and his Family' (colour plate 1) passed through several hands before reaching an Amsterdam dealer, Le Blond. Then the 'Madonna' developed a split personality [8]. One version (probably the original) moved through the market and eventually entered the Ducal collection at Hesse. A second version was pawned to a firm of Venetian bankers and found an honoured place in the Dresden Collection in 1743. Only when the two panels were brought together in the last century did the second version proclaim its seventeenth-century style by comparison with the original. The copyist (possibly Bartholomeaus Sarburgh) felt he had to introduce some 'improvements', the figures becoming smaller and the architectural surround more dominating. Current taste demanded more space of movement and a colour scheme of deeper, richer tones.

Some later case histories kept their secrets for a much shorter time. Luca Giordano, at the end of the seventeenth century, found himself in court for painting in the style of Durer. The work, 'Christ healing the Cripples' bore the re-nowned 'AD' monogram prominently enough while Giordano's own signature was concealed elsewhere in the picture. Oddly enough he was not found guilty, as it was judged that he could not be blamed for being able to paint as well as the German master. The more recent court judgement of one year's imprisonment on Han van Meegeren, in 1947, for his 'Vermeer' imitations was scarcely more severe.

Forgeries fall into three main categories. The first of these, *fakes without a model*, are rare. The path to acceptance can be made easier if the subject chosen has some connection to a legend or a fragmentary documentary reference. The fourteenth century provides us with one of the better-known examples of a fake based on a legend. Political manoeuvres against the Knights Templars in 1306 included a claim that they worshipped an idol called Baphomet [9]. The production of these idols (small mis-shapen stone figures covered in meaningless inscriptions) probably dates from the time when this story was popular, in the literature of the Gothic revival.

Fakes designed to fit in with genuine documentary evidence include some remarkable wholesale inventions of a complete, spurious artistic style, such as

that of the Obotrites (a Slavonic tribe from the Mecklenberg region later over-run by the Huns) and of the Moabites who came to public attention in 1869 with the discovery of a genuine inscription related to their King, Mesha. Archaeological material has been particularly susceptible to this kind of forgery. Gustav Wolf, in 1907, announced the discovery of cremations among Danubian peoples who first raised cattle and farmed in the region of Wetterau in the fourth millennium BC [10]. The unearthing of about a hundred of these graves led to the revision of academic belief that skeleton burial was the custom of those times. Finely-pierced flint tools, notched bone implements and carefully arrayed necklace beads all helped to compound a funerary assemblage. Wolf, in his autobiography, gave full credit for the finds to his co-excavator, Bausch, and died oblivious of the fact that he had been deceived by that very man.

The Stone Age and Neolithic cultures offer great potential to the forger because of the simplicity of workmanship required and the ready availability of media (flints, shales, antler bone and cave-wall rock) all ready for embellishment in hitherto unacknowledged ancient styles. Hieroglyphs cry out for interpretation, our fascination increasing in direct proportion to our ignorance. New languages emerge; new cross-linkages are established between cultures and the situation becomes more and more confused.

Runic inscriptions have been particularly prone to forgery. The Ura Linda Chronicle, with its notion that the Finns and Magyars are blood relations and its assertion that the Frisians are a Chosen People, was readily incorporated into the early racialistic attitudes of the Nazi Party in 1933. The Rune Stone of Minnesota served, for a while, as evidence of a Viking occupation of America by the end of the tenth century, long before Columbus set foot there.

Similar unique documents have appeared intermittently, including the last words of Moses to the children of Israel written on leather by an Egyptian scribe, Uanious, and scripts of a 'new' Phoenician historian called Sachuniathon. The Frenchman, Vrain Lucas, was a specialist in this type of production. In the course of a long career he forged thousands of original manuscripts purporting to stem from the hands of an illustrious gathering including Julius Caesar, the Apostle Paul and Joan of Arc.

We find scarcely any examples of fakes with no such literary associations, possibly because forgers realize that they will not fit into any art historian's 'data-bank' and are therefore liable to immediate rejection.

Alterations and additions to a work supplies our second category of fakes. We might mention, as an example, a painting with figures in the style of Philips Wouwerman superimposed upon a genuine landscape by Jan van Goyen [11]. The presence of both artists' monograms suggested the work was a joint effort but it now seems probable that the parts of the painting attributed to Wouwerman are the work of one Robert Griffier. The portrait of Edward VI illustrated in plate 2 is a case of radical adaptation of a minor work to produce a painting of documentary importance. A seventeenth-century child dressed in a full skirt with a high collar and holding a carnation became a stern-faced young king in sixteenth-century finery, including a plumed beret and ruffs, and holding a dagger [12]. To dispel any doubts about the personage the royal coat-of-arms was added.

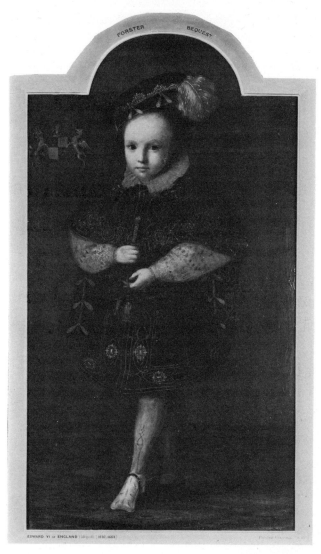

Plate 2/Portrait of young King Edward VI/Painted over a seventeenth-century Dutch picture depicting a little girl holding a carnation. Photograph: courtesy of the Director of the Victoria and Albert Museum.

Simple anthropomorphic sketches on bone and small sculptural reliefs executed on stone can endow Neanderthal man with unexpected skills while similar schoolboy rock-carvings have been known to rise to the status of national treasures [13].

The third and most common form of forgery is that of *pastiche*, that is to say, an object that derives its detailed units from a variety of similar elements in authentic material. Plate 3 illustrates this process for an 'Etruscan' painting on a terra-

a Clay altar from Corinth (detail).
b Fresco from the 'Tomb of Bulls'
at Tarquinia (detail).
c The feast scene of Herakles and Iole
at the house of Eurytios from
the 'Eurytios' krater (detail).

Plate 3/Pastiche of an Etruscan wall-painting on a terracotta slab/The picture shows the ambush of
Troilus and Polyxena by the treacherous Achilles (supposedly hidden behind
the water-fountain).

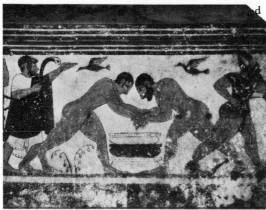

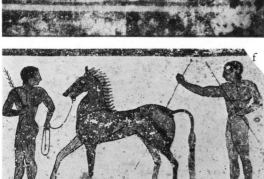

d Fresco from the 'Tomb of the
Augurs' at Tarquinia (detail).
e Terracotta wall-plaque, 'Female
figures', excavated at Banditaccia,
near Cerveteri (detail).
f Decorative frieze on a funeral urn
from Tarquinia (detail).

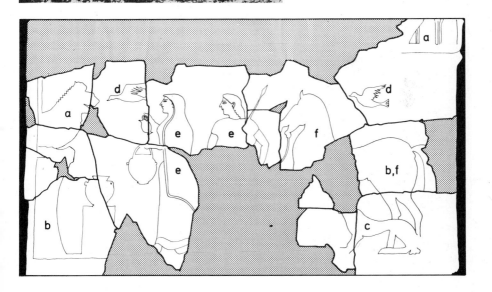

cotta slab, the authentic form of which would have decorated a niche of a tomb [14]. The scene is that of Troilus, son of Priam, leading his horse to water, accompanied by his sister, Polyxena. The fountain is only shown in part so that we could anticipate the existence of a further plaque, to be mounted to the left, displaying a treacherous Achilles waiting to pounce upon the unsuspecting prince.

This legend is depicted in a fresco from the 'Tomb of Bulls' at Tarquinia which provides the main theme and, in detail, is the source of the fountain chequering. Polyxena enters the scene via a frieze of this ambush that appears on the Corinthian 'Timonidas' flask, but she now has the shawled dress-style of the females on a plaque excavated at Banditaccia, near Cerveteri. The reined horse is derived from a funerary urn from Tarquinia with many of the outlines and muscle emphases reproduced with almost mathematical precision. The same accuracy of drawing is in evidence in the lion mouth-piece of the fountain and the upper border 'tongue' design that occur together on a Corinthian clay altar. Fresco details are faithfully copied, with the birds taken from the wrestlers scene in the 'Tomb of the Augurs' and the small decanting jug taken from the 'Tomb of the Lionesses'. Greek vases supply the water pitcher (from the 'Onesimos' bowl in Brussels) and the crouching dog (from the 'Eurytios' krater in the Louvre). Every component is readily available in photographs of books of the past two decades, often helpfully in colour.

An alternative source of information for the would-be forger is the showcases of museums. This is most convenient for single leaves of illuminated manuscripts; three-dimensional objects, parts of which are not visible through the front glass partitions, are often poorly executed. In the past engravings and woodcuts proved a valuable inspiration both for transfer into easel paintings and extension into an extra dimension as marble or terracotta statuary and stone reliefs. Similarly, medals supply small-scale versions of portraiture that translate well into stone reliefs of grander proportions while offering less risk of anachronism in costume and hair styling.

Slavish plagiarism is rare. It only appears at all commonly in the field of drawings, where it was common practice of the leading studios of the past to give each apprentice old prints to copy as part of his education. Reynolds produced 'Guercino' sketches with consummate ease. Michelangelo deliberately set out to deceive his master, Ghirlandaio, by copying a head, smoking the surface of the paper to simulate the effects of ageing, and exchanging his product for the original. Raphael, whose popularity was at its zenith in the nineteenth century, has been copied repeatedly even to the extent of enlarging small folio details into full-scale cartoon elements.

Surfaces often need major treatments to give them the necessary antique appearance. Cracking of a paint surface is an ageing effect that follows from the pigment or priming layers being too rigid to cope with the stretching of the flexible canvas or panel support. Once the oil medium has dried a simple rolling-up of a canvas will simulate this cracking quite well. Other 'recipes' include application of a heavily-contracting varnish or stiff glue to break up the picture's surface. Alternatively, some kind of heat treatment followed by rapid cooling causes shrinkage of the support at too great a rate to be taken up by the paint layers. For paintings on wooden panels the paint break-up usually runs parallel to the fibre structure of the wood and so the pressure directions require some deliberation (colour plate 3). A final

brush with soot highlights the damage. A 'fly-blown' appearance can be produced by stippling some areas with a stiff-bristle brush in a matching colour to create an illusion of antiquity. Swiftly applied restoration, damp-staining and blotching of paper, rim-chipping of pottery and the use of worm-eaten wood are all stock-in-trade skills of the ambitious faker.

Similar ageing effects, giving an appearance called *craquelure*, occur in the glazes of ceramics (this is discussed in detail in chapter three). The glaze ingredients fuse during kiln-firing and a glassy coating seals the pores in the underlying clay. If, during cooling, the clay body cools less than the glaze the latter is put under stress and coarse fissures appear on the surface. This crackling is due to kiln treatment and in no way indicates antiquity [15]. The passage of time leads to the development of many more, much finer crazing lines. This must be quite a difficult effect to simulate, judging by the rarity of good *craquelure* on established fakes, but examples do exist.

In the case of metals, corrosion of the surface, termed *patination*, records the effects of long-term exposure to the atmosphere or burial moisture as we shall see in greater detail in chapter four. The copper content of bronzes oxidizes to form amorphous cuprite which, in turn, reacts with carbonated water to form the familiar green encrustations of malachite. Other impurities in the metal, like tin, may preferentially oxidize to give a silvery sheen. Sulphur and chlorine, present in the attacking moisture, each give rise to different characteristic tarnishing effects. Unfortunately, the softening tone that patination produces on the raw, shining metal seems to have been to the taste of other civilizations besides our own. Vasari, in his discussion of technique in the Renaissance era [16], comments on the desirability of artificial ageing treatments such as oil-blackening, 'pickling' in vinegar and even varnishing.

Silver often carries a slight purplish tinge owing to chloride corrosion. However, this is a slow reaction compared with oxidation or chlorination of any copper present so that alloyed systems like those encountered in debased coinage usually suffer these reactions first. Chemical induction of artificial surface degradation poses no particular difficulty.

Despite the simplicity of the notion few deliberate artificial treatments offer the faker a better reward than burial of his work for a year or so to allow nature to begin the 'ageing' process. Although this requires patience and a steady nerve (someone else may accidentally dig up the forgery before the market is ripe) the method remains an effective one. Even the slightest traces of surface concretions or roots marks together with a degree of 'natural' damage and the inevitable softening in decorative brightness can only be helpful in generating a good archaeological provenance for a fake that has been subjected to a period of burial. This does not always work, particularly if the forger is careless in preparing a burial spot. In 1905 the Abbé d'Aguel, anxious to demonstrate that trade between Egypt and Gaul dated back to Neolithic times, announced the discovery of a number of finely worked flint implements and weapons. These, according to the Abbé, had been dug up from the sealed sedimentary limestone layers on the Ile de Riou, off the Marseilles coast. Experts soon became concerned that the surfaces of the objects had a bright, almost laquered appearance — the kind of surface patination found on objects which have been exposed for long periods to a dry desert atmosphere, not on articles buried in limestone for thousands of years.

The material was certainly authentic and Egyptian but its voyage from Egypt to France had been rather more recent than the Abbé claimed [17].

No forger wants his work to pass un-noticed as of minor importance in his chosen cultural era. For this reason the addition of some 'identifier' usually proves irresistible. Fake signatures have a long history all of their own. The Roman artists selected Praxiteles, Myron and Pausias for the imitation Greek 'spirits' in marble, silverwork and paintings while Pieter de Hooch became so identified with 'Dutch interior' painting that many of his contemporaries had their works 're-assigned' in later years (plate 4).

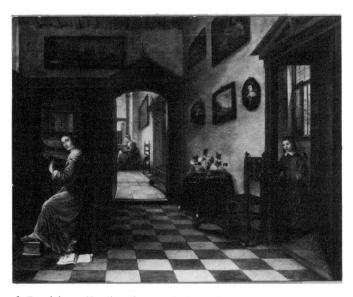

Plate 4/The interior of a Dutch house/Attributed to Hendrick van den Burch (active *circa* 1655). Spuriously inscribed on the foot-warmer to the left: P D Hooch. Photograph: courtesy of Sotheby & Co, London: see 'Old Masters' catalogue of July 12th, 1972, Lot 23.

The main error among forged signatures is over-embellishment such as a date or explanatory text. For example, early in the nineteenth century, Franz Rohrich pandered to the fashionable opinion that Lucas Cranach's real surname was Muler, his familiar name being derived from his birth-place of Kronach. Duly a portrait of the Duchess of Savoy appeared with the signature 'Cranach Muler' carefully inserted in the Duchess's jewelled hat. The ultimate mistake of the signature forger, mis-spelling, is commoner than might be supposed; in 1895 we find Camille Pissarro complaining about 'a large *gouache* by Piette signed with my name, forged of course, the name mis-spelled'.

Western imitators have been similarly unsuccessful in their production of many early Chinese works of art. One Buddhist stele, now in Cologne, bears an inscription date intended to attribute the work to AD 501 but quotes a day of that period that did not exist in the calendar. A more common error is the use of post-

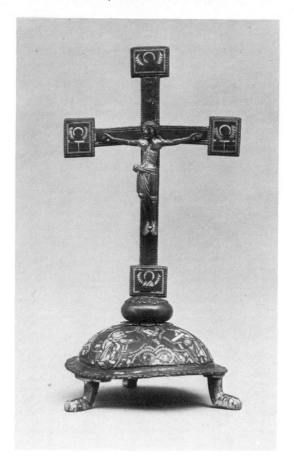

Plate 5/Cross, corpus and base/Copper-gilt with champlevé enamel on cross and base. Base and
 corpus: Mosan, twelfth century AD; cross, later construction. Overall height,
 0·30 metres. Photograph: courtesy of the Metropolitan Museum of Art, New
 York. Gift of J Pierpont Morgan, 17.190.341 a–c.

humously-allotted titles on a piece with the idea of placing it in a particular Emperor's
reign.

The appeal of signature forgery lies in the ease with which a minor
work of the right period can be boosted to a much higher market value. An early
drawing by Pieter Breughel, 'Big Fishes eat Little Ones' was converted into an Hierony-
mus Bosch creation in 1557, only to regain correct authorship when Breughel's skills
gained a world-wide recognition. In more recent times it is claimed that Modigliani
liberally signed several of his friends' works so that they could share the financial
benefits that accrued from his rise to fame, after years of poverty in Paris.

The same type of mistake often occurs in fake manuscripts where
insufficient understanding of their historical background lets the forger down. Notable
in this respect is Vaclav Hanka's inclusion of the signatures of imaginary Czech artists
in the vacant spaces of the Taromirsch Bible, plus a date, MCCLVIII. This last addition

was fatal as the manuscript is supposed to date from the fourteenth century. There is also the case of the 'Memories and Stories' attributed to Battistella, a notary from Verona. This seeks to establish Verona, rather than Florence, as the birthplace of Italian painting in the fourteenth century. Although these writings claim to record the lives of artists in the year 1303, one of the major figures, Attichiero, is documented elsewhere as active only from 1369 onwards.

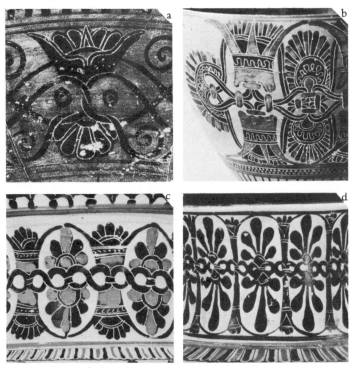

Plate 6/Development of the lotus-and-palmette frieze in Athenian vase decoration/ *a* 610 BC, *b* 575 BC, *c* 550 BC, *d* 525 BC. Photograph montage: courtesy of Dr J Boardman, Ashmolean Museum, Oxford.

Of course correct simulation of an ancient text requires not only the production of an intelligible story but also the use of the appropriate lettering form. Such considerations have been important in the study of long texts like the runic material which we have already mentioned. In the case of the Minnesota stone, a rune specialist, Erik Moltke, noted that late Medieval language like 'wi hafd hum' (for 'we had') should have been used instead of 'wi hade', the nineteenth-century style that made the text so easy to read.

Carelessness also pervades the efforts of the forger of the Medieval gilt cross illustrated in plate 5 [18]. The original base carries the names of the Evange-lists but these, in transcription to the four plaques on the cross became confused (MARCVS to OAVSRC for example). The failure to interpret the time-worn lettering properly, plus the incorrect matching of the new meaningless words to the saintly

symbols on the plaques (like the winged bull associated with Saint Luke), condemn the upper section of this piece as recent.

Fake hallmarks on silverware often accompany lavish embossing of simply-decorated, genuine plate but rarely does the official date successfully match the stylistic format. Another approach involves the cementing together of forged vessels and remnants of marked antique pieces. The equivalent date indicator for paper, the watermark, has also been treated in strange ways including the thinning of modern paper so that it can be glued to a genuine sheet and the whole document kept of similar bulk. The mark itself has been falsified in some cases by application of a blank stamp.

Apart from textual errors, authenticity judgement must often depend upon spotting other anachronisms perhaps in design, perhaps in costume fashion.

For the former, I would stress the 'protection' offered by the development in style and appearance of the 'lotus-and-palmette' frieze on Athenian vases which provides a valid relative dating indicator over a period of only a hundred years [19]. In plate 6 example *a*, dating to about 610 BC, the lotus is broad and swelling, big-leaved. In *b*, of about 575 BC, it is much more compact and square. In *c* (about 550 BC) it is slimmer and simple, having lost the central 'spike', while in *d* (about 525 BC) it has become totally emaciated. There is a matching change in the drawing of figures and their dress and in vase shape.

In dress fashion depicted in paintings the striking feature is the precise detail that a contemporary artist will record; each knot, each pleat in its proper position. A case of this is clear in the fresco 'Triumph of Venus', by Francesco Cossa, in the Schifanoia Palace at Ferrara, where minute tapering pleats (or 'darts') have been meticulously included even though the painting would some twenty feet away from any viewer [20]. This degree of attention to detail distinguished the contemporary artist (whose knowledge of the clothing of his own period is second nature) from the forger (who will often invent features that make a garment impossible to put on or take off).

The portrait group of colour plate 2, possibly by Icilio Joni (*circa* 1923) illustrates errors of this nature [21]. The man's raised cuff carries folds that defy gravity while the cloth above the elbow is cut so liberally that it would engulf the hand if the wearer dropped that arm to his side. To the expert eye the chequered cap is tilted too far back for the last decade of the fifteenth century to which we are supposed to ascribe the work. This might seem a minor detail but angle of headdress and hair arrangement have always been extremely sensitive to change of style as they frame the face, the focal point of human attention.

Many authenticity uncertainties based on more aesthetic grounds usually lack immediate tangibility. Most of us have that feeling of 'being followed' when close to da Vinci's 'Mona Lisa', wherever we are in the gallery and the same indefinable quality can be attached to the 'smile' of archaic sculpture or the 'austerity' of expression on Romanesque material. Perhaps only the master forger of this century, Alceo Dossena, achieved even a reasonable approximation to these past ideals and even then he often resorted to careful mutilation of tell-tale regions of his sculptures to minimize such weaknesses. However, these weaknesses can only serve to raise suspicion, not cause outright rejection.

In contrast simple technical errors can often swiftly clarify matters, albeit with the back-up of a detailed knowledge of past skills and attitudes. Earlier this century an unfinished female figure sculpted in marble was attributed to Michelangelo [22]. However, the stone had clearly been worked using the pointing process, a mechanical method loathed by the Renaissance master. The use of pointing also often betrays Roman replicas of Greek marbles.

The presence of mould-ridges on a Medieval bronze would be extremely suggestive of after-casting as originals were invariably cast in one piece by the *cire perdue* technique. The same used to be said of Renaissance bronzes but a recently re-discovered group of folios by da Vinci include sketches of piece-moulds destined for use in the casting of a colossal equestrian monument for the Sforza family of Milan and an outline of the ancient development of the technology [23].

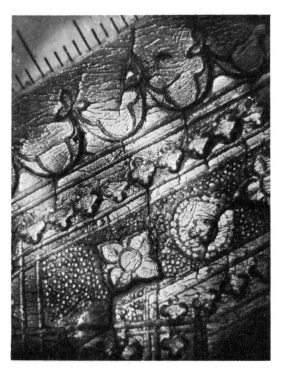

Plate 7/Punched adornment on the thin foil border around the edge of a panel/Crucifixion, attributed to Ambrogio Lorenzetti (active 1319–1347). Fogg Art Museum, Boston; accession number, 1939.113. Photograph: courtesy of Professor M Frinta, State University of New York at Albany.

In similar vein the absence of any engraved undersketching on Attic vase paintings and Etruscan decoration of tomb frescoes and terracotta wall-plaques is out of keeping with the usual approach of the ancients. Indeed the Etruscan artists seem to have gone to even greater pains to proportion their products by first dividing up each surface into zones using scribed horizontal lines.

The primary aim of a forger is to deceive the human eye. There are, however, many secrets of the past that demand investigation in much finer detail before they are revealed. This is well-illustrated by our present understanding of gold-working in Greek and Etruscan jewellery. Originally fine spiral patterning was achieved by cutting narrow strips of sheet metal and block-twisting them [7]. Modern attempts to simulate this appearance involve the engraving of the design along a length of drawn wire. Magnification of an object's surface by even a factor of ten (often termed 'macroscopic' investigation) will reveal such detail.

On the same scale the chiselling of a metal surface can soon be detected in motifs and inscriptions by the hardness of line and cracking of the brittle surface. Such treatment of an early Chinese bronze is certain evidence of faking even more obviously if the new lines carve through layers of corrosion. For pieces from other civilizations in which tool-working was employed a microscopic study may reveal the type of working-edge that incised the design [24]. A *tracer*, with its slightly bevelled edge, is gently hammered to indent the surface, so that metal is forced into mounds on either side of the marking. This tool was used in Minoan times at the beginning of the Bronze Age. A *graver*, in contrast, is a diamond-shaped tool that gouges out a v-cut in the metal as it is worked along the surface with a steady rocking action. The groove produced in this way usually bears a tell-tale track at the bottom. Bronze would not be a practical medium for graver manufacture so the introduction of this method of incision probably does not pre-date about 800 BC, the beginnings of the global Iron Age.

Plate 7 illustrates quite a different feature of gold-working that shows up particularly well in macroscopic analysis of this nature [25]. It represents the punched adornment on the thin foil border around the edge of a panel-painting, 'Crucifixion', attributed to Ambrogio Lorenzetti. He, like many of his contemporaries in Siena in the early fourteenth century, kept a special set of punching tools in his workshop, the patterning and minor imperfections of which are now regarded almost as signatures of the artist. Here Ambrogio Lorenzetti's hand can be seen in the inner 'arcade gothique' (particularly the tiny trefoil pendants) while his brother Pietro's involvement in this work is in evidence in the quatrefoil motif on the granulated strip.

Mojmir Frinta, who has specialized for more than a decade in interpretation of these punch types, has commented on the narrowness of margin between the activities of forgers and copyists in work of this kind. An exacting restorer might well attempt to produce an exact replica by casting it from an undamaged impression in the panel itself (or perhaps from another work by the same artist). The absence of punch imperfections that 'fingerprint' the original workshop product could be interpreted as evidence of fraudulent intent.

As for paintings, a macrophotograph of surface detail can reveal surprising features related to the crackle formation mentioned earlier. There is an instance now documented where some meticulous forger, having 'resurrected' what was probably a fairly dull still-life and heavily repainted it in the style of a seventeenth-century master, took time to incise cracks in the upper surface to match those in underlying original levels [26]. But that is an exceptional case: a far more common ploy is simply to paint a crackle network in black all over the surface.

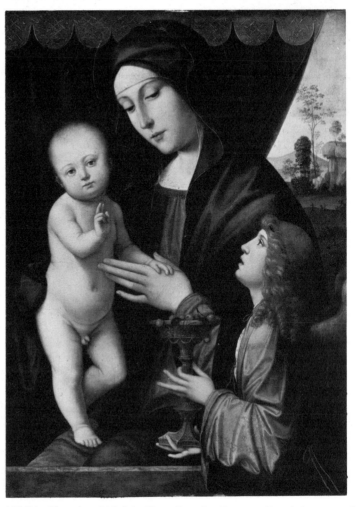

Plate 8/Madonna and Child with an Angel/Originally attributed to Francesco Francia (1450–1518) but now regarded as a modern forgery. Amongst other failings the normal crackle of a paint surface was found to be simulated using a fine network of painted-on lines. Photograph: courtesy of the Trustees of the National Gallery, London; catalogue number 3927.

An example of this is shown in colour plate 7, a detail of a work, 'Religious Procession', originally attributed to Pieter Breughel, and shown in full in colour plate 8. Another notable instance is the National Gallery's version of Francesco Francia's 'Madonna and Child with an Angel' (plate 8) which was promptly scientifically analysed when Leonard Koetser, a London art-dealer, in 1955 claimed he held a version of this work too [27].

The ultraviolet lamp is the best known 'gadget' in the art world and is as likely to be found in a dealer's hands as in those of a scientist. The basic ideas behind its use are deceptively simple. Regions of restoration (or artificial replacement

by a forger) may well be highly skilled and be quite undetectable to the naked eye. But differences in media and texture between original and new sections usually have quite distinct fluorescence properties (colour plate 6).

However, correct usage of a UV lamp calls for great care in interpretation of the fluorescence seen. It is essential to know what the hue of a genuine surface would look like before comparisons can be drawn with false material. George Savage has made this point particularly well with respect to porcelains [3]. Early and later

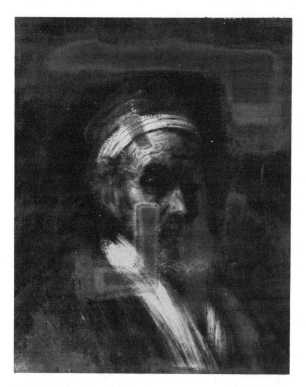

Plate 9/Detail from 'Jacob Trip', attributed to Rembrandt (1606–1669), photographed under ultra-violet light/The three areas of remaining varnish are shown to be made up of four distinct layers, distinguished by their different fluorescences. Photograph: courtesy of the Trustees of the National Gallery, London; catalogue number 1674.

Chelsea wares can be distinguished by their peach-coloured and dark violet fluorescence, respectively, a difference which seems to match a change of clay stock in manufacture. Additionally, a mustard-yellow hue seems to be a feature peculiar to the porcelains of Samson of Paris.

The forger's tactic here is not to copy an original or pass off his own handiwork as antique. Instead, the aim is 'to dress mutton as lamb', selling a piece as intact and in pristine condition when nothing could be further from the truth. But under UV his efforts often show up quite clearly.

In the case of paper, as watercolour backing or as documents, use of patches is a common enough device that can be detected, particularly if a cellulose acetate varnish has been used as a replacement for the original sizing. With bronzes which have been artificially patinated to simulate metal corrosion effects the location of paint is usually revealed by a pale pink fluorescence, matching activation of an oil or resin vehicle [28].

But there is ample room for caution in this work. Animal and vegetable glues fluoresce very little even when new while an alarmingly bright bluish-white hue is likely to be due to soap residues of recent washing and, as such, have no sinister connotation whatever. There are even rumours that some Japanese forgers of Chinese porcelains and early bronzes conscientiously apply a uniform spray-coating of a non-fluorescent material, purely to defeat this detection method.

Oil paintings offer some of the best examples of UV investigations, as re-touching with fresh pigments and new varnish is part of their restoration history over centuries. In the case of Rembrandt's 'Jacob Trip' (plate 9) the areas of remaining varnish indicate four such treatments, each layer distinguishable by a different fluorescent shade [29]. But there is an eventual limit to UV analysis in that even recent varnish coatings eventually oxidize and degrade just like their original counterparts and the contrast between new and old becomes weaker and weaker. It is also worth underlining here an observation recently made that although UV study may reveal paint regions overlying the varnish layer this is not conclusive evidence of later addition, a deduction often enough quoted in the literature [30]. In the Renaissance it was the exception for varnish to be applied over the whole picture area: complete coverage is a post-1650 phenomenon. In many earlier works varnish was often used only in the role of a glaze to highlight certain pigment zones.

These few comments on UV effects are intended as a warning to art dealers and connoisseurs alike. Even the simpler scientific tools are no more than a means of investigation. They do not provide 'instant interpretation' of an object's history; that is a subjective response that lies within the mind of the observer, a feature of analysis with adequate scope for error.

[1] Hoving T P F 1968 *Metropolitan Museum of Art, Bulletin* **26** 241
[2] Aitken M J, Moorey P R S and Ucko P J 1971 *Archaeometry* **13** 89
[3] Jeppson L 1970 *Fabulous Frauds* (London: Arlington Books) p 69
 Some of the x-ray photographs used at Wacker's trial are illustrated in
 Savage G 1963 *Forgeries, Fakes and Reproductions* (London: Barrie and Rockliff)
 plate 31 (Appendix 3 discusses use of ultraviolet light in surface examination)
[4] Roman copyists of Greek sculpture usually carried out a three-dimensional
 survey of the main points on an original's composition using calipers and a
 plumb-line. The 'mechanical' quality of the end product is considered to be
 still evidence to-day, though I feel it calls for remarkable experience to be able
 to detect this feature. See for example
 Konstam N 1972 *Apollo* **96** 144
[5] Boon G C 1974 *Scientific American* **231** 120
[6] King C E and Hedges R E M 1974 *Archaeometry* **10** 189
[7] Barker H 1973 *Application of Science in Examination of Works of Art* (Boston:
 Museum of Fine Arts) vol II p 187

[8] Teitze H 1948 *Genuine and False: Copies, Imitations, Forgeries* (New York: Chanticleer Press) p 20

[9] Kurz O 1967 *Fakes* (New York: Dover Publications) p 309

[10] Reith A 1970 *Archaeological Fakes* (London: Barrie and Jenkins) p 89

[11] See reference 9 plates 130 and 131

[12] Collins-Baker C H 1933 *The Connoisseur* **92** 161

[13] See reference 10, plate 30 and accompanying text

[14] Fleming S J, Jucker H and Riederer J 1971 *Archaeometry* **13** 143
Elements from the illustrated pastiche are derived from:
Pallatino M 1952 *Etruscan Painting* (New York: Skira) p 31 (for the main scheme and fountain chequering)
Robertson M 1959 *Greek Painting* (New York: Skira) plates 78 and 105 (for the lion on the fountain and the upper frieze fragment plus the water pitcher)
Arias P E 1962 *A History of Greek Vase Painting* (London: Thames and Hudson) plate 32 (for the crouching dog)
Buschor E 1921 *Griechische Vasen* (London: Chatto and Windus) plate XXI (for the theme of Polyxena and Troilus leading the horse to water)
Leisinger H 1953 *Malerei der Etrusker* (Zurich/Stüttgart:) plate 11 (for the horse)
Hinks R P 1933 *Catalogue of the Greek, Etruscan and Roman Paintings and Mosaics* (London: British Museum) plates 5c–e (for the style of Polyxena's dress)
Poulsen V 1969 *Etruskische Kunst* (Karl Robert Langewiesche Nachfolger Hans Köster Königstein im Taunus) plate 46 (for the two birds)

[15] Fleming S J 1973 *Archaeometry* **15** 31

[16] *Vasari, on Technique* translated L S Maclehose (New York: Dover Publications) p 166

[17] See reference 10 p 82

[18] Gómez-Moreno C 1968 *Metropolitan Museum of Art, Bulletin* **26** 263

[19] Illustrations and discussion on lotus-and-palmette friezes kindly supplied by Dr J Boardman of the Ashmolean Museum

[20] Birbari E 1975 *Dress in Italian Painting, 1460–1500* (London: John Murray) plate 43
See also Pearce S M 1959 *Studies in Conservation* **4** 127
and Newton S M 1965 *Antiques* **88** 650

[21] Pearce S M 1960 *Bulletin of The Needle and Bobbin Club* **44** 22

[22] See reference 9 plate 76 and accompanying text

[23] Bearzi B 1970 *Commentari* **21** 3

[24] Young W J 1970 *Art and Technology* ed S Doeringer, D G Mitten and A Steinberg (Cambridge, Mass: MIT Press) p 85

[25] Frinta M S 1971 *Art Bulletin* **53** 306
See also Frinta M S 1965 *Art Bulletin* **47** 261
Frinta M S 1972 *Conservation of Paintings and the Graphic Arts* (IIC Lisbon Congress) p 115

[26] Keck S and Feller R L 1964 *Studies in Conservation* **9** 1

[27] *Connoisseur* **136** 118 (1955)

[28] Gettens R J 1969 *The Freer Chinese Bronzes II: Technical Studies* (Washington DC: Freer Gallery) ch VIII

[29] Ruhemann H 1958 *Studies in Conservation* **3** 145

[30] Kurz O 1963 *Burlington Mag.* **105** 94

2

Paintings,

2 Paintings,

The history of pigments/ Pigment anachronisms/ Neutron activation analysis/
Mass spectrometry/ van Meegeren/ X-radiography/ Neutron autoradiography/
Blakelock/ Infrared reflectance measurements/ Painting grounds/ Tree-ring
dating

It is unlikely that a skilled forger will often oblige the scientist by
using such an unsophisticated device as painted-on *craquelure* or by failing to use an old
canvas or wooden panel on which to paint his forgery. We must assume that he will
do all he can to anticipate laboratory examination of his work. Authenticity judgement
becomes, to some degree, a test of the faker's patience, attention to detail and technical
knowledge.

The sub-surface of a painting can be examined to test the forger's
understanding of the pigments available to the original artist. Each colour has a well-
documented history which, in broad terms, reflects the progressive replacement of
pigments derived from natural sources by man-made materials. This trend became
particularly pronounced from the eighteenth century onwards as the chemical indus-
trial revolution gained momentum.

To look at these pigments we call into play two of the more con-
ventional methods of scientific analysis. The first is the preparation of a cross-section
of the layers of paint so that these can be examined under a high-power microscope
(colour plate 4) [1]. The cross-section may be obtained by careful cutting with a
scalpel, usually at the edge of a crackle line or region of paint loss [2] or by pricking
with a hypodermic needle so that the paint layers are displayed along a cylindrical
section. For microscope study the cross-section is mounted in a cold-setting polyester
plastic and polished. In the very extensive literature on the use of this method to
investigate artists' techniques, detailed projects on Vermeer [3] and Tintoretto [4] are
exemplary.

Most of the natural materials used for pigments have well-established
optical properties and some commercial products can be easily recognized under the
microscope. This is particularly true of pigments manufactured by a precipitation
process (early in the nineteenth century ultramarine was produced in this way) as these
are comprised of small round particles of regular shape [5].

Microchemistry is also a powerful tool in this field. Once a pigment
is in solution, individual droplets can be analysed to identify particular elements pre-

sent. For example, lead white {chemically $2PbCO_3.Pb(OH)_2$}, when treated
with nitric acid and evaporated to dryness, yields a characteristic lattice of dendrite-
shaped crystals of lead nitrate [6]. Further treatment with a solution of potassium iodide
yields a yellow precipitate of glistening hexagonal platelets of lead iodide. (A compre-
hensive list of such spot tests is given in reference 7.)

 However, a positive identification of the pigment usually requires a
second standard analytical technique: x-ray diffraction [8]. The crystal structure of a
mineral is characterized by the spacings between the planes of atoms. Even a single pig-
ment grain is enough to scatter an incident x-ray beam to produce a diffraction pattern.
This pattern, detected on a photographic film, consists of lines the spacings and in-
tensities of which are unique for each chemical composition and crystal structure.

 Microsampling of pigments is feasible using a vibrating needle probe
driven by ultrasonic power [9]. The minute heap of powder this produces can be
sampled with a fine nylon fibre slightly greased at the tip, so that it is an ideal form
for diffraction analysis.

 One illustration stresses the value of this method. A modern lead
white, disputedly termed 'pearlescent' and thought to be of a composition
{$4PbCO_3.2Pb(OH)_2.PbO$}, has obvious similarities to the ancient form of that pigment.
However, their x-ray patterns are quite distinctive. The pearlescent form is a twentieth-
century product of the National Lead Company in America [10].

 How do we use these methods of pigment analysis to decide if a
painting is genuine? We look for anachronisms; pigments which were not available
at the time when the picture was supposed to have been produced. The use of x-ray
diffraction to identify the presence of modern, pearlescent lead white is an obvious
example but, before we can make more general use of pigment anachronisms, we need
to look more closely at the history of pigment development.

 The ancients could draw on a wide variety of minerals, like the many
forms of ochre, cinnabar (mercury sulphide), orpiment and realgar (arsenic sulphides),
azurite and malachite (copper carbonates), as well as several vegetable sources like mad-
der root and the woad plant. The precious lapis lazuli used for making ultramarine was
quarried in Badakshan at the headwaters of the Oxus river and traded across continents.

 Early literary sources, such as Theophrastus and Pliny, give detailed
recipes for the preparation of verdigris (by exposure of copper to vapours from fer-
menting grapeskins), lead white (by pickling metallic lead in vinegar) and red lead
(lead tetroxide, produced by heating lead white to around 480°C) [11]. But during the
first millennium AD there seems to have been a paucity of fresh ideas with the excep-
tion of the synthesis of cinnabar, as vermilion, by direct unification of mercury and
sulphur [12].

 In the fourteenth or fifteenth centuries we begin to see evidence of a
new experimental approach in the numerous treatises on the preparation and suitability
of pigments for manuscript illumination. Notable amongst these are *De arte illuminandi*,
The Strasburg Manuscript, *Il libro dell' arte* and the *Göttingen Model Book* [13]. Mosaic
gold (*aurum musicum*), the artificial stannic sulphide, is a much discussed pigment in this
medieval literature and general use of massicot (a lead–tin oxide yellow) probably sets
in at about this time.

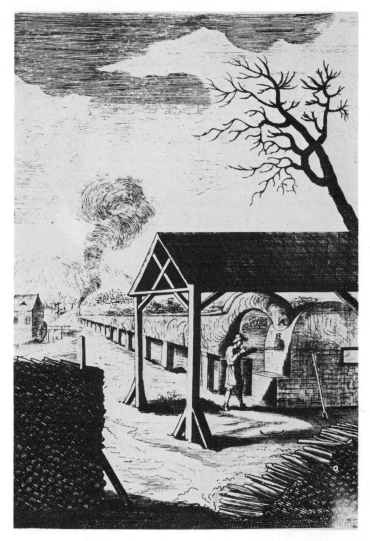

Plate 1/Cobalt smelting in Saxony during the seventeenth century/A is the beginning of the tunnel
through which the smoke passed and arsenic settled; B is the reverberatory
furnace in which the cobalt ore was placed. From J von Kunckel's *Ars vitraria
experimentalis* of 1689. Photograph: courtesy of the British Museum.

Early in the sixteenth century smalt (crushed blue glass) gained pop-
ularity in Northern Europe when Weidenhammer of Schneeberg, in 1520, exploited
cobalt deposits discovered in the Annberg region of Saxony [14]. But its composition
was a matter for conjecture in the literature of the following 160 years, until J von
Kunckel laid down directions for smalt manufacture in his treatise, *Ars vitraria experi-
mentalis* (plate 1) [15]. Experimentation early in the seventeenth century is attested by
the gradual emergence of Naples yellow (a lead antimonate) to replace massicot, a

switch that seems to have been completed around 1766 with de Bondaroy's publication of the pigment's recipe and composition [16].

The year of 1704 marks the beginning of the history of modern synthetic pigments with the discovery of Prussian blue by the German chemist, Diesbach. It is claimed by G E Stahl, in a report of this discovery in *Experimentes, Observationibus, animadversionibus* (1731), that Diesbach's achievement sprang from an accident during preparation of Florentine lake red pigment containing iron vitriol. He was obliged to use a waste potash solution for washing purposes, unaware that it was heavily contaminated with blood residues. This nitrogenous material reacted with the iron compounds and a deep blue precipitate of ferric ferrocyanide, Prussian blue, was the final product. The new pigment seems to have found very prompt usage in Dutch painting and to have been on the colour market of Amsterdam by 1722, if not earlier [17]. The following decade saw a proliferation of preparation methods once it was appreciated that almost any animal remains could serve as the source of nitrogen.

C W Scheele provided the next important step forward, in 1778, with a copper arsenite green that now bears his name. However, this pigment was soon found to be poisonous and was promptly replaced by emerald green (a much safer copper aceto-arsenite) in 1814. But the intervening years of the mid-eighteenth century had been an active period in chemistry with the isolation of several new elements, like cobalt (Brandt in 1735), zinc (Margraaf in 1746) and chromium (Vauquelin in 1797), each of which led in due course to a new pigment: Rinmann's green (1780), zinc white (1782) and chromium yellow (1809) [18]. At about the same time there was a resurgence of interest in green earth (a pigment derived from the minerals glauconite and celadonite) as a substitute for verdigris [19].

Throughout the nineteenth and early twentieth centuries artists and colour merchants laid more and more emphasis on pigments with desirable properties, notably those with permanence against ageing. This led to a rapid turnover of new formulations, while the history of this subject took an entirely new turn in 1856 with W Perkin's synthesis of the dyestuff, mauve [20].

The initial enthusiasm with which the colour merchants greeted this discovery gave way to disappointment as few of the new synthetic dyes produced during the next 50 years proved at all stable. But eventually these problems were overcome, notably with the production in 1910 of the cadmium reds which even began to challenge the traditional pre-eminence of vermilion.

As an illustration of a detailed pigment chronology we can examine the changes in popularity of the commoner blue pigments between the fourteenth and nineteenth centuries (plate 2). The introduction of Prussian blue led to a severe decrease in the use of azurite even though a cheap artificial form, blue verditer, was available. Natural ultramarine resisted replacement in the same way, probably because it was so highly regarded by artists themselves. Fresh sources of lapis lazuli mined in Russia (near Lake Baikal) plus its chemical synthesis by Guimet in 1826, should have turned the tide in its favour but the sharp growth of interest in cobalt blue (discovered by Thénard in 1804) seems to have hindered ultramarine's recovery [21]. In the face of all the various synthetic blues of the nineteenth century, the less frequently used

smalt and indigo colours seem to have been totally eclipsed. All these blues have now been virtually entirely superseded by monastral blue, a copper phthalocyanine dye-stuff first put into manufacture in 1936.

Having built up detailed documentation for the complete range of natural and synthetic pigments we can now begin the real task of detecting anachronisms in the forger's palette. As a first illustration we can recall the much-reported court action, 'Muller and Co *versus* de Haas'. This involved a 'Merry Cavalier' attributed to Frans Hals (1580–1666) [22]. The matter received no official judgement as Hofstede de Groot, the hard-pressed expert who first certified the work as an original, bought it for his own collection for a princely sum. But the court records contain some impressive technical evidence. The Cavalier's coat was painted in synthetic ultramarine and his broad collar in zinc white, while the entire background was cobalt blue. Even the earliest of these, zinc white, post-dates Hals' death by almost 120 years.

This is by no means an isolated example of pigment anachronism. Indeed more recent painting denouncements of this nature could fill a small catalogue. This would include an attractive landscape, 'Watermill under the Trees' which contains Prussian blue in the sky and in the garments of the peasants making their way through the woods [23] but spuriously signed 'Hobbema', who died in 1709.† And we can exclude a National Gallery painting, 'Entrance to the Cannaregio', (plate 3a) from Francesco Guardi's *oeuvre* as the artist died in 1793, some eleven years before cobalt blue was invented, yet the pigment occurs in a blue coat amongst the scene's promenaders [24]. The profile portrait of a Florentine lady illustrated in plate 3b is certainly not the work of a fifteenth-century Italian artist, as was first thought, even if we disregard the heavy layers of modern varnish and retouching it recently bore [25]. Though a crackled ground on an old wooden panel gave it credibility, the paints of the portrait itself, chrome green (1825+), titanium oxide white (1919+) and the addition of barium chloride amongst the red and yellow ochres (a post-1800 treatment) clearly label the work a fake [26].

The same can be said of the 'Religious Procession' of colour plate 8 originally attributed to Pieter Breughel (1525–69). This picture has already been discussed in chapter 1 in connection with the painted crackle on its surface. The forger was just as brash about his choice of colours, using chromic oxide (a post-1862 pigment) liberally throughout the painting of the house-walls [27].

Finally, we should include the recent judgement on 'The Vinland Map' (plate 3c) previously invoked as evidence that the Viking, Lief Ericsson, first visited America some 500 years before Columbus' more celebrated voyage [28]. Suspicions were voiced when the map ink did not quench the vellum's fluorescence under ultraviolet light as would have been expected with a normal ancient iron gallotannate ink. But it was the presence of the twentieth-century titanium oxide pigment in regions originally viewed as an age-staining from the ink vehicle that clinched matters in revoking this historical document.

† The Brooklyn Museum, accession number 17.69. This work also 'falls down' on the grounds of painted crackle found on the surface, but pigment analysis came first in this instance.

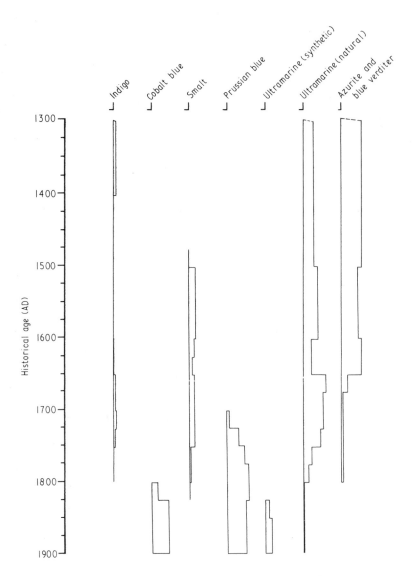

Plate 2/Examples of usage of the major blue pigments during the period AD 1300–1900.

a Cobalt blue, 'The Heerengracht at The Hague', attributed to B J van Hove (*circa* 1840). Pigment used in the central figure's jacket and in the clothing of the little boy with the nurse. Collection Haags Gemeentemuseum, The Hague; catalogue number 391.

b Artificial ultramarine, 'Les Parapluies' attributed to Renoir (1841–1919). Pigment used in the brightest blue of the skirt of the girl in the foreground. National Gallery, London; catalogue number 3268.

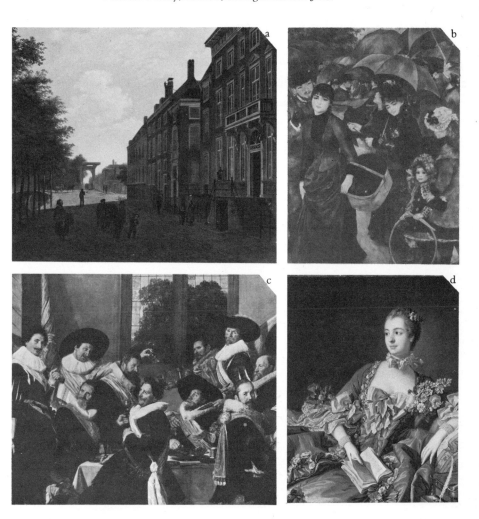

c Indigo, 'Banquet of Officers of the Civic Guard of Saint Adrian' attributed to Frans Hals (1580–1666).

d Blue verditer, 'Madame de Pompadour' attributed to François Boucher (1703–1770). Pigment used in the silk dress. National Gallery of Scotland, Edinburgh; catalogue number 119.46.

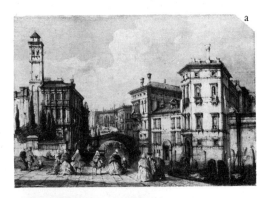

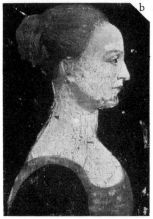

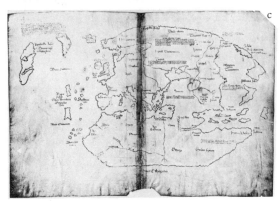

Plate 3 / a Entrance to the Cannaregio / Attributed to an imitator of Francesco Guardi (1712–1793).
 Photograph: courtesy of the Trustees of the National Gallery, London;
 catalogue number 1054.
 b Profile portrait of a lady / Twentieth-century painting in fifteenth-century
 Florentine style. Photograph: courtesy of Dr W J Young, Museum of Fine
 Arts, Boston.
 c The Vinland Map / Photograph: courtesy of Yale University Library.

However, one needs to be cautious about adopting too dogmatic an attitude towards pigment anachronisms. No doubt a few curators blanched when they learnt that the famous Rubens' work, 'The Gerbier Family' illustrated in plate 4 had regions covered with a varnish containing synthetic ultramarine [1]. Fortunately the painting's conservators were finally satisfied that the varnish really was a late addition and gave the work a clean bill of health. This is likely to be quite a common problem, few Old Masters having survived until the present day without some re-touching.

Plate 4/Deborah Kip, wife of Sir Balthasar Gerbier, and her children/Attributed to Rubens (1577–1640). Photograph: courtesy of the National Gallery of Art, Washington DC, Andrew W Mellon Fund, 1971; catalogue number 2558.

Isotope data	$^{206}Pb/^{204}Pb$	$^{208}Pb/^{206}Pb$
'Gerbier' painting (14 samples)	18·27–18·51	2·075–2·083
Pre-1800 paintings	18·35–18·80	2·07–2·09
(Dutch, Flemish and Belgian)		

Unfortunately, the painting faker is likely to be an artist himself, albeit one embittered by the failure of his own style to win acclaim. He may even be adequately grounded in pigment history: certainly the literature of the past two decades contains many detailed palette studies, often specific to a particular artist, upon which a modern forger could capitalize [29]. From the earlier discussion it is clear that a simple palette largely dependent upon natural pigments would be least susceptible to detection.

However, if a pigment is studied, not in its gross composition but in its trace impurity content, subtle extra differences between ancient and modern forms emerge. A suitable scientific tool for this is *neutron activation analysis*, the physical principles of which can be outlined as follows.

When an atomic nucleus absorbs a neutron it becomes unstable and subsequently breaks down by radioactive decay. Bombardment with low-energy 'thermal' neutrons results almost exclusively in 'radioactive capture' where the decay

process involves the emission of gamma-rays. The element involved is characterized by the energy and the radioactive decay half-life of the gamma-ray emission. For example the activation half-life data for zinc and copper are 245 days and 0·53 days; the zinc reaction has a gamma-ray energy of 1115 keV while that of copper is characterized by two energies, 511 and 1340 keV.

Most nuclear reactor stations provide convenient sources of thermal neutrons for activation analysis; the protective water pool over the fuel pile slows the neutrons down to suitable speeds.

Not every collision between a neutron and an atomic nucleus results in a capture reaction; the probability for capture by a given nucleus is conveniently expressed in terms of the 'capture cross-section', the larger the cross-section the more likely the neutron capture reaction [30]. The fact that cross-sections vary considerably from one atom to another means that some elements like antimony (with a cross-section of $30 \times 10^{-24} cm^2$) are detectable at much lower concentrations than, say, copper ($3·9 \times 10^{-24} cm^2$) or zinc ($0·5 \times 10^{-24} cm^2$).

A typical gamma-ray spectrum consists of a large number of over-lapping peaks, all partially obscured by the background count of the detection system. Computer 'stripping' techniques can be used to remove the more intense peaks, one by one, and give weaker peaks a better chance of resolution [31]. Ultimately this approach greatly enhances the detectibility of several scarcer constituents. The maximum signal is governed not only by the total number of atoms of an element present in the pigment but also by the saturation effect where the build-up of the number of radioactive atoms is balanced by radioactivity decay losses.

Quantitative analysis of element concentration requires that due account be taken of the detection system's efficiency as a function of incoming gamma-ray energy. To this end an irradiation jig will contain extra slots to carry some standard materials of known trace impurity content and bulk composition similar to that of the 'unknown' so that the general absorption characteristics are matched. The detection system itself is usually a thallium-activated sodium iodide or lithium-activated germanium crystal connected to a multichannel pulse height analyser.

Lead white has been the primary white pigment in western oil paintings ever since Roman times; it is only in the past few decades that it has faced any serious challenge, primarily from titanium pigments. It is particularly popular with artists, largely because of its homogeneity and density of coverage; it is also resistant to degradation once it has been given a coat of varnish. Lead white is equally popular with scientists; it is usually used to cover quite large areas of a painting on its own, without contamination, and this makes it a good candidate for detailed analysis.

The method of lead white manufacture remained almost unaltered until the eighteenth century. The lead sulphide ore, galena, was first roasted to the oxide, litharge, and then smelted down to the raw metal. So-called 'buckles' of broad strip lead were stretched across clay pots containing acetic acid and several such units were piled high in a dung-bed. The latter's fermentation produced carbon dioxide which, together with acetic vapours, caused carbonate formation. The eighteenth-century innovation was the replacement of dung with waste tanner's bark to increase the fermentation heat and thereby improve the rate of conversion of metal to pigment.

During the latter half of the eighteenth century mechanization arrived in the manufacturing process, the buckles being squeezed through brass rollers to free them of pigment flakes while subsequent hand-grinding was replaced by milling linked to extractor units to keep the workshop air free of poisonous residual pigment dust. Meanwhile, early in the nineteenth century, Cremnitz white, a purer pigment of the same composition, gained popularity. In its preparation litharge replaced the raw metal in the fermentation process just described. It is likely that the former was the by-product of 'cupellation', a refined treatment of galena, intended to extract as much as possible of the valuable silver sulphide impurity in that ore.

Around this time a competitor, zinc oxide, emerged to challenge the position of lead white. Some artists resisted the new substitute, finding that it lacked sufficient body when prepared as an oil paint but, by 1830, colour merchants were offering zinc white under the name 'Chinese White' as an excellent replacement for lead white in water colours. The problems of using zinc oxide in an oil medium were gradually overcome and in 1845 Le Claire, in Paris, began producing zinc white oil paint on an industrial scale using a specialized process.†

These technological changes are revealed by scientific analysis of white in Dutch paintings from the sixteenth to the nineteenth centuries particularly in the variation of silver and zinc impurity content (plate 5) [32a]. The two decades around 1850 mark a switch in silver concentration from a steady level around 22 ppm in earlier works to a level around 4 ppm for late nineteenth-century works and typical pigments of this century. Meanwhile, the virtually zinc-free lead white (rarely more than 1 ppm impurity) of the Old Masters is in strong contrast with post-1850 works where zinc levels fluctuate violently, occasionally reaching 26000 ppm. Slight zinc contamination of a few ppm can probably be attributed to particles of brass picked up from the mechanical parts of the milling equipment while a content between 20 and 70 ppm could be due to residues of zinc oxide pigment left in grinding units. The huge levels of more than 1000 ppm which are sometimes encountered could well originate from deliberate adulteration with zinc white, particularly as this contamination features only amongst modern *paint* samples rather than modern *pigments* fresh from the factory.

To silver and zinc we could add chromium as a lead white impurity of value in chronology. Pre-1650 paintings usually contain as much as 600 ppm whereas more recent works contain an order of magnitude less. The reason for this sharp change remains obscure and we can only hypothesize a sudden change of ore sources that has remained undocumented.

A recent fake of a seventeenth-century Dutch painting might well be characterized by lead white impurity levels of: $Ag \leqslant 10$ ppm: $Zn \geqslant 15$ ppm; $Cr \leqslant 40$ ppm, while the authentic work would register: $Ag \geqslant 18$ ppm; $Zn \leqslant 1$ ppm; $Cr \geqslant 200$ ppm. There are also strong signs that if the fake post-dates 1960 it will stand out even more obviously, not only in these three impurities but also in antimony content of less than 1 ppm in its lead white, compared with a level of more than 15 ppm amongst Old

† The earliest documented use of this pigment in an oil painting is J A Klein's 'Cattle with Herdsman' (1844) antedating Le Claire's process by one year (Bayerische Staatsgemäldesammlungen, Munich: catalogue number 14.186).

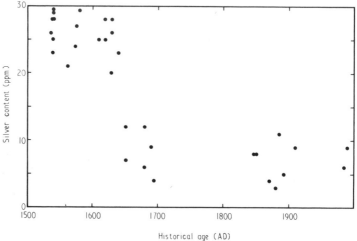

Plate 5/Trace impurity analysis of lead white pigments/
a 'Meleager and Atalanta' attributed to Jacob Jordaens (1593–1678). Photograph:
courtesy of the Royal Museum of Fine Arts, Antwerp; catalogue number 844.
Inset figure: change, with time, of the *silver* content of lead white pigment
used in Dutch and Flemish paintings dating between 1510 and 1909 and some
manufactured pigments and paints post-dating 1820.

| Artist | Painting | Date | Impurity concentration (ppm) | | | |
			Ag	Cr	Zn	Sb
Jacob Jordaens	Meleager and Atalanta	1620	27	460	< 1	72
A Schelfhout	Landscape	1806	26	36	61	19
A Wynantsz	Gothic Hall, The Hague	1848	23	8	35	37
Pigment (factory unspecified)		1927	6	0·1	230	16
Pigment (G Greve of Utrecht)		1961	2	0·2	35	0·7

b 'Landscape' attributed to A Schelfhout (1787–1870). Photograph: Collection
Haags Gemeentemuseum, The Hague; catalogue number 436.
c 'Gothic Hall, The Hague' attributed to A Wynantsz (active 1820).
Photograph: Collection Haags Gemeentemuseum, The Hague; catalogue
number 533.

Masters. The recent trend towards higher purity can be linked to further changes in technology with a switch to electrolytic and precipitation processes.

But rules that apply amongst Dutch paintings cannot necessarily be carried over to other major art regions like Venice in the sixteenth and seventeenth centuries. Lead white from works by Titian, Tintoretto and Tiepolo contain silver and chromium contents close to those of modern north European pigments (about 4 ppm). The trap for the Venetian school forger lies in the manganese and copper impurity levels which are almost absent from modern paints but in genuine paintings would have levels of around 15 ppm and 300 ppm, respectively [32b].

Authenticity judgements based on trace impurity analysis at the ppm level are often open to criticism on the grounds that the pigments may have been accidentally contaminated; this is particularly true for pigments other than lead white that are used in admixtures. Also accidents or other chance variations in the refining and smelting process could, in principle, lead to significant differences between pigment batches.

For these reasons we would prefer to obtain our chronological information direct from the main constituents of a pigment. This has stimulated appreciable interest in the use of mass spectroscopy as a means of studying important pigment elements, like carbon, oxygen, sulphur and lead, each of which occur naturally in more than one isotopic form [33]. For example a typical sample of sulphur might have an isotope distribution of:

$$^{32}S, 95.0\%; \ ^{33}S, 0.76\%; \ ^{34}S, 4.22\%.$$

There will be slight variations in composition from one sulphur sample to another; factors such as temperature and acidity can disturb the relative contributions of each isotope involved when an ore stratum is laid down. However, the isotopic distribution in a raw natural material will not alter during the conversion to a pigment. Thus in its raw form or as a pigment, lapis lazuli from Afghanistan (until the nineteenth century the only ultramarine source known) is quite different in the relative abundance of sulphur isotopes from that more recently mined in the Chilean Andes (the $^{32}S/^{34}S$ ratios differ by about 0.52). This is readily detectable over and above 'in-source' variations of \pm 0.07 or less.

Other sulphur-bearing minerals include the arsenates, orpiment (As_2S_3) and realgar (As_2S_2), the common Italian painting ground material, gypsum ($CaSO_4$), and cinnabar (HgS). The last of these is of particular interest in European painting as, between 1750 and 1800, there was a progressive replacement of Dutch sources of cinnabar by imports from China. The orpiment substitute, cadmium yellow (CdS), which was first manufactured around 1835, is an important nineteenth-century pigment that would also repay study in this way.

Oxygen has an average isotope distribution of:
$$^{16}O, 99.76\%; \ ^{17}O, 0.037\%; \ ^{18}O, 0.204\%$$

and we might expect studies of the $^{18}O/^{16}O$ ratios of native ochres (which consist largely of Fe_2O_3) to be similarly useful as customs records indicate a gradual swing away from Dutch sources to Italian ones early in the nineteenth century, particularly to the raw and burnt sienna forms that draw their name from their ore locality.

Carbon fractionation has been studied in detail in connection with the well-known archaeological dating method based on the radioactive decay of the ^{14}C isotope, so $^{13}C/^{12}C$ ratios for many sources of the element are well established (figure 1). This is expressed for each sample (S) in terms of a deviation, δ, of the isotope ratios from that of a standard (a calcium carbonate from the cretaceous Peedee formation of South Carolina, labelled *PDB belemnite*).†

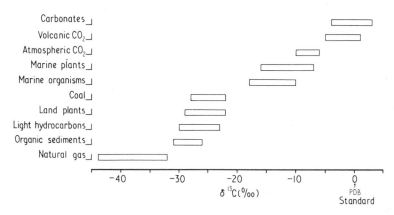

Figure 1 / Carbon isotope ratios of various carbonaceous materials. After Baxter M S and Walton A 1971 *Proc. R. Soc.* A **321** 105.

There are a host of major pigments rich in carbon, such as malachite {$CuCO_3.Cu(OH)_2$}, verdigris {$Cu(CH_3COO)_2.[Cu(OH)_2]_3.2H_2O$} and bone black {$C + Ca_3(PO_4)_2$}, but the principal interest is at present focused on Prussian blue {$Fe_4[Fe(CN)_6]_3$} which has undergone a great number of manufacturing changes since its invention.

Diesbach's first preparation in 1704 had involved calcinated blood residue (with a δ value of about $-27‰$) but the first commercial forms of the pigment seemed to have been produced from a variety of animal remains which could differ from the blood residue δ value by as much as $5‰$. Though Scheele, in 1782, suggested a change to a preparation of ammonia and charcoal ($\delta \simeq -5‰$), the main manufacturers continued to use the traditional methods until the middle of the nineteenth century. Then coal ($\delta \simeq -25‰$) became involved either through its distillation products or from waste associated with coal-gas purification.

New processes, the Beilby process of 1891–1900 that partly reverts to Scheele's ideas, the Castner process that replaced it and even one based on sugar-beet molasses, have led to further δ variations throughout this century. The most recent technique of Andrussow is the most distinctive of all as it uses natural gas ($\delta \simeq -38‰$). There can be little question that a forger of an eighteenth-century work would be making a cardinal error in using modern Prussian blue.

† The deviation is measured in parts per thousand (‰) and defined as:
$$\delta = \left\{ \frac{(^{13}C/^{12}C)\ \text{sample}}{(^{13}C/^{12}C)\ \text{PDB}} - 1 \right\} \times 1000.$$

Studies of the different isotopes of lead can also reveal quite a lot about the origins of pigments. The fact that different isotopes of uranium and thorium decay to give three distinct isotopes of lead means that galena ores of different origin and, hence, different geological age differ in their lead isotope distributions.

A sensitive indicator, the $^{206}Pb/^{204}Pb$ ratio shows little variation in the lead whites used in European paintings before 1800, independent of whether they came from Italy, Germany or Holland (figure 2). But, early in the nineteenth century, as new trade links with Canada, Australia and the United States grew, new ore sources were exploited and a much wider isotope ratio scatter emerges. Clearly this data has only minor value in dating paintings except perhaps in the transition period around 1820, but as an authenticity tool its potential is obvious. Any 'Old Master' with a ratio less than 18·0 or more than 19·0 can be labelled as a fake, and this information can be gained using samples of less than a microgram, thus causing a painting no significant damage.

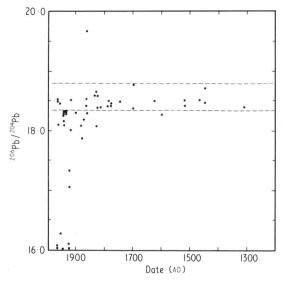

Figure 2/Lead isotope ratios for lead white pigment used in European easel painting/The horizontal lines mark the extremes of isotope ratios of European ores analysed up to this time. After Keisch B 1970 *Studies in Conservation* **15** 1.

The ratio, $^{208}Pb/^{206}Pb$, is also valuable as it seems to show very little variation in the lead white of pre-1800 Dutch, Flemish and Belgian paintings (2·07 to 2·09), even though the extensive number of European sources available at that time offer a much wider range (2·00 to 2·11). The isotope data for 14 samples from Rubens' 'The Gerbier Family' (plate 4) clearly supports some documentary evidence that it was painted in Brussels.

Yet another isotope of lead ^{210}Pb has also been used in detecting a particularly famous forgery; the 'Vermeer' painting of 'Christ and His Disciples at Emmaus' (plate 6).

Han van Meegeren must be one of the few forgers ever to welcome technical analysis of his wares. Early in 1945 he had been taken into custody by agents of the Dutch Field Security, accused with the crime of collaboration with the Nazis. The charges against him rested on his involvement in the sale of a Vermeer, 'The Woman taken in Adultery', to Hermann Goering, some three years earlier. In the period that immediately followed the German surrender, emotions ran high in the newly liberated countries and such crimes carried the death penalty.

Faced with even the suggestion of such a fate, van Meegeren's buoyant personality deflated like a pricked balloon and he flung up a seemingly outrageous defence; a claim that he had fooled, not helped, the Nazis by selling them his own work. He went further and claimed as his own some of the best known early 'Vermeers' in Dutch collections, including 'The Washing of Christ's Feet' purchased by the Rijksmuseum only a short while before and 'Christ and His Disciples at Emmaus' discovered by the scholar, Abraham Bredius, back in 1937 and subsequently

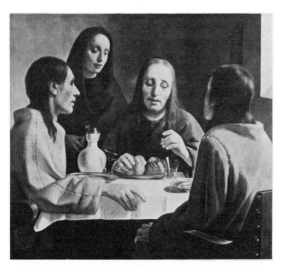

Plate 6/Christ and His Disciples at Emmaus/Attributed to Han van Meegeren (1889–1947), imitating the style of Vermeer. Photograph: courtesy of the Boymans–van Beuningen Museum, Rotterdam.

bought by Rotterdam's Museum Boymans. He added a later 'Vermeer', 'Lady playing a Mandolin' (plate 7) which bears all the correct characteristics of a Dutch Interior of the 1660s, a 'Pieter de Hooch', a 'Frans Hals', and a 'Gerhard Ter Borch'.

With so many national treasures under a cloud the art historical community closed ranks and rejected van Meegeren's claims as a reckless attempt to save his own neck. Previous examinations of the 'Emmaus' work were brought out once more. The paint's surface had resisted alcohol and solvent attack, the chemical composition of the pigments themselves fitted in with a conventional Dutch seventeenth-century palette and summary x-ray study had shown up nothing untoward under the paint layers.

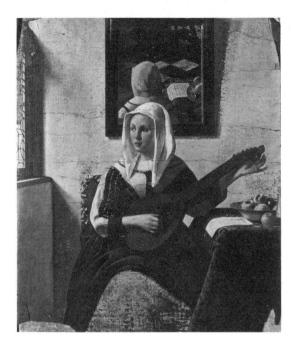

Plate 7/Lady playing a Mandolin/Attributed to Han van Meegeren (1889–1947), imitating the style of Vermeer. Photograph: courtesy of the Rijksmuseum, Amsterdam.

But, with the seeds of doubt sown, fresh technical examinations were much more rigorous. As they progressed van Meegeren independently set out to prove his skills and, under police supervision, produced another 'Vermeer', 'Jesus amongst the Doctors', explaining how he had treated his earlier fakes to defeat those previous analyses. He had scraped away the surface of an old painting leaving only its lead white ground and he had used an artificial formaldehyde resin instead of an oil medium so that the paint layers rapidly hardened to the texture of an antique painting.

At the same time, van Meegeren detailed his strategy of outwitting the art experts with the 'Emmaus' painting. Only a year or two earlier a quite uncharacteristic painting 'Christ in the House of Mary and Martha' (colour plate 9) had been grudgingly accepted as an example of the early work of Vermeer and, with that precedent set, there was a natural opening for any Vermeer which began to link this early work (*circa* 1634) and the style with which we are much more familiar such as the 'Woman weighing Gold' (*circa* 1665) (plate 8), especially if it showed the influence of Caravaggio (on whom Vermeer was thought to have modelled himself at the beginning of his career). The religious aspects of both the museum-held works fitted well into such a scheme. And van Meegeren included one characteristic Vermeer touch: the 'dotting' of patches of highlights in his still-life studies. (Note the painting of the bread in plate 6.)

By 1947, the collaboration charge had been dropped and van Meegeren found himself in court facing only an accusation of forging artists' signatures.

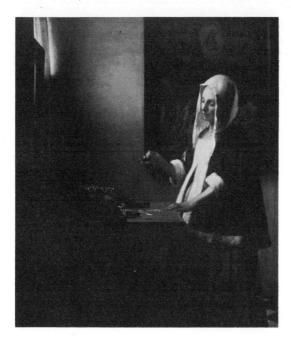

Plate 8/Woman weighing Gold/Attributed to Vermeer (1632–1675). Photograph: courtesy of the National Gallery of Art, Washington, DC; catalogue number 693.

Here he learnt of two mistakes he had made. First, the crackle in the ground underlayer, as shown up by x-ray photographs, did not always match that visible in the paint surface (van Meegeren stated he had rolled up each painting to create plenty of cracked regions). Second, the expensive ultramarine he had carefully chosen, avoiding any of the cheaper blues manufactured since the eighteenth century, was slightly adulterated with cobalt blue.

The court's sentence of a year's imprisonment was never carried out. Van Meegeren suffered a heart attack, was admitted to hospital but died shortly afterwards. But his death did not close the book on this affair by any means. A number of people remained convinced that 'Emmaus' was a genuine Vermeer and had been used by van Meegeren as a source of inspiration for his forgeries. For several years afterwards they mounted attack after attack on the evidence of P G Coremans, the principal technical witness in the trial.

The final verdict came only in 1968 with the development of a new dating technique based upon the minute levels of radioactivity contained in every lead white pigment [34]. This pigment's manufacture involves the extraction of lead metal from the sulphide ore, galena. Each ore contains some uranium ($^{238}$U) together with its products all in a state of radioactive equilibrium. In this situation as fast as the nuclei of an isotope in the chain are breaking up and converting to a daughter product so its concentration is being appropriately replenished from the decay of an immediate predecessor. Two isotopes are of particular importance here: radium-226 which has a

half-life of decay of 1600 years and lead-210, which has a half-life of 22 years, and is a direct descendant of radium-226.

But radium and lead behave quite differently during ore smelting. While the 210Pb is carried through with the metal itself most of the 226Ra stays with the waste slag products. The 210Pb concentration, now left unsupported, decays at a rate controlled by its own shorter half-life. After some 200 years radioactive equilibrium would be re-established when a decay balance is set up with the small amount of 226Ra that was retained (figure 3). The 226Ra concentration is measured by detection

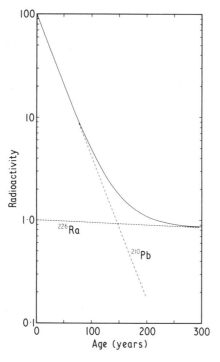

Figure 3 / A plot of the return to radioactive equilibrium of the lead-210 content of a lead white pigment / The initial concentrations of lead-210 and radium-226 immediately after pigment manufacture are shown here in an initial ratio of 100:1. Equilibrium is achieved after about 270 years, equal to some twelve half-lives of the lead decay. After Keisch B 1970 *Application of Science in Examination of Works of Art* (Boston: Museum of Fine Arts) vol II p 193.

of the α-radiation (4·78 MeV) of decay in an alpha spectrometer. 210Pb decays with β-radiation emission and this is difficult to measure accurately in the face of high background (mainly due to cosmic-ray activity). But 210Po, which lies next in the decay sequence, is an α-emitter (5·30 MeV) and so is readily detectable.

Pigments with very similar 210Pb and 226Ra concentrations need not necessarily be ancient as it could be that smelting caused only a small separation in some instances (though no case of more than 15% radium retention has been found amongst modern paints). But proof of a state of radioactive inequilibrium in a pig-

ment is straightforward. For example, the count-rates for $^{210}$Po and $^{226}$Ra in lead white taken from, 'Christ and the Disciples at Emmaus' were 8·5 and 0·8 disintegrations per minute per gram of lead (dpm/g).

The Vermeer–van Meegeren time gap is equivalent to about 13 half-lives of $^{210}$Pb decay, so if the lead white in question was of mid-seventeenth century origin the post-smelting $^{210}$Po activity would have been about $8·5 \times 2^{13}$ or 7×10^4 dpm/g. This unrealistic figure excludes that painting from being a Vermeer.

The van Meegeren affair illustrates all the typical features of a technical unmasking of a fake. Once suspicion is roused each part of the work is looked at that little bit more closely. Mistakes stand out so obviously in hindsight but only rarely does one analytical result settle the matter. Ingenious minds can always raise that hint of doubt: 'Was the paint region sampled a re-touched area? No wonder pigment anachronisms occur!' and so on. Gradually each loophole is closed and the scientific case becomes watertight.

I would like to add a final point that arose while discussing the 'Emmaus' with a fashion expert. Observe the sleeves of the disciples. In an attempt to give the clothing a 'primitive' simple look van Meegeren has followed the fashion of his own time and depicted fabric that had been 'cut on the bias', (cut at an angle of 45° to the grain of the weave). There are few treatments that would have been more alien to a seamstress of Vermeer's period.

So far we have concentrated on analysis of the layers of paint which form part of the picture itself. Another rich source of evidence becomes available to us when we use x-ray photography to look beneath these layers.

Canvases and good oak panels have always been an expensive item in an artist's budget; aspiring young painters and forgers alike can rarely afford waste. Van Meegeren was more careful than most and left scarcely more than a vestige of an earlier work on the canvas he used for 'Supper at Emmaus' but he eventually grew lazy (perhaps over confident?) and produced his version of 'The Last Supper' on top of a hunting scene by Hondius. We have subsequently learnt this as the earlier painting showed up clearly in an x-ray photograph of the whole canvas.

The principles of x-ray photography of underpaintings can be illustrated well by a recent study of William Hogarth's 'Tavern Scene: an Evening at The Rose' (plate 9), an oil sketch for 'Scene III: The Rake's Progress', a painting now in the Soane Museum, London [35]. Radiographs were produced by fixing a photographic plate in contact with the sketch's surface and exposing it to x-rays from behind the canvas support. The x-rays used lie in the wavelength range 0·5–2·0 micrometre spectrum, as used for medical radiography.

With startling clarity the portrait of a man emerges, stretched out across the width of the canvas as we now see it. But, on closer inspection, there is another tavern scene sketch just discernable in the undersketching, one with the gallery of framed paintings on the far wall running at a slight angle across the room. The most obvious change in the final, visible sketch is the use of a shattered mirror instead of a large map which one of the tavern girls is trying to set alight. It is interesting that many of the features in the earlier composition, such as the map incident, re-appear in the finished painting.

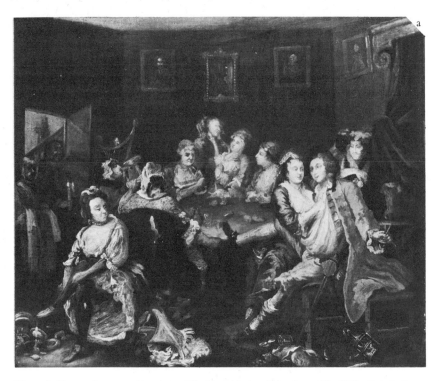

Plate 9/*a* Tavern Scene: an Evening at The Rose/A sketch for Scene III of 'The Rake's Progress' by
William Hogarth (1697–1764).
 b Radiograph of Hogarth's 'Tavern Scene' upper right-hand quadrant.
 c Radiograph of Hogarth's 'Tavern Scene' lower right-hand quadrant.
 Photographs: courtesy of The Nelson Gallery and Atkins Museum, Kansas
 City; catalogue number 56.2.

The clear contrast of the man's head with its surroundings in the
radiograph is due to the use of lead white in the flesh tones. As x-ray absorption in-
creases with higher atomic number and density, the presence of lead is readily detect-
able while lighter pigments, such as yellow ochre, diluted by an oil medium to the
same degree, is relatively 'invisible'.

 The data indicate that use of a long-wavelength x-ray would provide
appreciable extra detail, but the practical effect of this is often just to over-clutter the
image and make its interpretation far more difficult. At the same time some image
anomalies may be created by the high absorption regions of the 'K-edges' of elements,
such as copper and iron, that lie in this 'softer' radiation zone. Lake pigments, organic
dyestuffs absorbed on a substrate of aluminium hydroxide, remain virtually undetect-
able by x-ray exposure, but this weakness of the technique usually only disturbs
conservators worried about loss of surface glazing. However, it is worth noting that
addition of aluminium oxide to oil colours, with the aim of keeping down costs, has
become an increasingly common practice of the past decades, so that some useful
authenticity information may be lost to this method of study.

The literature now carries a great number of x-ray reports similar to the Hogarth example reviewed above [36]. One of these reports is particularly fascinating [37]. It discusses the radiography of a Goya portrait of an army officer, Alberto Foraster. An underpainting of another man in an earlier style of uniform has now been identified as the portrait of Manuel Godoy, who became Secretary of State in 1793, to Carlos IV of Spain, and attributed to a relatively unknown artist, Jose Caetano de Pinho. It seems likely that the re-use of the canvas possibly dates to the period 1798–1801 when Godoy was out of favour, though why Goya should have chosen one of Pinho's portraits to paint over remains a mystery.

There are also several applications of x-radiography in the solution of authenticity problems. These include a work 'Holy Antony Eremita' in the State Gallery at Stuttgart, attributed to Bernhard Strigel but actually produced about 250 years after the master's death [38]. Under the surface a quite separate work dating from 1713 was discernible. Equally assertive was a radiograph of an alleged Picasso, 'Absinthe Drinker' painted in the manner of his 'blue' period [39]. An underpainting of an abstract design was an historical impossibility.

The x-ray detail from Campin's 'Madonna and Child' in the National
Gallery, London illustrates an extra resource available with this technique (plate 10).
The right-hand part of the panel-mounting is a replacement section of inferior quality
wood, already riddled with wormholes. A priming of its surface before inclusion
caused many of these wormholes to become filled with lead white which now shows
up clearly under x-rays.

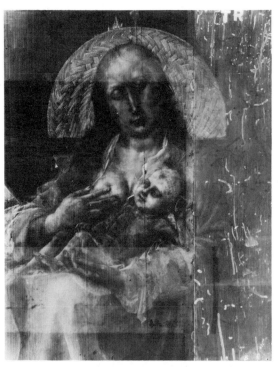

Plate 10/X-ray detail of 'Madonna and Child'/Attributed to Robert Campin (active 1406–1444).
The added panel can be distinguished by its greater opacity and by the lead
white filled wormholes. The new wickerwork also shows up in contrast to the
original. Photograph: courtesy of the National Gallery, London; catalogue
number 2609.

A similar analysis unmasked a triptych in the style of the fifteenth-
century Sienese school now in the Courtauld Institute of Art in London. Over-anxiety
on the part of the faker to use old wood led him to choose a badly mutilated piece
that no Renaissance painter in his right mind would have looked at twice. In this
case the x-radiograph was equally definite in its authenticity statement when it
revealed long machine-made nails pinning the frame to the central board.

Icons have suffered exceptionally heavily from overpainting treat-
ment though perhaps not always through attempts at fraud. Plate 11 illustrates a rather
badly damaged representation of the 'Virgin and Child' which dates stylistically from
1710. But cracks in the upper surface layer reveal an underpainting of quite a different

form and an x-radiograph confirms this. A method has now been developed to separate off successive paint layers whereby the work originally visible has been retained but the hidden icon, a rather fine sixteenth-century example, has been restored [40]. This is by no means an isolated instance. There are even examples of double-overpainting separated by intervals of several centuries.

Information about a painting can be obtained from various depths in its structure. At one extreme, at the upper surface, it is often possible to detect details of brushwork or even fingerprints, as in the case of 'The Virgin of the Rocks' in the National Gallery, London (plate 12), attributed partially to Leonardo da Vinci [41].

Such a study was one of the factors which contributed to the downfall of Otto Wacker. His faked versions of Van Gogh paintings lacked the coherent brush strokes which always characterize the underpainting of the originals [42]. At the other extreme an x-radiograph may reveal a crackle pattern in the ground layer that does not match that on the visible paint surface, indicating an old canvas has been stripped down and re-used [43]. Even intermediate paint layers can be viewed selectively using a system of stereoradiography [44].

In some cases there are advantages to be gained from turning from x-rays to neutrons as the means of studying a picture's structure in depth. The point has already been made that x-ray absorption rises steadily with a material's atomic number. Neutrons interact with the structure of the atomic nuclei in their path and often this means that they penetrate heavy elements more readily than light ones. This difference is particularly important for canvases primed with lead white. An x-radiograph then carries a heavy background over the complete area of the work but the more penetrative neutrons ignore this sub-stratum.

There is a variety of possible interactions between a neutron and a nucleus.† We have already discussed the absorption process of radiative capture as the basis of neutron activation analysis. In addition to these (n, γ) reactions there are the so-called (n, n) scattering reactions which we can picture as similar to billiard ball collisions. A neutron detector placed on the far side of the painting under study registers the sum of these effects during irradiation [45]. The scattering process is exceptionally strong for hydrogen and so radiography of wooden panels in this way is virtually impossible.

As yet this form of radiography has been largely ignored. The same cannot be said of neutron *auto*radiography [46]. Once the neutron beam is removed the scattering-type reactions cease but, by virtue of the absorption processes, the picture is now slightly radioactive. Each radioactive element is characterized not only by the x-ray energy and intensity that results from the (n, γ) reaction as discussed earlier, but also by the same characteristics of associated β-radiation.‡

† As with the lead white neutron activation discussion earlier the work here involves the 'thermal' portion of the neutron energy spectrum concentrated around the 0.025 eV region.

‡ Some important and typical reactions in this work include,

$^{27}$Al(n, γ)$^{28}$Al: Maximum β-ray energy of 3·0 MeV $t_{\frac{1}{2}}$ = 2·3 minutes

$^{58}$Fe (n, γ)$^{59}$Fe: Maximum β-ray energy of 0·46 MeV $t_{\frac{1}{2}}$ = 46 days

$^{63}$Cu (n, γ)$^{64}$Cu: Maximum β-ray energy of 0·57 MeV; $t_{\frac{1}{2}}$ = 12·8 hours

$^{55}$Mn (n, γ)$^{56}$Mn: Maximum β-ray energy of 2·86 MeV; $t_{\frac{1}{2}}$ = 2·59 hours

Plate 11/*a* Virgin and Child/Icon, Byzantine, circa 1710.
 b X-radiograph indicating the presence of an underlying earlier work.
 c Virgin and Child icon, the original, painted in the sixteenth century.
 Photographs: courtesy of Tasso Margaritoff.

Plate 12/Fingerprint impressions revealed by x-radiography of 'The Virgin of the Rocks'/
 Attributed to Leonardo da Vinci (1452–1519). This is an example of working
 the still-moist paint film often intended to achieve a 'soft-focus' effect in the
 paint layer structure. Photograph: courtesy of Dr T Brachert of the
 Schweizerisches Institut für Kunstwissenschaft, Zurich, and the National
 Gallery, London; catalogue number 1093.

The reaction that converts ^{27}Al to ^{28}Al is of particular interest because aluminium hydroxide is the base for many of the organic lake pigments such as rose madder, virtually undetectable by x-rays; others involving iron are important in detecting the natural ochres, which are almost transparent to x-radiation.

Other reactions, of copper and manganese, illustrate an additional virtue of this method. If film exposure for detection of emitted radiation covers the four to ten hour period after neutron irradiation both the manganese and the copper activities in the painting may be quite intense. But, if a lead filter about 0.5 mm thick is put between the paint surface and the photographic film, all the copper radiation is cut off. The picture observed is then due only to manganese. This is particularly useful in the study of grounds of nineteenth-century pictures when a manganese-bearing pigment was often used as a colorant, mixed with lead white. Consequently the manganese image often shows the fibre structure of the canvas support, just as x-rays reveal it in the presence of lead white.

The sad story of the American artist, Ralph Blakelock, serves as an example of the use of neutron radiography in the field of authenticity analysis [47]. Blakelock, early in his life, had toured the western states and kept a record of his trip in numerous pencil and ink drawings. In 1872 he settled in New York and began to transcribe his memories into oil paintings, though he allowed himself appreciable artistic licence and soon allowed his romantic style to overwhelm true pictorial accuracy. The work 'Landscape' illustrated in plate 13a typifies his style at that time.

Unfortunately Blakelock's highly personal approach to scenic art failed to attract buyers during the artist's lifetime. He seems to have found this lack of recognition too much to bear and, in 1899, at the age of 52, he suffered a mental collapse. From then, until his death in 1919, Blakelock was almost continuously confined to mental institutions.

Ironically, during those twenty years the art world had re-appraised this artist and prices for his works soared. Paintings by Blakelock's daughter, Marian, shared some of this success but she too was to suffer a mental breakdown only a few years later. By that time the forgers had been busy and several hundred new 'Blakelock' paintings had found their way onto the market. Though in the intervening years between 1920 and today there has been little interest in this artist's work he still seems to hold the questionable honour of 'most forged American artist'.

Fortunately Blakelock's 'attack' of his painting surface had some quite distinctive characteristics, two of which stand out clearly in autoradiography of the 'Landscape'. First, an arsenic-rich pigment seems to have been worked hard into the painting (possibly using the wooden end of his brush) in regions of highlights amongst trees to give the sensation of light breaking through the foliage. Second, a mercury-rich pigment, in a coarsely-ground form, was applied very thinly with broad brush strokes throughout the painting (plate 13b). The pigment distribution in underlayers bears scarcely any resemblance to the format of the final painting, possibly because Blakelock re-worked the paint so extensively while it was still wet.

Perhaps the most ingenious Blakelock forgery was the 'Woman in Red' of colour plate 10. There are close similarities in the technique of paint application between this work and 'Landscape' already mentioned. Yet scientific study revealed

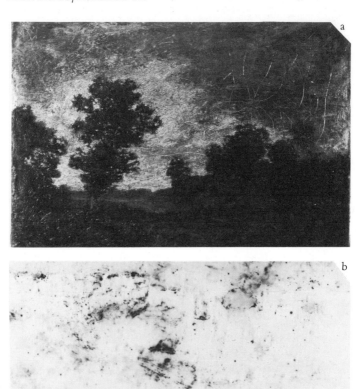

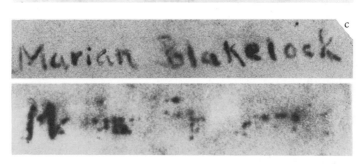

Plate 13/*a* Landscape/Attributed to Ralph A Blakelock (1847–1919). Photograph: courtesy of the Metropolitan Museum of Art, New York; accession number 26.158.2.

b Autoradiograph (detail) from 'Landscape' showing application of a coarse mercury pigment in a thin vehicle. Photograph: courtesy of Dr P Meyers, Metropolitan Museum of Art, New York.

c Comparison of detailed autoradiographs of works attributed to Marian Blakelock:
Upper: Signature on the surface of 'Landscape' in the Sheldon Memorial Art Gallery.
Lower: Hidden, partially destroyed signature on 'Woman in Red' (colour plate 10).

no tell-tale Ralph Blakelock mercury-rich wash or arsenic-rich 'squiggles'. The arsenic that was detected in 'Woman in Red' occurred in surface regions matching specific features of the final painting.

Now the painting is a mystery no more. Long-delayed autoradiographs detected mercury (half-life 46·5 days) in an unusual place, down in the lower left hand corner, in the remains of a partially-erazed signature (plate 13c). This signature bears a strong resemblance to that of Marian Blakelock as found on another landscape work now in the Sheldon Memorial Art Gallery. It is now known that at least one dealer, perhaps several, specialized in 'ageing' the works of the Blakelock family by the simple transformation of 'Marian' to 'Ralph'.

Plate 14/Detail on an infrared photograph of 'The Justice of Othon'/Attributed to Th Bouts (1415–1475). Magnification × 0·5. Photograph: courtesy of l'Institut royal du Patrimoine artistique, Brussels. The painting is in the Royal Museum of Fine Arts, Brussels; catalogue number 65–66.

In many cases the same x-ray technique that reveals an earlier painting beneath the surface of a more recent one can be used to examine the sketching detail. The preparatory undersketching of a painting often reveals much more about the processes which led to its creation than is evident in finished surface appearance. The undersketching may well carry several quite personal features of an artist's style quite as distinctive as brushwork and tonality in the paint layers themselves.

In one technique of outlining a composition, common in early Italian religious paintings, a needle is used to trace the lines of the preliminary drawing, particularly architectural detail and the folds in drapery, on to the primed surface. When the first lead-white layer is applied these grooves fill up with paint so that the painting is slightly more opaque to x-rays along the lines and the original needle drawing is revealed.

However, many undersketches are prepared in black using either charcoal or bone black, sometimes black chalk, all media with no appreciable x-ray absorption. For these materials we have to turn to a quite separate scientific technique known as infrared reflectography which often shows up the drawn line with remarkable clarity (plate 14) [48].

The human eye sees little more than the surface colours of a painting since light in the visible portion of the spectrum, as it is reflected back from the under-

lying layers, is severely scattered and attenuated in intensity in the upper pigment layer. There are important exceptions to this in the role of overlying glaze layers that can alter quite radically the hue of a pigment colour, as in the case of madder lake superimposed on a yellow oxide layer, illustrated in figure 4 [49]. This effect is often enhanced by the fact that the eye is more sensitive to some colours than to others.

In contrast infrared radiation is much more penetrating to the extent that it can reveal a painting's underlying features at a depth often four times greater than that detectable visually. For measurement purposes this penetration power is

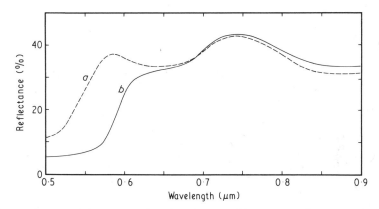

Figure 4 / Spectrophotometric curves recording the reflectance characteristics of yellow oxide pigment (curve *a*) and the effect of addition of an equal volume concentration of crimson madder pigment as a 'colour extender' (curve *b*). After Taylor D 1958 *J. Oil and Colour Chemists Association* **41** 707.

thought of in terms of how much pigment is needed to obscure an underlying drawing of a certain contrast with the priming, and expressed as a 'hiding thickness' [50]. Some examples of the variation of hiding thickness with wavelength are shown in figure 5. Lead white and vermilion show only a moderate increase in hiding thickness as we move deeper into the infrared, but verdigris loses virtually all its hiding power. The raw ochre curve typifies the behaviour of several pigments such as malachite, azurite, iron oxide and raw sienna.

Of course the human eye will not see any infrared image of the undersketching as it has no response to the main reflectance in the infrared region of the spectrum. For detection of this light we must turn to systems that, in one way or another, convert the infrared image into a visible one.

A variety of imaging techniques are available: lead sulphide detectors, vidicon television systems, polaroid films or direct infrared photography with specialized developing and printing methods to remove 'background' from near-surface reflections [51, 52]. Each of these techniques has applications to particular regions of the infrared spectrum (figure 6).

Earlier on brief reference was made to *contrast* in the underdrawing. Clearly in the absence of any contrast the reflectogram will draw a blank. This is no problem in early works such as those of the Flemish Primitives and the Florentine

Figure 5/Pigment 'hiding thickness' plotted as a function of wavelength/For *a*, vermilion, *b*, lead white, *c*, raw ochre and *d*, verdigris. Each pigment was grained in linseed oil in volume concentrations of 11%, 28%, 31% and 25% respectively. After van Asperen de Boer J R J 1969 *Studies in Conservation* **14** 96.

and Sienese Schools in Italy during the late fifteenth century for which light grounds were used. The Primitives favoured a white consisting of chalk mixed in animal glue and they sketched with a brush using bone black in a water paint. The Italians favoured a gypsum-based gesso and, in their much more perfunctory treatment of under-drawing seem to have preferred charcoal black.

However, in the sixteenth and seventeenth centuries there was a general swing towards dark grounds, most notably in Venetian canvas paintings. This allowed quick execution of shadowed zones, while a thin paint film produced half tones and a thick paint loading created the full tones. Sketching in white chalk is documented in contemporary literature but it is difficult to trace evidence of this now. Nothing shows up in visible light as the chalk and the painting oil have very similar refractive indices and nothing seems to be gained by using infrared reflectography.

Consequently it is the works of the early Flemish Primitives that dominate the literature on the application of infrared reflectography. But, certainly, some of the results of these studies are quite astonishing in the way in which they offer a new insight into artists' methods of that period. For example, we now know that there were painting workshops in the Low Countries that specialized in copying famous works [53]. The principal features were registered on an overlying pattern sheet by needle pricks. Then the pattern was transferred to a new backing by dusting the perforations with charcoal powder. Rogier van der Weyden's 'Portrait of Philippe le Bon' is now known to us by its six extant copies produced this way, though the original is now lost.

It is also possible to recognize, with some certainty, the individual sketching style of several of the well-known Primitive artists. Petrus Christus em-phasized shadows and folds in his preparatory drawings with a close network of fine hatching lines; Rogier van der Weyden relied on finer linear outlines with virtually no

Figure 6/Spectral characteristics of various detectors as a function of wavelength/*a*, the human eye, *b*, infrared film (Polaroid 413), *c*, room temperature lead sulphide detector, and *d*, infrared vidicon with a lead suphide target. The vertical scale of responsivity for *a–c* is in different arbitrary units, while, for *d*, it is in units of milliamps output per watt of power input. After van Asperen de Boer J R J 1969 *Studies in Conservation* **14** 96.

hatching at all; Thierry Bouts used broad, coarse, parallel hatching lines to reinforce boldly drawn folds (plate 14).

Infrared studies like these have been of great help in building up catalogues of genuine Primitive paintings—the artists of that period rarely signed their work [54]. Hieronymus Bosch is one artist who suffered heavily from imitation during the middle of the sixteenth century particularly at the hands of the Spanish workshops. Yet his sketching is distinctive in its widely-spaced, bold hatching.

We have already taken a couple of 'surreptitious' looks at the ground layer in paintings using infrared reflections in studies of undersketching and x-ray studies of crackle patterns. But this part of a painting is often accessible to sampling at the edges of a canvas or panel so it is available for scientific analysis in many of the ways already used for overlying pigments.

The two major ground materials in antiquity were chalk and gypsum. Chalk was used in northern Europe from early medieval times onwards either mixed with an animal glue for panel-coating or in a resin-oil vehicle for canvas preparation (colour plate 5). The Italian and Spanish schools preferred gesso (a mixture of gypsum and glue) for this purpose. Unfortunately there is singularly little scientific data available on gesso that has any dating potential [55]. However, in seeking a chronology for chalk grounds we can begin by treading the well-worn paths of lead white analysis as this ubiquitous pigment occurs here as an additive intended to give the surface a denser, whiter look. Our previous comments on pigment anachronisms can be reiterated too as zinc white found popular use for this purpose from the middle of the nineteenth century onwards.

But chalk has a history of change in its own right. Up to 1850 only natural sources (notably those at Rouen, Troyes and Orleans and along the Marne) were exploited; then an artificial form was produced in England as a precipitated

Plate 15/Scanning electron microphotograph of a coccolith, *Zygodiscus*/In the chalk ground of
 Rubens' 'Deborah Kip, wife of Sir Balthasar Gerbier, and her Children'.
 National Gallery of Art, Washington DC; catalogue number 2558.
 Magnification × 4700. Photograph: courtesy of Dr R L Feller, Mellon Institute,
 Pittsburgh.

Plate 16/Scanning electron microphotograph/Showing microbial deterioration of canvas by
 spawning of micro-organisms that feed on the highly proteinous sizing coating
 the fibres. Magnification × 5400. This example is taken from 'Lady Leake' by
 Mary Beale, English *circa* 1675. Photograph: courtesy of Dr B Hallström,
 Dokumenta, Stockholm.

calcium carbonate [56]. For the artist this innovation resulted in a whiter, more homo-
genous ground. But from a scientific standpoint, this change was more radical. Natural
chalk is derived from marine ooze so that it is littered with the fossil remains of uni-
cellular algae, whereas precipitated chalk is fossil-free.
 Although adequate differentiation between the two forms of chalk
is quite straightforward using a high-power microscope, the detailed nature of the
fossils can be determined from a scanning electron microscope picture. The species,
Zygodiscus, illustrated in plate 15 (at a magnification of 4700) is one of several coccoliths

found in the ground of Rubens' 'Gerbier Family' shown, in full, in plate 4. This group of coccoliths indicates that the chalk used is from a deposit laid down in the Cretaceous period, as one might expect for a painting produced in Flanders. This kind of ability to specify the source of a material is obviously of the greatest value in authenticity work [57].

It may be possible to take the use of the scanning electron microscope a step further as the ground layer in an old painting is a veritable breeding ground for micro-organisms [58]. Spores are brought in by earth pigments and feed on proteins either in the binding media or the canvas sizing that lies beneath the ground (plate 16). As these fungi grow stronger they gradually dehydrate the fibres of the canvas, eventually causing paint flaking. The presence of micro-organisms in damaged regions of a painting could well act as a sign of antiquity though it is not yet clear whether a forger could simulate this phenomenon by acceleration of bacterial activity in a humid atmosphere.

Our study of the anatomy of a painting now brings us to the very 'bones' of its construction, the canvas or wood panel support. There are frequent comments in the literature to suggest that the weave pattern of the canvas fabric and the methods used in the joinery of wooden stretcher frames have a history all of their own [59]. Unfortunately the detailed data that might prove invaluable for authenticity work do not seem to have been collected and only the introduction of 'pre-primed' canvas (canvas sized and primed before being placed on its stretcher) late in the eighteenth century, has any obvious chronological implications.

Additionally there are ample grounds for caution. Ever since the eighteenth century it has been possible to transfer a painting from its original panel to a new canvas support. Many Parisians, notably Riario, Picault and the Hacquin family, specialized in this conservation technique and there are several nineteenth-century examples of such activities amongst Polish collections. The Joos van Cleve work 'Portrait of Francis I' (in the National Museum in Warsaw) is typical, the present canvas carrying a date of 1877 which matches the treatment period at the Hermitage in Leningrad [60]. Thus, in this case there are quite innocent reasons why the portrait of an early sixteenth-century monarch should appear on a backing which is more than 300 years younger.

However, the technical analysis of panels, particularly those made of oak, is far more advanced. Here the scientific principle invoked is that of tree-ring dating or *dendrochronology*.

A close-up of one edge of a Tudor panel is shown in plate 17 [61]. It comprises a sequence of closely spaced, almost parallel bands which represent, in radial section, the annual growth rings of the oak used.† The variation of ring-width, year by year, has a distinctive pattern. It is controlled by regional climatic con-

† Poplar was used in Italy for this purpose. Unfortunately, this wood is of the 'diffuse-porous' variety, whereby the annual rings are indistinctly defined. Additionally the ring widths themselves show little variability from year to year, so they are of little value for dendrochronology.

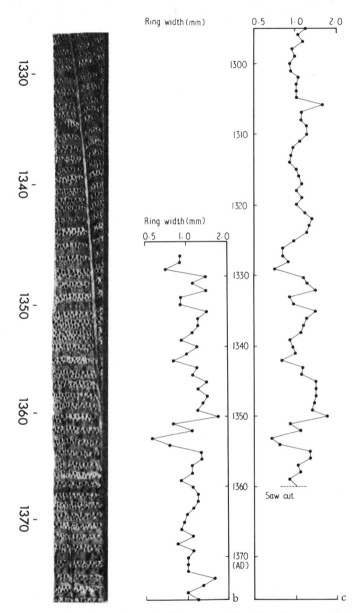

Plate 17/*a* Edge view of an oak panel, typical of the type used for fifteenth-century Tudor portraits.
 b Part of a typical chart for the widths of successive annual rings derived from measurement of edge *a*.
 c Hypothetical ring-width pattern of another panel, illustrating their cross-matching by synchronization. Note that a perfect match is not to be expected as localized differences in environmental conditions influence each tree differently. Only the gross regional features of climate that control tree-growth will be reflected in the patterns of both panels (eg the narrow ring of 1353). Photograph: courtesy of Dr J M Fletcher, Research Laboratory for Archaeology and History of Art, Oxford.

ditions for the most part, so other panels of the same period will bear a similar ring pattern as the timber used for them may well have all grown in the same forest.

Neither the panel makers of Tudor England, nor their counterparts in nothern Europe, were wasteful. A radially-sawn board would be trimmed at its outer edge quite carefully, removing only the spongy 'sapwood' region that could later attract insects, so the last ring on a panel's edge can usually be attributed quite confidently to the first region of heartwood just within the oak's bark at the time the timber was cut down. We can cross-match ring patterns between a pair of panels (assuming roughly equal sapwood thickness) and estimate their age difference from the relative position of their terminal rings. The ring patterns will rarely match perfectly because the growth of each tree will be affected to some extent by localized environmental circumstances as well as the main regional climatic trend. However, their degree of synchronization (matching of their rise and fall) can be looked at statistically and a position for optimum agreement worked out by sliding the sequences relative to one another, ring by ring.

At this stage we are still two steps short of actually dating the painting. First of all, the ring patterns all refer to wood growth some centuries ago. Each ring still has to be assigned to a specific year. Of course only living trees can offer this kind of information immediately as the bark matches present-day, the first ring inside matches last year's growth, and so on. However, the same cross-matching procedures used above for linking together old timber can be applied to recent material too. 'Bridging' of timber from a variety of periods and from a similar geographical region eventually provides a complete ring sequence into the distant past, and on an absolute time-scale [62].

Fitting our panel's ring pattern into such a regional sequence provides us with a felling-date for the oak used. We must still add on some time to reach the date at which the panel was eventually used for a painting. First of all the timber would have been stored to dry out. This probably took only a year, at least to reach a condition suitable for panel-cutting as some 'greenness' in the wood would discourage wandering of the saw. But, after that, a prepared panel could well have lain in store, first in the panel maker's workshop and then in the artist's private stock, for some five years, perhaps more. It is the uncertainty in this time interval which is the main source of error in tree-ring dating of panel paintings.

Despite uncertainties of this nature, successful studies have been made in ordering the output of several artists, including Philips Wouwerman (1619–1688) (a master of riverside and village scenes depicting life in the Dutch Lowlands), Rembrandt (1606–1669), Rubens (1577–1640) (for his Antwerp works), Adriaen van der Werff (1659–1722) [63] and several court painters (Hans Eworth, Gerlach Flicke and Hans Holbein the Younger, particularly) of the Tudor monarchy [64]. But it is a more recent application that has caught the attention of art historians; that of the detection of copies of much earlier original portraits.

There are a large number of examples of this activity. Some were stimulated by a fashion in Late Elizabethan and Jacobean society for hanging complete sets of English royal portraits in the Long Galleries of mansions; others were commissioned by the monarchy itself. As an exhibition at the National Portrait Gallery,

London in 1973 amply demonstrated Richard III was one of the more popular subjects for this treatment [65].

The 'Anne of Cleves' illustrated in plate 18 serves as a good example of the confusion such a copy can cause [66]. Acquired in 1734 by the then President of St John's College, Oxford, Dr Holmes, it appeared in several subsequent inventories as an unidentified portrait until Dean Burgon, in 1855, suggested the present identity for the subject. An attribution to Bartholomew de Bruyn (1493–1555) was made later; this artist was active and in demand in the area of Cleves when Duke John (Anne's father) is thought to have requested a local portrait in response to Thomas Cromwell's first overtures on behalf of Henry VIII. A typical mid-fifteenth century feature, the arch-topped frame, lent some support to the suggestion.

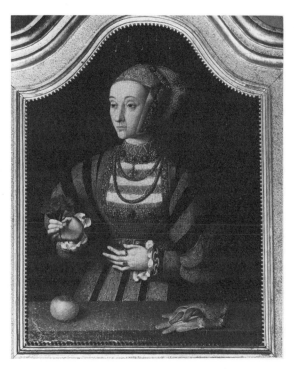

Plate 18/Anne of Cleves/Once attributed to Bartholomew de Bruyn (1493–1555) but now recognized as a mid-seventeenth-century copy. Photograph: courtesy of St John's College, Oxford.

But tree-ring analysis produced a result that was quite unexpected. As the portrait's panel bore a terminal ring which corresponded to the year 1622, any date other than the mid-seventeenth century for the painting itself is out of the question. But, if de Bruyn did not paint this work who did and, perhaps more importantly, why? Anne of Cleves was only in the limelight of international politics for a couple of years and would have been long forgotten more than a century after her brief marriage to Henry VIII in 1540.

One possibility is that de Bruyn's original was a casualty of the Thirty Years' War which devastated those parts of Germany adjacent to the Lower Rhine and that the Duke's descendants sought a replacement, suggesting to their artist that he produce a portrait in de Bruyn's style, using the Holbein version now in the Louvre as his prototype.

Of course this portrait is no forgery, although it must be clear that the same dating principle used in this example, that is, identification of a panel that post-dates the claimed period of the painting on its surface, extends to authenticity analysis as well. Yet it is difficult to find examples of such usage except amongst fakes which are of poor stylistic quality anyway. The simplest explanation of this is that a forger who takes plenty of care over his painting is precisely the kind of person who will seek out an old panel of the right age. He may have to overpaint an inferior work or scrape away remnants of a damaged original, but his ultimate profit would justify the effort.

There is a classic example of this careful selection of panel material in a portrait now on exhibition in the Herzog Anton Ulrich Museum (Braunschweig, catalogue no. 257). This is now recognized as a later copy of a Rembrandt in the Den Haag Museum (catalogue no. 556). The oak panel the imitator chose is, if anything, a little too old with a felling date *circa* 1600, about a quarter of a century before Rembrandt's active period.

We conclude this chapter with a brief account of the Valfierno affair, a story in which the art of a confidence trickster made any protection that science could offer quite useless [67]. In Argentina at the turn of the century Eduardo de Valfierno had already set up a flourishing trade in fake Murillos. His prime targets were wealthy widows anxious to commemorate their late husbands. Valfierno persuaded these ladies that the ideal memorial would be a painting by Murillo which they could donate to their local church. Eventually the confidence trickster and his painter accomplice, Yves Chaudron, recognized the hazards of their trade and moved on to Mexico City.

In the Mexican capital there was a highly regarded Murillo and it was this work that Valfierno now set out to sell. His customers were, understandably, as suspicious as they were corrupt and demanded assurances that the painting they were shown, in a poorly-lit church, was indeed the one eventually smuggled to them. The confidence man was more than happy to oblige, suggesting that they sign or mark the back of the painting or even snip off threads from the edge of the canvas. Nevertheless, it was still a Chaudron duplicate that was finally sold. It had been carefully inserted in the rear recess of the original's heavy frame some time before the viewing and bargaining.

Valfierno and Chaudron had little to fear. The buyer could scarcely complain without admitting his complicity in the theft of a Mexican art treasure. Anyway most of the numerous victims were supplied with equally spurious newspaper clippings reporting the removal of the painting. It was neither action by the police nor scientific tests which finally put an end to this lucrative caper, but rather the rumours of its success which eventually attracted gangster elements in search of easy pickings. Valfierno and Chaudron fled to Paris and looked for fresh pastures.

[1] Feller R L 1973 *Studies in the History of Art* (Washington DC: National Gallery of Art) p 54
[2] Butler M H 1970 *State Microscopical Society of Illinois, Centennial volume* p 1
[3] Kühn H 1968 *Report and Studies in the History of Art* (Washington DC: National Gallery of Art) p 154
[4] Plesters J and Lazzarini L 1972 *Conservation of Paintings and the Graphic Arts* (IIC Lisbon Congress) p 153
[5] Plesters J 1966 *Studies in Conservation* **11** 62 and plate 11
[6] Gettens R J, Kühn H and Chase W T 1967 *Studies in Conservation* **12** 125
[7] Plesters J 1956 *Studies in Conservation* **2** 110
[8] Dana E S 1958 *Textbook of Mineralogy* (New York: Wiley) p 28
[9] Feller R L 1971 *American Painting to 1776: a Reappraisal* p 327
[10] Keisch B 1972 *Secrets of the Past* (World of the Atom Series, USAEC) p 94
[11] *Theophrastus' History of Stones* translated by Sir John Hill (London 1774) p 223
 Bailey K C 1932 *The Elder Pliny's Chapters on Chemical Subjects* **11** 41, 75
[12] Gettens R J, Feller R L and Chase W T 1972 *Studies in Conservation* **17** 45
[13] Thompson D V and Hamilton G H 1933 *An anonymous fourteenth-century treatise: De arte illuminandi* (New Haven and London)
 Borradaile V and Borradaile R 1966 *The Strasburg Manuscript* (London: Tiranti)
 Cennino d' Andrea Cennini's Il libro dell'arte translated D V Thompson as *The Craftsman's Handbook* 1933 (New Haven)
 Lehmann-Haupt H 1972 *The Göttingen Model Book* (Columbia: University of Missouri Press)
[14] Morall T R 1957 *Wire and Wire Products* **32** 300
[15] von Kunckel J 1679 *Ars vitraria experimentalis, ader vollkommene Glasmacher-Kunst* (Frankfurt and Leipzig)
[16] de Bondaroy F 1766 *Histoire de l'Académie Royales des Sciences* pp 60, 303
[17] Kapp H 1847 *Geschichte der Chemie* **4** 369
 Buck R D 1965 *Allen Memorial Art Museum Bulletin* **22** 74 (Oberlin, Ohio)
[18] Rose F 1916 *Die Mineralfarben* (Leipzig: Otto Spamer) pp 84, 290
 Vauquelin L N 1809 *Annales de Chemie* **70** 90
 Rabaté H 1950 *Peintures, pigments, vernis* **26** 355
[19] Kühn H 1973 *Application of Science in Examination of Works of Art* (Boston: Museum of Fine Arts) vol II p 199
[20] Farrar W V 1974 *Endeavour* **33** 149
[21] Gettens R J and Stout G L 1966 *Painting Materials: a Short Encyclopaedia* (New York: Dover)
 Thénard L J 1804 *Journal des Mines* **15** 128
[22] Kurz O 1967 *Fakes* (New York: Dover) p 32
[23] Keck S 1942 *Brooklyn Museum Journal* 71
[24] Levey M 1971 *Italian Schools (XVII & XVIII century)* (London: National Gallery) p 140
[25] Constable W G and Young W J 1948 *Magazine of Art* **41** 183
[26] Trillich H 1923 *Das Deutsche Farbenbuch* (Munich: Heller) vol III p 52
[27] Laurie A P 1935 *New Light on Old Masters* (London: The Sheldon Press) p 44
[28] McCrone W C and Woodard G D 1975 *Physics in Technology* **6** 18
[29] Hanson N W 1959 *Studies in Conservation* **4** 162 (Turner)
 Schmid F 1958 *Art Bulletin* **40** 334 (Goya)
 Church A H 1901 *The Chemistry of Paints and Painting* (London: Seely Service) p 35 (Hogarth)
 Maxon J 1973 *Paintings by Renoir* (Illinois: Art Institute of Chicago) p 208
 Coremans P, Gettens R S and Thissen J 1952 *Studies in Conservation* **1** 1 (Bouts)
 Delbourgo S, Faillant L and De Forges M–T 1973 *Annales du Laboratoire de Recherche des Musées de France* p 5 (Courbet)
 Plesters J and Lazzarini L 1972 (IIC Lisbon Congress) p 153 (Tintoretto)
 Richter E L and Harlin H 1974 *Studies in Conservation* **19** 83 (Bocklin)
[30] *Handbook of Chemistry and Physics* (Cleveland Ohio: Chemical Rubber Publishing Co)
[31] Schubinger A and Wyttenbach A 1973 *Helvetica Chimica Acta* **56** 648

[32a] Houtman J P W and Turkstra J 1965 *Radiochemical Methods of Analysis*
 (Vienna : IAEA) vol I p 85
[32b] Kühn H 1966 *Studies in Conservation* **11** 163
 Lux F and Braunstein L 1966 *Z. analytische Chemie* **221** 235
[33] Keisch B 1970 *Studies in Conservation* **15** 1
[34] Keisch B, Feller R L, Levine A S and Edwards R R 1967 *Science* **155** 1238
 Keisch B 1970 *Application of Science in Examination of Works of Art* (Boston :
 Museum of Fine Arts) vol II p 193
[35] Roth J B 1959 *Bulletin Nelson Gallery and Atkins Museum* **2** 1 (Kansas City,
 Missouri : William Rockhill Nelson Trust)
[36] Van Schendel A 1958 *Museum Journal* **57** 234 (X-radiography of the Rembrandt
 canvas, 'The Ghost of the Staelmeesters')
 Ruhemann H 1955 *Studies in Conservation* **2** 17 (Technical analysis of Botticelli's
 'The Adoration of the Kings')
 Gould C 1964 *Burlington Mag.* **106** 420 (X-radiography showing undersketch-
 ing in Correggio's 'School of Love')
 Hours M 1965 *Exhibition Catalogue, Kunsthaus, Zurich* (X-ray and infrared
 photographs of Rembrandt paintings in the Louvre Museum)
 Urdareanu E 1966 *Studii Muzeale* **3** 175 (Technical analyses of works by
 Cranach, Courbet, A van Dyck and N Grigoresco)
 Corradini G 1959 *Gazette, National Museum of Fine Arts, Buenos Aires* **51** 149
 (Manet's 'The Nymph Surprised')
 Millar O 1962 *Burlington Mag.* **104** 347 (X-radiography of Hogarth's 'Garrick
 and his Wife')
 Thompson C 1961 *Burlington Mag.* **103** 318 (Radiographs of van Dyck's 'St.
 Sebastian Bound for Martyrdom')
 Packard E 1960 *Walters Art Gallery Journal* **23** 49 (The technical history of
 El Greco's 'St. Francis')
 von Sonnenburg H 1971 *Metropolitan Museum of Art, Bulletin* Part 2 476
 (Analysis of Velasquez's technique in 'Juan de Pareja')
 Hours M and Jouan A 1972 *Annales du Laboratoire de Recherche des Musées de
 France* p 75 (Radiographs include Piero Cosimo's portrait of 'Simonetta
 Vespucci' and Thomas Couture's 'Man pushing a cannon')
 Walters C 1955 *Studies in Conservation* **2** 87 (X-radiography of the needle-incised
 technique of undersketching preparation used in a 'Madonna and Child' panel
 of the Tuscan School of Lucca)
 Delbourgo S and Faillant L 1973 *Annales du Laboratoire de Recherche des Musées de
 France* p 6 (Discussion of Gustav Courbet's technique in several of his paintings)
 Hours M 1960 *Annales du Laboratoire du Musée du Louvre* p 3 (Analysis of works
 by Nicolas Poussin)
 Shapley F R 1972 *Studies in the History of Art* (Washington DC : National
 Gallery of Art) p 93 (Studies of Titian's 'The Toilet of Venus')
 Panfilova O 1955 *Bulletin, State Hermitage Museum, Leningrad* **7** 36 (van Dyck's
 'Portrait of Antwerp Physician, Lazarus Mahercuysus')
[37] Beyersdorf E S 1962 *Burlington Mag.* **104** 536
[38] Brandt W, Danninger E and Straub R E 1968 *Jahrbuch der Staatlichen
 Kunstsammlungen Baden-Wurtemmberg* **5** 33
[39] Keck S 1948 *Magazine of Art* **41** 172
[40] Margaritoff T 1967 *Studies in Conservation* **12** 140
[41] Brachert T 1969 *Reports and Studies in the History of Art 1969* (Washington DC :
 National Gallery of Art) p 84
[42] Van Dantzig M M 1954 *Vincent?* (Amsterdam : Keesing)
 Savage G 1963 *Forgeries, Fakes and Reproductions* (London : Barrie and Rockliff)
 plate 31
[43] Keck S and Feller R L 1964 *Studies in Conservation* **9** 1
[44] Kozlowski R 1960 *Studies in Conservation* **5** 89
[45] Barton J P 1965 *Studies in Conservation* **10** 135
[46] Sayre E V and Lechtman H N 1968 *Studies in Conservation* **13** 161
[47] Cotter M J, Meyers P, van Zelst L and Sayre E V 1973 *J. Radioanalytical
 Chemistry* **15** 265

[48] Sonkes M 1970 *Bulletin de l'Institut royal du Patrimoine artistique* **12** 195, plate 6
[49] Taylor D 1958 *J. Oil and Colour Chemists Association* **41** 707
[50] van Asperen de Boer J R J 1969 *Studies in Conservation* **14** 96
[51] Loose L 1958 *Bulletin de l'Institut royal du Patrimoine artistique* **1** 85
[52] Heiber W 1968 *Studies in Conservation* **13** 145
 van Asperen de Boer J R J 1974 *Studies in Conservation* **19** 97
[53] Sonkes M 1969 *Bulletin de l'Institut royal du Patrimoine artistique* **11** 142
[54] Folie J 1963 *Bulletin de l'Institut royal du Patrimoine artistique* **6** 183
[55] Gettens R J and Mrose M E 1955 *Studies in Conservation* **4** 174
[56] Gettens R J, Fitzhugh E W and Feller R L 1974 *Studies in Conservation* **19** 157
[57] Kozlowski R 1950 *Ochrona Zabytków* **3** 93
 Coremans P, Gettens R J and Thissen J 1952 *Studies in Conservation* **1** 1
[58] Hallström B and Göransson B 1974 *Dokumenta* **1** 15
[59] Keck S 1942 *Brooklyn Museum Journal* 74
 Gettens R J and Stout G L 1966 *Painting Materials: a Short Encyclopaedia* (New York: Dover) p 228
[60] Marconi B 1965 *Application of Science in Examination of Works of Art* (Boston: Museum of Fine Arts) vol I p 246
[61] Fletcher J 1974 *Burlington Mag.* **116** 250
[62] Bouch J 1970 *Mitteilungen Bundes forschungsanstalt für Forst-und-Holzwirtschaft Reinbeck* **77** 43
[63] Bauch J and Eckstein D 1970 *Studies in Conservation* **15** 45 (Wouwermans)
 Bauch J 1971 *Angew. Botanik* **45** 217 (Rembrandt and Rubens)
 Bauch J, Eckstein D and Brauner G 1974 *Maltechnik/Restauro* **1** 32 (Adriaen van der Werff)
[64] Fletcher J M, Tapper M C and Walker F S 1974 *Archaeometry* **16** 31
[65] Tudor-Craig P 1973 *Richard III: Catalogue of an exhibition at The National Portrait Gallery, London*
[66] The data on 'Anne of Cleves' was generously provided by Dr J M Fletcher, prior to his own fuller publication. Attribution of the painting is discussed in Blakiston H E D 1904 *Burlington Mag.* **5** 111
[67] Jeppson L 1970 *Fabulous Frauds* (London: Arlington Books) p 31

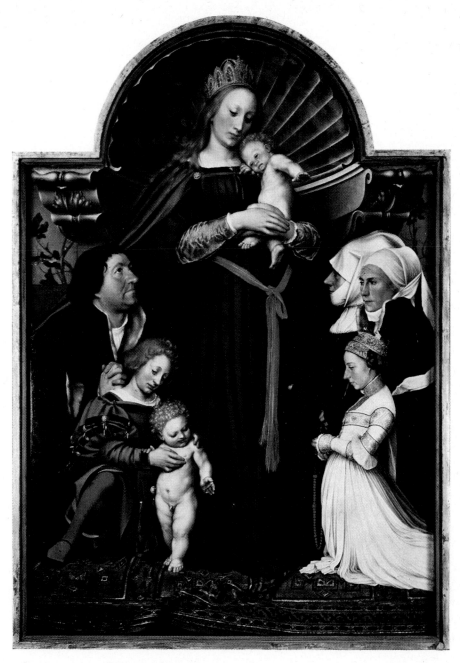

Colour plate 1 / The Madonna as Protectress of Jacob Meyer, Mayor of Basle, and his Family / Attributed to Hans Holbein, the Younger *circa* 1525. Photograph: courtesy of the Schlossmuseum, Darmstadt.

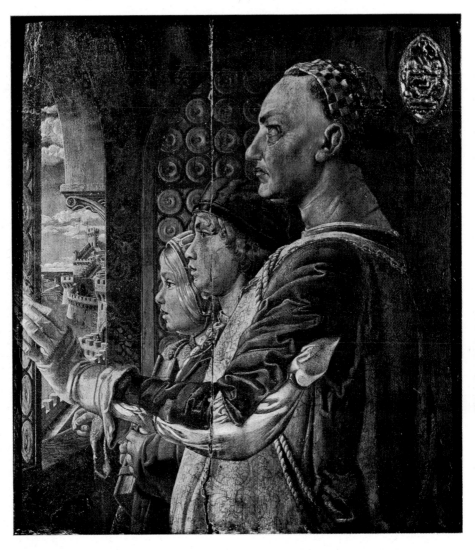

Colour plate 2 / The Montefeltro Family / Modern forgery, once attributed to the late-fifteenth-century artist Melozzo da Forli, but now recognized to be *circa* 1923, possibly by Icilio Joni. Photograph: courtesy of the Trustees of the National Gallery, London; catalogue number 3831.

Colour plate 3 / Detail from a panel forming the wings of an altar piece / Attributed to Joos van Cleve *circa* 1485–1540. Note the vertical cracking of the paint surface (spacing approximately 1 mm) corresponding to the position of the annual growth rings of the oak timber beneath. Photograph: courtesy of the Courtauld Institute of Art, London.

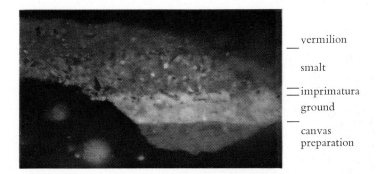

vermilion

smalt

imprimatura
ground

canvas
preparation

Colour plate 4 / Photomicrograph of a cross-section of paint layers. From the painting 'Deborah Kip, wife of Sir Balthasar Gerbier, and her Children' / magnification × 180. National Gallery of Art, Washington DC, catalogue number 2558, attributed to Rubens (1577–1640). Photograph: courtesy of Dr R L Feller, Mellon Institute, Pittsburgh.

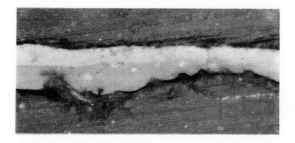

Colour plate 5 / Photomicrograph of a cross-section of paint at the top left corner of the work 'Deborah Kip, wife of Sir Balthasar Gerbier, and her Children' / A thin paint layer is underlaid by a white imprimatura layer, a tan-coloured ground and a layer of proteinaceous glue size stained here with Coomassie blue.
Photograph: courtesy of Dr R L Feller, Mellon Institute, Pittsburgh.

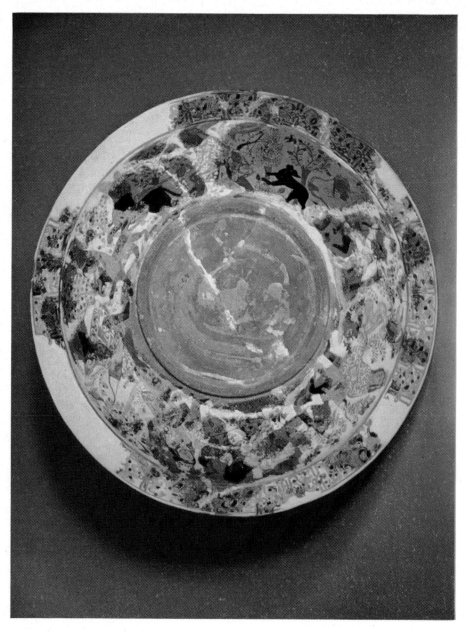

Colour plate 6/Large thirteenth-century Iranian *minai* bowl with flared sides, everted rim and low foot/Photographed under ultraviolet light, showing regions of extensive restoration. Photograph: courtesy Dr J Winter, Freer Gallery of Art, Washington DC; bowl accession number 43.3.

Colour plate 7/Detail of the paint surface of the painting 'Religious Procession'/Note the simulation of crackle using a network of black painted lines. Photograph: courtesy of the Courtauld Institute of Art, London.

Colour plate 8/Religious Procession/Forgery in the style of the mid–sixteenth–century master, Pieter Breughel. Photograph: courtesy of the Courtauld Institute of Art, London.

Colour plate 9/Christ in the House of Martha and Mary/Attributed to Vermeer (1632–1675) and believed to be his earliest extant work, *circa* 1654. Photograph: courtesy of the National Gallery of Scotland, Edinburgh.

Colour plate 10/Woman in Red/Signed 'R A Blakelock' in the lower right corner, but now
attributed to Marian Blakelock, his daughter. Photograph: courtesy of
Dr P Meyers, Brookhaven National Laboratory, New York.

Colour plate 11 / White-glazed stoneware Guardian Figure ('Warrior') / From Sawankalok, Thailand, *circa* thirteenth century AD, height 1·3 m. Photograph: courtesy of Spink and Son Ltd, London.
Thermoluminescence data:
Archaeological dose, 225 rad R_e, 0·14 rad/year
R_1, 0·17 rad/year Age, 730 years

Colour plate 12 / Counterfeit coin moulds / From Whitchurch in Somerset. Roman late third
 century AD. Top: Tetricus I *antoninianus* catalogue number 1960.61. Right:
 Victorinus *antoninianus* catalogue number 1960.17. Left: reverse HILARITAS
 AUG type, catalogue number 1960.15. Photograph: courtesy of The City
 Museum, Bristol.

Colour plate 13 / Artificial patination / Simulated by crushed malachite strewn over the surface of a vessel coated with glue. Many of the randomly oriented particles show the characteristic banding of massive malachite. Magnification × 2. Photograph: courtesy of the Smithsonian Institution, Freer Gallery of Art, Washington DC.

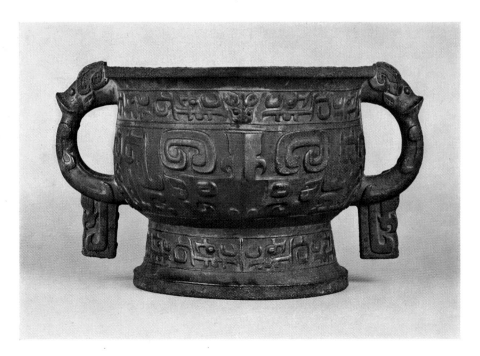

Colour plate 14 / Large ritual bronze food vessel (*kuei*) / Early western Chou Dynasty in China, late eleventh to early tenth century BC, diameter 0·32 m. This vessel is rare in that it carries with it documentary evidence that it was unearthed from a grave at Wu-Kang Chou, in Honan province. Photograph: courtesy of Sotheby Parke Bernet, New York. Catalogue 'Chinese Works of Art' 23 April 1975, lot number 244.

Colour plate 15 / Bronze standing figure of the Buddha, his right hand raised in abhaya-mudra. / Gandhara, North-West India *circa* fifth century AD, height 0·33 m. Photograph: courtesy of Spink and Son Ltd, London.
Thermoluminescence data:
Archaeological dose, 730 rad R_e, 0·13 rad/year
R_i, 0·41 rad/year Age, 1350 ± 210 years.

Colour plate 16/ Gourd flask, Chinese Ming Dynasty, early fifteenth century AD. Mn/Co ratio in the blue glaze 0·13–0·15. Photograph: courtesy of the Percival David Foundation of Chinese Art, London. Catalogue number 674.

Colour plate 17/ Bowl, Yung Chêng period, 1723–1735. Mn/Co ratio in the blue glaze 1·98–2·03. Photograph: courtesy of the Percival David Foundation of Chinese Art, London. Catalogue number A697.

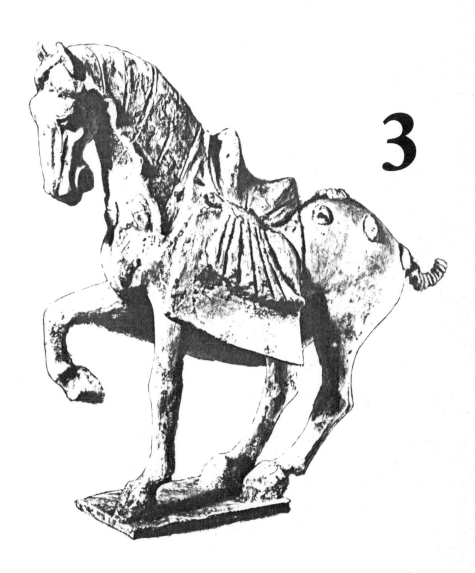

3

Ceramics,

3 Ceramics,

The high-temperature thermoluminescence method/ T'ang pottery/
Renaissance terracottas/ Pre-dose method/ Glazed T'ang funerary wares/ The
Pevensey tile hoax

Our discussion of authenticity analysis of ceramics concentrates
almost exclusively upon one scientific technique, thermoluminescence. True, there
are isolated cases where other methods have been used, such as the 'Etruscan Warriors'
of the Metropolitan Museum of Art in New York; chemical analysis showed that
the fakers had misunderstood the kiln technology of the ancients [1]. Up to 1943
it had always been assumed that black glazing on ceramics owed its coloration to a
manganese additive, but Theodor Shumann then demonstrated that interruption of
the firing process by a brief reducing (oxygen-starving) period, perhaps by sudden
addition of green wood to the fire, produced the desired effect by production of fer-
rous oxide. Other techniques can only lead to tentative judgements of ceramic objects.
For example, it may be established that the clay composition differs from the usual
materials associated with a particular culture but it is well-known that many fake
workshops select their clay source with great care. They do not have to search too
deeply in the archaeological site literature to find expert opinions on the source of raw
materials used in antiquity.

The strength of the thermoluminescence dating method lies largely
in its absolute nature; it does not require 'standards' from each period of art under
scrutiny. Even with a small drilling of about 30 milligrams of pottery powder (this can
often be conveniently taken from a region not in view during display) a dating accuracy
close to $\pm 15\%$ is now feasible for many important wares. When the choice is between
an antiquity of, say, 2500 years for a genuine Etruscan or Greek vase, and only 120
years or less in the case of a modern fake such an accuracy allows no ambiguity.

However, matters are made somewhat more complicated by the fact
that there are now two methods of thermoluminescence pottery dating each based
upon a different physical principle. The better known *high-temperature method* [2] is used
for archaeological dating over the time range of 500 to 30000 years while the more
recently developed *pre-dose method* [3] has been most effective in filling the gap of 500
years to the present day, with an advantage here of a capacity to put an accurate date to
forgeries as well as authentic wares.

The high-temperature method depends on the fact that all materials contain at least traces of natural radioactivity (for example uranium, thorium and potassium-40) which release nuclear energy as they decay. This is true of the clay fabric of the pottery itself and of the soil and other burial media in which the ceramic spends its archaeological life. Several crystalline minerals included in the pottery fabric (notably quartz and the various forms of feldspar) can absorb this nuclear energy and store a fraction of it by electron trapping at impurity atoms and other crystal lattice flaws. A subsequent heating to 500°C causes a release of this stored energy in the form of light, termed thermoluminescence.

The raw materials destined for use in pottery making will have stored huge amounts of energy during their long geological history of radiation exposure. But the act of kiln firing, usually at temperatures of 600°C and above, is more than adequate to eraze all this geologically accrued thermoluminescence and duly set a *time-zero* in the pottery's energy storage. Thus the signal that we measure in the laboratory now represents only the archaeological re-accumulation of such energy and thereby acts as a measure of the pottery's antiquity (figure 1).

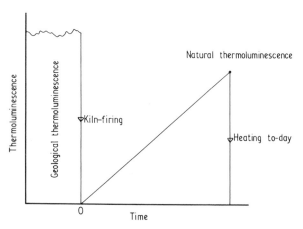

Figure 1/Simple representation of the 'time-zero' setting process in thermoluminescence dating of ceramics/After Fleming S J 1974 *Electronics and Power* **31** 894.

The temperature at which the trapped electron breaks with its host lattice imperfection depends upon the nature of the imperfection. For a complex crystal structure the laboratory plot of light output against heating temperature (called a 'glow curve') will comprise several overlapping peaks each due to a different imperfection (figure 2). The higher the temperature at which a peak occurs, the stronger is the binding of the electron to the imperfection.

For many of the lower temperature peaks even ambient ground temperatures are sufficient to disrupt this binding. For example, the common 110°C peak attributed to the presence of quartz has a half-life of only 145 minutes at 20°C, so it is scarcely detectable in a radiated sample stored only two days before analysis. Resistance to electron 'leakage' rises sharply, roughly by an order of magnitude for

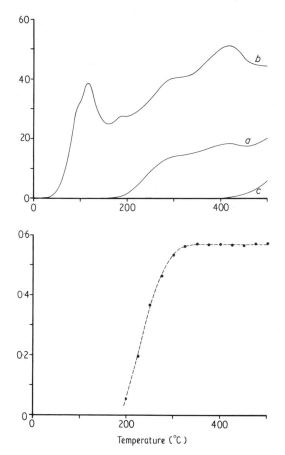

Figure 2/Thermoluminescence glow curves for the 'Affecter' amphora/Ashmolean Museum, accession number G 268, illustrated in plate 1. *a*, natural thermoluminescence, *b*, natural thermoluminescence *plus* thermoluminescence induced by 2250 rads of laboratory β-radiation, and *c*, background incandescence. The plateau analysis of these curves is shown in the lower portion of the figure. After Fleming S J 1971 *Naturwiss.* **58** 333.

each 35°C rise in temperature according to normal thermoluminescence kinetics, so that the decay half-life reaches an archaeological magnitude of around ten thousand years at 300°C and above. The 'natural' glow curve reflects any long-term electron loss by the absence of any significant signal below 200°C and an overall shape which agrees with thermoluminescence produced by laboratory irradiation at 350°C and above.

　　　　The stability of electron storage can be studied by a ratio plot technique. The ratio of the natural thermoluminescence to the laboratory-induced thermoluminescence is plotted, gradually increasing the temperature until a plateau region is reached (where the shapes of the curves agree). It is important to carry out this ratio plot because the natural glow curve may well contain a 'spurious' component that has

nothing to do with the radiation history of the piece but arises from electron storage activated mechanically by drill grinding effects. This spurious signal occurs extremely strongly when the heating is carried out in air, so routine analysis must be made using an atmosphere of high-purity nitrogen or similar inert gas (the combined oxygen and water vapour content must be less than five parts per million).

There may be appreciable variations, from piece to piece, in the radiation sensitivity of pottery minerals as this parameter depends upon the mineral type, defect concentration and the firing and cooling conditions of manufacture.

However, laboratory irradiation serves to calibrate this sensitivity and supply a quantative estimate of the total radiation that the pottery experienced archaeologically. This is illustrated here for the 'Affecter' amphora (plate 1) where an additional laboratory dose of 2250 rads† increases the thermoluminescence at 375°C by 29·8 light units. The natural output is this region is 17·0 units, so the archaeological dose is estimated as 1280 rads, on a proportionality basis.

Glow curve analysis involves one other feature that must be discussed here. Any material, ancient or modern, will glow red-hot when heated as high as 500°C. This incandescence acts as a background signal which, even after strong bias in the detection system towards the blue end of the spectrum, often dominates thermoluminescence readout at higher temperatures. As the true signal can only be assessed after this contribution has been subtracted out, very low light levels carry a poor accuracy.

Such low levels are common amongst imitative wares so that only an upper limit to the possible period of manufacture can be estimated for them. This is shown for the column krater of plate 2, in the glow curve data of figure 3. A natural level of 0·6 light units at 375°C is dwarfed by a laboratory-induced signal of 35·2 light units for a dose of 2250 rads, once more. An archaeological dose of not more than 39 rads is predicted. At 450°C the incandescence is already on a par with the natural signal and throughout the high-temperature region it would be unjustifiable to claim that the latter has any glow curve structure. Plateau tests are impractical and spurious thermoluminescence rejection impossible.

The thermoluminescence dating equation can be written,

$$\text{Age (years)} = \frac{\text{Archaeological dose (rads)}}{\text{Annual dose-rate (rads/year)}}.$$

The annual dose-rate can be divided into two components, R_i due to radioactivity within the pottery fabric itself and R_e, due to environmental radioactivity in the burial surroundings. There is a similar split in the nature of radioactivity that makes up each R-component. Internally, uranium and thorium (about 1–10 ppm of each) provide a dose through short-range α- and β-radiation, while potassium-40 (about 20 ppm) adds a further β-radiation component. Externally, those same three isotopes provide a dose through long-range γ-radiation while a small cosmic-ray component (0.015 rad/year) must be added in.

† The rad is a standard radiation unit representing 100 ergs of energy absorbed per gram of sample.

Plate 1 / Amphora / Attributed to the 'Affecter painter' *circa* 540 BC. Photograph: courtesy of the Department of Antiquities, Ashmolean Museum, Oxford; catalogue number G268.
Thermoluminescence data
Archaeological dose, 1280 rad
R_i, 0·37 rad/year
R_e, 0·15 rad/year
Age 2460 years.

When a pottery fragment is collected during excavation, samples of soil can be taken from nearby areas. Then R_i and R_e can be determined accurately by standard methods of radioactivity assay, and a dating accuracy of \pm 8% is feasible. In contrast, by the time an art ceramic reaches an auction room or museum shelf all knowledge of its burial environment is lost.

Plate 2/Black-figured column krater of recent origin/Photograph: courtesy of the Metropolitan Museum of Art, New York; accession number 49.101.10.

Thermoluminescence data
Archaeological dose \leqslant 39 rad
R_i, 0·23 rad/year
R_e, 0·15 rad/year
Age \leqslant 102 years.

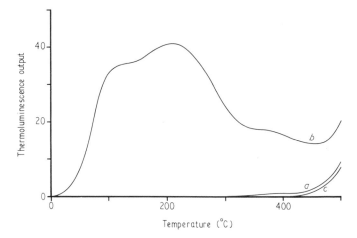

Figure 3/Thermoluminiescence glow curves for the krater (Metropolitan Museum of Art, accession number 49.101.10) illustrated in plate 2. *a*, natural thermoluminescence, *b*, natural thermoluminescence *plus* thermoluminescence induced by 2250 rads of laboratory β-radiation, and *c*, background incandescence. After Fleming S J 1971 *Naturwiss.* **58** 333.

The internal dose-rate can still be assessed but the environmental dose-rate now stands as an unknown about which we can usually only make an intelligent guess. For example, using a typical level of environmental dose-rate of about 0·15 rads/year for the two vases used to illustrate glow curve analysis earlier, some age estimates can be made.

But final authenticity judgement calls for a more rigorous approach to assumptions about the environmental rate. Could the 'Affecter' amphora be a fake that has been in a highly radioactive environment for some 120 years? (Forgeries of this kind of material were not produced earlier than this.) The data require an environmental dose rate of more than 10 rads/year, a level far higher than any normal burial conditions and a thoroughly unhealthy region, even for a dead Etruscan nobleman buried with a hoard of tomb goods. No, the amphora is certainly genuine.

Could the column krater be a genuine piece that had spent its archaeological life in a region of very low radioactivity? Now we can invoke a simple fact that the highly penetrative nature of cosmic rays provides a lower limit for the environmental dose rate of 0·015 rads/year. Thus the maximum *possible* age for this krater is 160 years. There is no scientific doubt that this piece is a fake. This is consistent with the opinion of art historians.

These comments and calculations are instructive in several ways. First, dating accuracy has little immediate meaning if the environmental dose-rate can take up a whole range of values between 0·02 and 0·70 rads/year. This uncertainty has been the main stimulus to extra research amongst two specialized groups of art ceramics, Chinese T'ang Dynasty wares and Renaissance terracottas, each of which carries problems of its own in stylistic authenticity judgement.

Most of the rest of this chapter will deal with these two specialized areas. There are, however, several other authenticity programmes which base themselves on the fairly simple procedures outlined above. These include studies of vessels and figurines said to come from the Neolithic site of Hacilar in Turkey [4] and the classic pastiche forgery of 'Etruscan' terracotta slabs (chapter 1) [5]. Some well-known single pieces have also been investigated, for example the 'Copenhagen' Pontic amphora now in the Danish National Museum [6] and the Metropolitan Museum of Art's 'Euphronios' Attic krater [7].

Western interest in T'ang Dynasty funerary ceramics dates back to the beginning of this century. As railway construction cut a path across the Chinese mainland, a great number of tombs were unearthed which yielded up many fine ceramics and pottery effigies of wide variety. Time and again the local workmen hurried excitedly to the missionaries and officials of the area with colourfully glazed wine jars and fruit-dishes or miniature figurines of court musicians, a horse or a camel. News of finds swiftly spread to the West and by 1909 these wares were fetching good prices in the art centres of Europe.

But at the same time several kiln-sites were found that revealed in some detail the ways of the T'ang artisan, and, most importantly, provided groups of original moulds that twentieth-century craftsmen were quick to exploit (plate 3). Mould re-use inevitably created wares of impeccable style quite indistinguishable

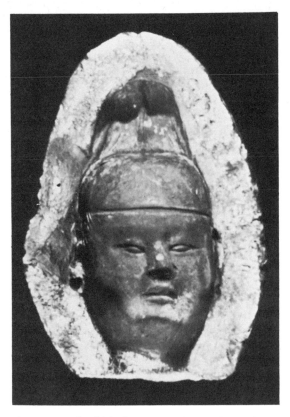

Plate 3/Mould for casting a pottery head/Used in mass production during the T'ang Dynasty
(AD 618–906) tomb goods. Private collection, New York.
Thermoluminescence data
Archaeological dose, 640 rad
R_i, 0·39 rad/year
R_e, 0·15 rad/year
Age 1180 ± 140 years.

from genuine T'ang material. By 1912, mass production was in full swing in Peking, at least, while a tourist trade flourished near the sites themselves.

Complete identity of two figures or animals in no way indicates fraudulent imitations as the original genuine pieces were mass produced in much the same way. During the early part of the first millennium AD an increasing liberalism permeated Chinese society and more and more ideas were absorbed from the West. Strong trade links, built up across Asia along the silk route and stretching to Antioch on the Mediterranean, led to a growth of Chinese power and wealth that reached its zenith at the end of the seventh century during the T'ang Dynasty. By then the T'ang potters were severely under pressure in the face of a huge demand for their tomb goods which had taken on the role of status symbols. The elaborate street parades associated with the funerals of this period seemed to have been more concerned with advertizing the social ranking of the bereaved than with the needs and comforts of the deceased.

The shelves of the stores were kept well stocked with ready-made items from which the less wealthy could select whatever suited their pocket. It was the technique of *piece-moulding* that made this stockpiling possible. A horse would comprise a body broken at the neck and knees, a separate head and independently moulded legs. Harness trappings and a saddle would be added later and, after firing, the whole figure would usually be finished off with a horse-hair mane and tail. The torso of a human figure would be cast in two sections to be joined at the edges with a smeared clay seam, then each piece would be given some individuality: perhaps a head bearing the features of a foreign trader or with the addition of a musical instrument to make up a court orchestra.

This re-use of moulds is exemplified by the two 'Prancing Horse' pieces of plates 4 and 5 [8]. The medallion-like decorations about the body attest this method of manufacture in both cases. Yet according to thermoluminescence one horse (plate 5) is ancient while the other (plate 4) is of twentieth-century origin.

With T'ang material it has been possible to look at likely environmental conditions within the tombs in some detail. As most of these tombs had gradually silted up (alternatively the mounded earth roofing may have collapsed) most pieces contain remnants of the original soil† suitable for radioactivity analysis. A histogram of the data obtained from 56 samples is given in figure 4. Treating this distribution as a normal one (though a degree of skewness is clear), the *mean* environmental dose-rate applicable to T'ang wares is close to 0.15 ± 0.02 rads/year (the error quoted is one standard deviation). Within the framework of this approach the genuine horse can be dated to the end of the seventh century with an accuracy of close to $\pm 12\%$.

Equally importantly, such a study provides confidence that T'ang wares are unlikely to have ever been buried in unusual, extreme environments. The R_e-values all lie in the range 0.09–0.26 rads/year. This range is probably quite a realistic reflection of the variation in geological conditions along the length of the Yellow River that cuts through the provinces of Honan and Shensi where the majority of the T'ang tombs are situated, particularly around the Empire's capital, Sian.

In theory the same authenticity problems should arise amongst glazed T'ang wares as the underlying pottery would have been mould-fashioned originally, as well. However, as the patronage for these items lay in the noble orders of society, demand for a greater versatility and individuality probably limited mould repetition to a large extent. That is not to say that glazed wares have not been faked. We will return to this question below.

The second major group of ceramics that have been investigated by thermoluminescence techniques are of rather more recent origin. The important sculptural works of the Renaissance era were produced in the durable media of bronze, marble and stone, while terracotta (and sometimes plaster) for the most part served as modelling material for preparatory 'sketches', open to experimentation and swift modification. Verrocchio's *modello* for 'Monument of Cardinal Forteguerri', now in

† Unlike many types of art ceramics, T'ang tomb goods are often deliberately left uncleaned presumably to enhance antique appearance. On occasion restorers have been known to *add* 'T'ang-like' soil to cover over break lines on the surface.

the Victoria and Albert Museum in London, is one of the earliest surviving examples. It was the source of a contract for that artist in 1475 when a marble memorial was requested by citizens of Pistoia (the native city of the dead Cardinal) to decorate their cathedral.

Figure 4/Distribution of the environmental dose-rates measured for soil samples taken from 56 authentic T'ang ceramic pieces/The ever-present cosmic-ray dose-rate component (0·014 rads per year) is included in this data. The mean value of the histogram lies at 0·15 rads per year. After Fleming S J 1973 *Archaeometry* 15 31.

But by the middle of the fifteenth century terracotta had become a more significant art medium, partly through the introduction of the tin-enamel glazing technique developed by Luca della Robbia around 1440. The terracotta industry flourished, particularly in Florence, as the demand for exterior decoration of buildings increased. At the same time there was a popular demand from the new-rich classes for terracotta sculptures and reliefs in imitation of the marble carvings commissioned by the nobility. Understandably the nobility also commanded the services of the better sculptors so that, of the few surviving terracottas of this type, a large proportion are the handiwork of mediocre or provincial artists. This bias is most obvious in the numerous representations of the Virgin and Child.

These three different objectives of Renaissance terracotta manufacture have each eventually set their own authenticity problem over the past century. A *modello* is a precursor to a fuller sculptural work but fakers recognized that this order of production could be conveniently reversed. Also the collector's appetite for the *Quattrocento* could be more readily whetted by identifying the characters represented in portraits; some inscribed name on a fraudulent piece served to guide the buyer's thoughts in the desired direction.

Plate 4/Prancing horse/White clay with traces of polychrome decoration, in the style of tomb goods of the T'ang Dynasty (AD 618–906) in China.
Thermoluminescence data
Archaeological dose \leqslant 55 rad
R_i, 0·43 rad/year
R_e, 0·15 rad/year
Age \leqslant 95 years.

Plate 5/Prancing horse/White clay with traces of polychrome decoration. T'ang Dynasty (AD 618–906) in China. Photograph: courtesy of John Sparks, London.
Thermoluminescence data
Archaeological dose, 600 rad
R_i, 0·31 rad/year
R_e, 0·15 rad/year
Age 1300 \pm 160 years.

But it is the 'workshop' products, even of the highest quality, that offer the forger most scope. Minor professional craftsmen or apprentices in the employ of the master sculptors furnish enough stylistic variation in detail to create a major headache to the modern art historian. The 'shadings' in the treatment of a theme within a workshop leave ample scope for minor 'discrepancies' in later imitations.

Interest in terracotta as a sculptural medium continued steadily through the seventeenth and eighteenth centuries, but the works of those times drew only limited inspiration from earlier pieces. Their diversity in style reflects a movement of sculptural activity away from Florence to Rome while Bernini (1598–1680) was active and eventually to Venice and, to some degree, Bologna. Around 1850 interest in earlier Florentine sculpture revived dramatically and stimulated a wave of innocent imitation of very high quality. In this direction Angelo Minghetti of Bologna and the Doccia factory of Florence excelled, the latter even gaining medals for its realistic simulation of tin-enamel lustre. In contrast some sculptors set to work expanding the catalogues of Renaissance masters. The della Robbia family suffered most heavily in this respect. The misdeeds of Ferruccio Mengaroni of Pesaro only received their just deserts when his 'della Robbia Medusa' head caused his demise by falling on his head as he stood below admiring it.

The middle of the nineteenth century also produced one of those rare individuals, Giovanni Bastianini (1830–1868), who have such strong affinities with certain craftsmen of the past as to almost capture their inspiration afresh. Bastianini was the son of a peasant family living in the Tuscan village of Fiesole and during his youth he developed an intense love of art, stimulated by the magnificent Villa Medici nearby and by the San Domenico monastery at which Fra Angelico had been a prior. His skill as a sculptor was readily recognized by a Florentine dealer, Giovanni Freppa, who not only became Bastianini's patron but also influenced him to change from his contemporary style to produce Renaissance material. This partnership began in 1847 and lasted almost twenty years.

Freppa's sales tactics were ideal for the situation. A terracotta would stand among his stock 'unrecognized' in attribution and marked at a low price. Other dealers were allowed to draw their own conclusions and if they chose to see a Rossellino or a di Credi in the style, that was their affair. Greed dissuaded the buyers from sharing their opinions with Freppa. In this way busts of Marsilio Ficino, president of the Platonic Society in Florence around 1492 (plate 6) and of Hiermus Benivieni† (a poet and philosopher of the same period) entered the art market and were acclaimed as masterpieces in 1865.

Unlike so many partnerships between forger and dealer the break did not stem from internal strife and cheating. Instead it was Freppa's disillusion with his own profits compared with those of the Paris art houses that caused him to publish his story in *Chronique des Arts* in 1867. The previous year had witnessed the Louvre's purchase of the 'Benivieni' for more than 13 000 francs yet the Florentine pair had received only a twentieth of that sum to share between them.

† This bust is executed in plaster, not terracotta.

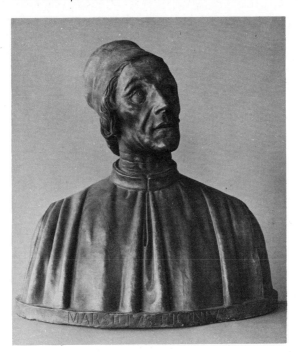

Plate 6/Marsilio Ficino/Terracotta bust attributed to Giovanni Bastianini (1830–1868). Photograph: courtesy of the Director of the Victoria and Albert Museum, London.

Thermoluminescence data	*Pre-dose technique*
Archaeological dose \leqslant 60 rad	Archaeological dose, 47 rad
R_i, 0·29 rad/year	R_i, 0·21 rad/year
R_e, 0·18 rad/year	R_e, 0·18 rad/year
Age \leqslant 130 years	Age 120 \pm 18 years

Respect for Bastianini's skills in present-day art circles together with a full realization of the magnitude of his productivity during his long period of activity before exposure is probably one of the main stimuli for thermoluminescence studies of Renaissance terracottas today.

The thermoluminescence analysis itself posed few problems despite the comparative youthfulness even of genuine material [9]. Some general consistency in environmental dose-rates is to be anticipated amongst genuine terracottas as the industry was so heavily concentrated in Florence. Much of the surrounding brickwork might be made of similar raw materials as the clay of the sculptures themselves; these supply a fraction of their own environmental dose, by virtue of their sheer bulk.

Such optimism seems to be sound as the data indicate (figure 5). For each of 14 Florentine terracottas of reasonably firm stylistic attribution and age [10] a value of the environmental dose-rate was obtained from the re-organized age equation:

$$R_e = \frac{Q}{T} - R_i$$

where Q represents the archaeological dose and T the age.

Figure 5/Distribution of environmental dose-rates appropriate to the dating of Florentine Renaissance terracottas/As deduced from thermoluminescence analysis of each piece.

 a Bust of Tacopo Contarini (Vittoria, *circa* 1580)
 b Adoration of the Shepherds, relief (Annabole Fontana, *circa* 1585)
 c Figure of Saint Sebastian (Civitale, *circa* 1475)
 d Madonna and Child, relief (Giovanni di Turino, *circa* 1425)
 e Bust of Saint Matthias (Algardi, *circa* 1655)
 f Bust of a Nobleman (Onofri, *circa* 1475)
 g Madonna and Child (Donatello, *circa* 1460)
 h The Adoration of the Shepherds, relief (Verrocchio del Andrea, *circa* 1475)
 i Bust of Lozenzo de'Medici (Verrocchio, *circa* 1500)
 j Bust of an Old Man (Florentine school, *circa* 1475)
 k Bust of Giuliano de'Medici (Verrocchio, *circa* 1490)
 l Bust of a Young Knight (Vittoria Alessandro, *circa* 1590)
 m Bust of Andriana Palma (Vittoria, *circa* 1580)
 n Bust of a Florentine Statesman (Benedetto da Majano, *circa* 1475)
 The terracottas form part of the Kress sculpture collection in the National Gallery of Art, Washington, DC. Attributions provided by Professor U Middeldorf of the Institute Longhi, Florence.

 Treating this distribution as statistically normal (the fit is really quite good) a *mean* environmental dose-rate of 0·18 ± 0·05 rads/year can be estimated. Routine use of these figures allows thermoluminescence dating of genuine wares with an accuracy of about ± 13%. Comparison of the results for the 'Pietà' attributed to Giovanni della Robbia (plate 7) and the 'Ficino' bust by Bastianini illustrate the authenticity and dating principles outlined here.

 The third terracotta in the illustration, 'Virgin and Child' (plate 8) may well reflect present-day nervousness about the extent of nineteenth-century imita-

Plate 7/Pietà/Terracotta attributed to Giovanni della Robbia (1469–1529). Photograph: courtesy of the Metropolitan Museum of Art, New York, Rogers Fund, 1913; accession number 14.23 A–D.

Thermoluminescence data	*Pre-dose technique*
Archaeological dose, 297 rad	Archaeological dose, 148 rad
R_i, 0·47 rad/year	R_i, 0·20 rad/year
R_e, 0·18 rad/year	R_e, 0·18 rad/year
Age 470 ± 60 years	Age 390 ± 70 years

tion. Purchased in 1861 by the Victoria and Albert Museum, this piece was first attributed to Jacopo della Quercia (1374–1438), subsequently to Luca della Robbia, Lorenzo Ghiberti, Michelozzo and now to an unknown artist working around the same time as Bastianini [10]. There are certain stylistic aspects to support this final attribution, notably the Virgin's sentimental expression which could be compared with the fake marble portrayal of Lucrezia Donati illustrated in chapter 1. Technically the terracotta has been put together from three sections prepared in moulds which may have been made from impressions of a superior modelled original.

Duly the thermoluminescence age of *circa* AD 1400 brings the story full circle, possibly back to Quercia, possibly back to a choice amongst many Florentine sculptors of the early fifteenth century.

In order to assign accurate dates to ceramics of age between 50 and 1500 years it is necessary to go beyond the conventional high-temperature technique to the more sophisticated *pre-dose method*. This method depends on an effect exhibited by the 110°C peak in the glow-curve.

This low-temperature peak in the glow-curve of a laboratory-irradiated sample (figure 2) is due to the presence of quartz in the pottery fabric. From what we said about thermoluminescence energy storage in the discussion of the high-temperature method we would not expect this peak to be of any dating value. It does not appear in a natural curve as ambient ground temperatures of about 20°C are quite sufficient to cause disruption of the electron–defect link responsible for that peak within a matter of hours.

Plate 8 / Virgin and Child (detail) / Florentine terracotta, at various times attributed to Jacopo della
Quercia (1374–1438), Luca della Robbia, Lorenzo Ghiberti and Michelozzo but
most recently catalogued as of nineteenth-century origin. Photograph: courtesy
of the Director of the Victoria and Albert Museum, London; catalogue number
739.

Thermoluminescence data	*Pre-dose technique*
Archaeological dose, 360 rad	Archaeological dose, 210 rad
R_i, 0·44 rad/year	R_i, 0·21 rad/year
R_e, 0·18 rad/year	R_e, 0·18 rad/year
Age 580 ± 75 years	Age 540 ± 85 years

However, this 110°C peak possesses the unusual characteristic of
retaining *a memory* of its tradition history despite the loss of the electrons produced by
that radiation. The memory can be 'unlocked' by 500°C heating which enhances the
radiation sensitivity of the peak. This enhancement is quantitatively linked to the
magnitude of the previous radiation dose. No enhancement can be induced by this
heating in the absence of pre-irradiation, or *pre-dose*. These concepts are illustrated in
figure 6 for the glazed stoneware 'Warrior' of colour plate 11.

The archaeological dose experienced by this piece is estimated from
the following sensitivity measurements:

(i) S_0, represents the response of the 110°C peak to a small test-dose (in
this case, about 2 rads) of laboratory beta radiation, *before* any heat
treatment.

(ii) S_N represents the response of the peak to the same test-dose now applied after a 500°C heating of the sample.

(iii) S_N' is measured after a simple 500°C reheat. At this point pre-dose, β is applied and all the thermoluminescence associated with it is drained by a further 500°C heating.

(iv) $S_{N+\beta}$ represents a subsequent sensitivity measurement, again using a test dose.

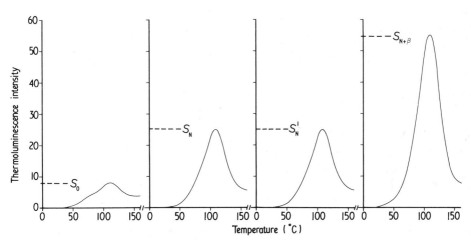

Figure 6/Pre-dose analysis of the Thai stoneware Warrior of colour plate II. Definitions of sensitivities marked here (S_0, S_N, S_N' and $S_{N+\beta}$) are given in the main text. After Fleming S J 1973 *Archaeometry* **15** 31.

For the Warrior: $S_0 = 8$ light units, $S_N = 25$ light units, $S_N' = 25$ light units, and $S_{N+\beta} = 55$ light units, while $\beta = 400$ rads.

The lack of growth between S_N and S_N', shows that heat alone leads to no changes in the 110°C peak's luminescence properties. However, inclusion of a pre-dose leads to the change $(S_{N+\beta} - S_N)$. By analogy the sensitivity change $(S_N - S_0)$ can be attributed to heat activation of the effect of natural pre-dose Q in the age equation. On a proportionality basis,

$$Q = \frac{S_N - S_0}{S_{N+\beta} - S_N} \beta.$$

In the case of the Warrior figure $Q = 225$ rads.

Thereafter, dating proceeds in much the same way as in the high-temperature method, except that within the ceramic body α-radiation causes virtually no pre-dose, effect. Consequently the environmental dose-rate plays a rather more important role in the total annual dose-rate used in age determination.

The Warrior's sensitivity enhancement *rate*, about 2% for every rad of pre-dose, is reasonably typical of ceramics from many cultures, though a few instances are recorded where the rate is an order of magnitude greater. An S_N/S_0 ratio of

2 is feasible for a piece manufactured only about 50 years ago, sometimes much less. The pre-dose method thus becomes an ideal tool for study of imitative material produced during the past century. Thermoluminescence ages for forgeries now often carry a standard dating error (of magnitude related in some degree to the enhancement rate) rather than just a maximum age limit of the type discussed earlier.

Two well-known Etruscan fakes, 'Diana the Huntress' and the 'Kore' illustrate these comments well [11].

The 'Diana' terracotta (plate 9) is now attributed to Alceo Dossena (1878–1937) who gained recognition as a master forger in a multitude of art media. His *forte* was certainly Madonna sculptures both in wood and stone, in the style of Giovanni Pisano, but he followed cautiously in the footsteps of Bastianini and produced some impressive Renaissance terracottas and marbles both as religious reliefs and as bust portraiture. Dossena's career came to an abrupt halt when H W Parsons eventually tracked down his Rome studio in 1928. His admission to faking many pieces (by then well distributed throughout major museum collections of the world) earned him recognition with an exhibition of his wares and a catalogue of his activities, *Alceo Dossena: Sculptore*, published in 1955.

The 'Kore' (plate 10) was acquired by the Glyptothek ny Carlsberg in 1930 and subsequently published in a catalogue of the museum's sculpture collection in 1951. Again it was Parsons who identified the modern source of this piece and published a photograph of the statue in its pre-firing state. The sculptor was Alfredo Fioravanti who began his activities in the workshop of the Riccardi brothers, helping them construct the three 'Etruscan Warrior' terracottas destined to cause such controversy at the Metropolitan Museum of Art [1]. Having served his 'apprenticeship' between 1915 and 1919 (at which point the death of the eldest Riccardi caused the break-up of the organization) Fioravanti set out to establish his own industry, the Kore being only one of his achievements during the following decade.

In pre-dose response both these pieces have enhancement rates in excess of 10%/rad so that their youth poses no difficulty. Each age quoted probably carries an error of about \pm 15% owing more to environmental dose-rate uncertainties than any weakness in glow-curve interpretation.

Unfortunately the pre-dose technique is largely limited to dating applications over the past 1200 years or so (the sensitivity of the 110°C peak cannot be boosted ever upwards by increasing the pre-dose). The enhancement process (considered at present to be a luminescence efficiency change with dose) eventually saturates for natural pre-dose levels of about 500 rads while deviation from linearity of the curve of enhancement against the pre-dose curve usually sets in at 300 rads or less. Such saturation leads to a somewhat low age determination amongst genuine wares of older cultures.

Renaissance terracottas offer a common ground for the pre-dose and high-temperature methods while pre-dose analysis has proved invaluable in the dating of many metal castings (using their ceramic-like casting cores; see chapter 4), from West Africa, the Islamic world and South-East Asia.

Two 'case histories' are discussed in greater depth here. First the results of pre-dose thermoluminescence analysis of T'ang Dynasty tomb goods are

Plate 9/Diana the Huntress/Terracotta in Etruscan style, attributed to Alceo Dossena (1878–1937).
Photograph: courtesy of the City Art Museum of St. Louis, Missouri.
Thermoluminescence data (pre-dose technique)
Archaeological dose, 23 rad
R_i, 0·29 rad/year
R_e, 0·29 rad/year
Age 40 years

compared with judgements of their authenticity based on the *craquelure* criterion (the visible effects of glaze ageing). Second the affair of the Pevensey tiles is outlined as an example of archaeological faking of particular interest as it relates to the well-known hoax of the Piltdown skull.

While the large majority of T'ang potters struggled to keep up with the public's eager call for their simpler unglazed funerary wares (as discussed above) some specialized workshops catered to more expensive tastes amongst the nobility. Their products were brightly coloured glazed pottery sculptures, such as tomb guardians (some even life-size), images of court dignitaries, powerfully-modelled horses (plate 11) and camels, together with all manner of dishes and wine-jars. These pieces were a major departure from the normal style of Chinese craftsmen, the monochrome greens and straw-beige finishes of earlier wares being replaced by boldly dappled and splashed designs in golden-yellow, copper-green, cream and blue (derived

Plate 10/Kore/Terracotta figure in Etruscan style, attributed to Alfredo Fioravanti (1886–1963).
Photograph: courtesy of the Glyptothek ny Carlsberg, Copenhagen; catalogue number 845.
Thermoluminescence data (pre-dose technique)
Archaeological dose, 16 rad
R_i, 0·19 rad/year
R_e, 0·15 rad/year
Age 48 years

Plate 11 / Standing saddled horse with elaborate trappings / T'ang Dynasty (AD 618–906), height
0·48 m. Thermoluminescence data is given in the caption to plate 12. Photograph:
courtesy of Hugh M Moss Ltd, London.

from cobalt ore imported from Persia). This colour scheme was in the spirit of the
growing cosmopolitan atmosphere of the T'ang Empire in the eighth century.

The specialized artisans who produced these pieces clearly gave much
thought to the technological problems of glazing their larger and, occasionally,
awkwardly-shaped pieces in such an extravagant way. Early in the T'ang Dynasty
craftsmen recognized the advantages of adding lead oxide to the glaze ingredients to
encourage a low melting temperature and an associated improvement in kiln control.
The various constituents, quartz, soda, potash and alumina, plus the lead oxide, were
ground together and put into a water suspension which could then be brushed on to
the surface of the sun-baked clay body.

Kiln-firing hardened the body and created some fusion between the clay and the glaze as the latter, in fusion, gradually spread across the surface of the piece and sealed its fine pores. To ensure that the larger particles dissolved completely the glaze mix was matured slowly and carefully. But the real advantage of this careful treatment lay in the fine lustre it gave the finished wares.

A successful production depended not only on the visual impact of the piece's decoration but also whether the glaze was properly bound to the clay body. Achievement of the latter objective calls for proper matching of the expansion characteristics. If the clay fabric contracted more than its glassy coating during kiln cooling, the glaze would tend to peel away early in its life. In contrast if the body shrank less than the glaze the piece would come from the kiln covered in a crackle of surface fissures. A mild degree of crackle was scarcely avoidable and probably regarded as the lesser of two evils.

In burial the glaze aged gradually as remaining stresses were released or fresh pressures were put on the glassy surface by the rehydration of the clay's alumin-ium silicates and the subsequent swelling of the body. This caused a new network of fine fissures to build up (termed crazing), inter-lacing the coarse-meshed crackle pattern due to kiln-firing. The overall appearance of the glaze as we see it today is called *craquelure* (plate 12) [12].

For many years *craquelure* has been regarded as firm evidence of authenticity amongst T'ang wares on the basis that a genuine piece carries a crazing pattern but an imitation has only the kiln-induced crackle on its surface. There seem to be several examples recently where this notion is in discord with stylistic judgement (Two are illustrated here, plate 12 *b,c.*) Also the *craquelure* criterion, as a matter of visual impression, has a strong subjective element in the definition of terms like 'fine' and the distinction of crazing from crackle. If kiln-crackle is identifiable by linear extent and intensity of fissuring (as emphasized by ingrained dirt) and crazing by much shorter, shallower arcs, then both the Chestnut Horse and the Court Lady exhibit *craquelure*. Yet the Horse's fissure spacing is about six times as wide as that of the Lady's glaze.

Thermoluminescence analyses of the various pieces in the illustration make it is clear that the only complete agreement lies between stylistic judgement and thermoluminescence dating; there is an absence of crazing on the *genuine* Blue-glazed Figure and an excellent *craquelure* on the *imitation* Baggage-laden Camel.

In the light of this data it is interesting to ponder on the likely weak-nesses of the *craquelure* authenticity criterion. Amongst genuine wares we need only imagine that the T'ang tomb resisted decay and breach sufficiently well to act as a thermally-stable, dry environment that did not encourage crazing. In other cases sheer thickness of glaze would resist surface break-up.

Amongst imitations with good *craquelure* it may be reasonably claimed that a chance firing condition was responsible, though the 'recipe' for the effect remains obscure. I am inclined to look elsewhere as we remain ignorant of the rate of crackle development other than in general terms. When T'ang imitation flourished around 1912 no doubt pristine glazes did stand out strongly in contrast to

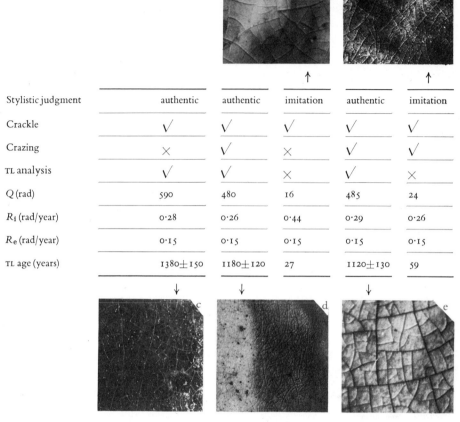

Stylistic judgment	authentic	authentic	imitation	authentic	imitation
Crackle	√	√	√	√	√
Crazing	×	√	×	√	√
TL analysis	√	√	×	√	×
Q (rad)	590	480	16	485	24
R_i (rad/year)	0·28	0·26	0·44	0·29	0·26
R_e (rad/year)	0·15	0·15	0·15	0·15	0·15
TL age (years)	1380±150	1180±120	27	1120±130	59

Plate 12/Authenticity studies amongst T'ang glazed wares.

 a Detail of the glaze on the neck of a 'Duck' rhyton in the T'ang style. The coarse-meshed *crackle* is spaced at about one fissure every 1·4 mm.

 b Detail of the glaze on a 'Baggage-laden Camel' in the T'ang style. The irregularly-spaced *crazing* on the animal's rump is spaced at roughly one fissure every 0·5 mm.

 c Detail of the glaze of a 'Blue-glazed Figure', T'ang Dynasty (AD 618–906). The coarse-meshed *crackle* on the front of the skirt is spaced at roughly one fissure every 1·4 mm.

 d Detail of the glaze on the skirt of a cream-scarfed 'Court Lady', T'ang Dynasty (AD 618–906). The coarse-meshed *crackle* is spaced at about 1·2 mm intervals while the finer *crazing* is spaced at about 0·2 mm intervals.

 e Detail of the chestnut glaze splash on the saddle of the Horse illustrated in plate II. Note the coarse texture of the crazing and the two networks on the surface: a very wide-meshed one with fissuring of long extent (*crackle*) and a finer mesh interlacing the intense lines and randomly orientated (*crazing*). Photographs: courtesy of Sotheby & Co, London (*a*); Thomas-Photos, Oxford (*b, e*); and the Clarendon Laboratory, Oxford (*c, d*).

their authentic counterparts but now, more than 60 years later, perhaps the ageing effect is underway.

The case-history of the Pevensey tile forgeries is a good example of a fake designed to fit in with genuine documentary evidence [13]. In the closing decade of the fourth century AD, the Roman general, Stilicho, overcame the Irish and the Picts and strengthened coastal defences against possible Saxon attack. This we know from fragments of poetry by Claudian in praise of this victory. During excavations of the fortress site of Pevensey in Sussex at the beginning of this century, great excitement was generated in academic circles by the discovery of a group of tiles stamped with inscriptions, the most complete of which read, HON AUG ANDRIA (plate 13). This brief text was heralded as a clear reference to the Emperor Honorius (AD 395–423) so that the tiles represented a rare archaeological document of Stilicho's campaign. As such they have been cited frequently in recent literature on the final stages of the Roman occupation of Britain. Unfortunately the only two tiles that can now be traced, one in the British Museum and one at Lewes, are both fakes and, according to thermo-luminescence analysis, of an age consistent with manufacture only shortly before their public display and discussion at the Society of Antiquaries of London in April, 1907.

The celebrated lecturer on that occasion was a solicitor, Charles Dawson. Throughout the preceding years he had repeatedly stunned the archaeological and anthropological communities alike with his unusual finds on the Sussex downs; a petrified toad encapsulated in flint and the tooth of a mammal with distinct reptilian connexions, called *Plagiaulax dawsoni*. The learned literature also records his finds of cast-iron figurines at Beauport Park as the earliest known examples of this metal in Europe. Dawson discoursed with great eloquence on the meaning of the word ANDRIA and once again found an appreciative audience.

Historical aspects of the story surrounding the Pevensey material might in the context of this book seem only mildly unusual. There is no lack of forgery case histories where a good academic has found himself accessory to the fact, albeit un-wittingly. However, in 1912, Dawson re-emerged, this time at a meeting of the Geo-logical Society of London to present the fossil, cranium and jaw bone of *Eoanthropus*, an ancestor of man but with ape-like characteristics still strongly in evidence. This material came from gravel beds near a place called Piltdown (again in Sussex) and was soon termed 'The Dawn Man' in popular reports as geologists assigned an early Ice Age date to these ancient river deposits.

Of course we now know that this fossil is also a fake constructed from a human cranium and an orang-utan mandible both less than 800 years old. The Piltdown Hoax is legendary [14]. But what of the identity of the perpetrator of these frauds? The evidence now points towards Dawson himself with little room for doubt. The only alternative seriously mooted before the Pevensey investigation was a young Jesuit, Teilhard de Chardin, who conveniently found a 'fitting' human canine in the Piltdown quarry site only a few months after Dawn Man's first publicity. But de Chardin did not meet Dawson until 1908 and so could not have been involved in the Pevensey affair. Even in the past year Dawson's defence has been even further weak-ened by the direct linkage of his hand to a fake map of the Maresfield Forge (which lies close to Piltdown) claiming to depict the historical geography of that region [15]. It

Plate 13 / The Pevensey tile / Photograph: courtesy of the British Museum.

was published as illustrative material in the 1912 volume of *The Sussex Archaeological Collections* and described as a copy by C Dawson FSA of a 1724 original. A great number of anachronisms have been detected not least of which is a mill-pond that was only sunk in local marshland after 1880. Dawson's deliberate suggestion to the journal's editor that his version should be compared with another famous map of the area by a man called Budgen was audacious. He correctly assumed that no such archive check would be made. This hoax sums up the man's vengeful nature in response to local jealousies. Perhaps he was also motivated by a desire to pay back the experts of the British Museum who in 1883 had dismissed his first 'Roman' cast iron acquisitions as 'pretty reproductions'.

[1] von Bothmer D and Noble J V 1961 *An Inquiry into the Forgery of the Etruscan Terracotta Warriors* (New York: Metropolitan Museum of Art) p 20
[2] Fleming S J 1971 *Naturwiss.* **58** 333
[3] Fleming S J 1973 *Archaeometry* **15** 13
 see also Fleming S J 1972 *Naturwiss.* **59** 145
[4] Aitken M J, Morrey P R S and Ucko P J 1971 *Archaeometry* **13** 89
[5] Fleming S J, Jucker H and Riederer J 1971 *Archaeometry* **13** 143
[6] Fleming S J and Roberts H 1970 *Archaeometry* **12** 129
[7] von Bothmer D 1972 *Metropolitan Museum of Art Bulletin* p 31
[8] Fleming S J 1974 *Archaeometry* **16** 91
[9] Fleming S J and Stoneham D 1973 *Archaeometry* **15** 229
[10] Pope-Hennessey J 1965 *Catalogue of Italian Sculpture in the Victoria and Albert Museum* (London: HMSO) vol III p 689
[11] Parsons H W 1962 *Art News* **60** 34; this presents photographs of the 'Diana' said to have been taken in Dossena's studio and of the 'Kore' claimed to have been taken by Fioravanti in his own workshop
[12] Fleming S J 1973 *Archaeometry* **15** 31
[13] Peacock D 1973 *Antiquity* **47** 138
[14] Oakley K P and Weiner J S 1955 *American Scientist* **43** 573
[15] *The Times* 1974 March 30

4

Metals.

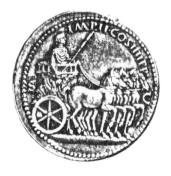

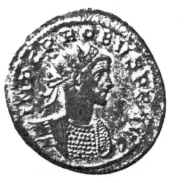

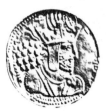

4 Metals.

Sassanian silver/ Burgundian gold coins/ The moneyers of Henry I/ Inflation in the Roman Empire/ The gold *aurei* of Carl Becker/ The sixth 1933 penny/ Bronze technology/ Authentication of early Chinese bronzes.

The faker's interest in metals probably has two main roots. First, there is an immediate contemporary market for coin counterfeits yielding calculable financial reward. Second, use of precious metals, such as gold and silver, immediately places an object in the higher realms of the dealers' world. The real headache here is that several of the techniques of the ancients have been successfully reproduced by more recent craftsmen, copyists and forgers alike!

The supreme achievement in this respect can be attributed to Fortunato Castellani, who, around 1830, revived the art of *granulation*, such a familiar feature of the finer Classical Greek and Etruscan gold vessels and jewellery. As this technique involves fabrication of minute gold globules each of which has to be soldered into place individually, one might have expected that forgers would have been deterred from this field of operation. Alas, not so; Castellani (and subsequently his son, Augusto) created a fashion for this kind of material in Italy, an environment tempting as ever to forgers, indeed their veritable spawning ground. The extensively-reported Rouchomowsky affair stems from this era [1].

The nineteenth century was also the heyday of medieval gold imitation, though stylistic weaknesses (mainly a predilection for over-ornamentation) have appreciably softened the impact of such material. In this field the audacity of the Viennese goldsmith, S Weininger, deserves special mention. Called upon to restore two elaborate ostensories on behalf of the Imperial Treasury of Austria, he copied them and returned his versions to the authorities. This exchange must have proved extremely lucrative, as Weininger sold both the originals, one, an enamelled 'Reliquary of the Holy Thorn', to the British Museum [2]. The impressive feature of these pieces is their well disciplined plagiarism; Weininger's only concession to contemporary fashion seems to have been the modernization of some architectural features and inclusion of some neo-Gothic foliage.

Unfortunately our knowledge of faking in gold is still based more on scandalous anecdotes rather than upon technical analysis, except in the coin world. It may well be that owners are reluctant to subject valuable gold objects to the sampling

damage which may be necessary in a thorough scientific analysis. There is a similar scarcity of scientific data on silver wares with the notable exception of early Persian material of the Sassanian Empire. Neutron activation analysis, which we have already encountered in our discussion of paintings, finds another application here.

One new method is introduced later on in the chapter, that of x-ray fluorescence. I have refrained from introducing this topic earlier even though there are some reports of its usage amongst paintings [3]. However, as a virtually non-destructive technique x-ray fluorescence has proved of major value in determining the composition of coins and jewellery while portable units are now available so that much larger objects (even Cathedral doors) can be studied *in situ*.

We end the chapter with a separate discussion of authenticity problems amongst bronzes. Although of much less intrinsic value than gold or silver, bronze is one of the most important art media amongst many ancient civilizations, and has suffered its share of abuse at the hands of the forger. It is, however, quite a complex material in the metallurgical sense and I include a brief preface on its origins and technological history as an aid to the subsequent discussion. Many of the scientific methods described in earlier sections, such as thermoluminescence, microscopy and radiography, appear once more, though occasionally in unusual applications.

The Sassanian period (AD 224–641) was one of great prosperity and political stability in the Near East. Except for a brief hiatus of heavy coin debasement during the reign of Shapur I (AD 241–272) (possibly the consequences of that king's abortive attempt to extend the frontiers of his control) the silver mints of that region were able to maintain high standards, particularly from AD 350 onwards. A silver content of less than 80% in this coinage is a rare event.

But a recent study using neutron activation analysis has yielded a valuable detail: the sources used always carried a contaminant of gold (typically between about 0·5 and 1%), even though the mines exploited were changed many times over the centuries [4]. A purer form of silver only became available in the last quarter of the sixth century AD, towards the end of the reign of Khusrau I. This information is summarized in plate 1.

The technique of sampling this coinage is particularly important. It involves rubbing a roughened quartz tube on to sound metal, after the outer regions of corrosion have been abraded away. (The corroded region tends to be rich in gold as that noble metal resists leaching attack rather better than the host silver; the opposite would be the case with any copper present.) Streaks, as these samples are called, weigh no more than a tenth of a milligram.

Gold is regarded as one of the few elements that is a useful indicator of the origin of a particular sample of silver as both metals behave quite similarly during the chemical refinement processes available to ancient man [5]. Copper would also be a common enough contaminant but any ore-specific characteristics this element might show would be overwhelmed by the concentration introduced as a means of deliberate coin debasement. Minor impurities, such as antimony and arsenic, would originate from the ore of the copper additive rather than from the silver source itself.

Figure 1 typifies the gamma-ray spectra obtained from silver/copper alloys of this Sassanian type. The $^{108}$Ag-activity will not survive the transport time

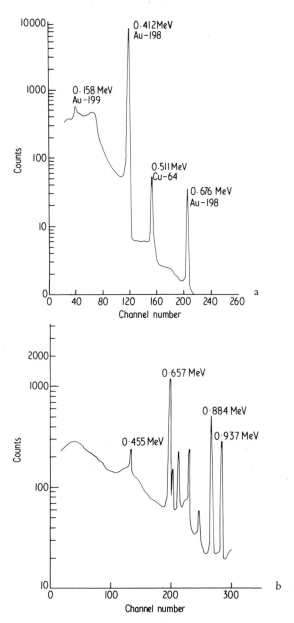

Figure 1/*a* The gamma spectrum obtained from a streak of metal on a roughened quartz plate
after thermal neutron exposure in a nuclear reactor. Measurement in this case
was delayed only a matter of hours.

b The gamma spectrum obtained from the same streak of metal after re-
exposure to neutron for almost thirty times as long as above and with
measurement now delayed a couple of months. Silver-110m activity (all
peaks) is now detectable but requires much longer counting times for accurate
evaluation. After Keisch B 1972 *The Atomic Fingerprint: Neutron Activation
Analysis* (Oak Ridge: USAEC Technical Information Centre) pp. 38–9.

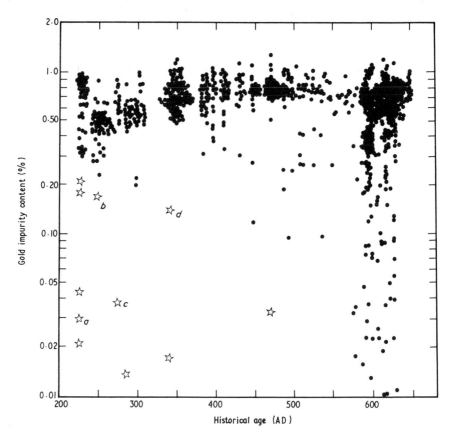

Plate 1 / Gold impurity level in more than 1000 Sassanian silver coins / Stars represent data for modern
fake coins of this period, probably all castings. Photographs opposite:

from the nuclear reactor to the measurement laboratory, so a reasonably prompt spectral
analysis (a couple of hours after irradiation) is dominated by $^{64}$Cu- and $^{198}$Au-activities
(figure 1a). But some two months later only the much longer-lived $^{110m}$Ag-activity
remains (figure 1b). Comparison of these spectral peak heights with those obtained from
standard alloys exposed to the same irradiation allows the concentration of these three
elements to be quantified [6].

Modern forgeries of earlier Sassanian coins give themselves away
quickly enough in this form of analysis by virtue of their extremely high silver purity,
with gold levels less than 0·2%. (Some examples are recorded in plate 1, alongside
data from original coins.) Some are fashioned from the highly refined silver (gold
content less than 0·001%) which has only been available over the past few decades.

Such conclusions extend to Sassanian objects other than coins. A
remarkable survey of privately-owned pieces in America indicated that about two
thirds were spurious, being not only very low in gold content but often debased with
about 10% extra copper addition. The common ground between coinage and larger

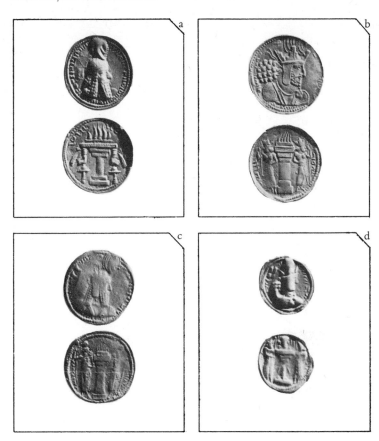

a Ardashir I: Ag 80·5% ; Au 0·030% (weight normal at 4·2g).
b Shapur I: Ag 91·1% ; Au 0·17% (weight excessive at 4·63g).
c Bahram I: Ag 90·0% ; Au 0·038% (a crude casting well overweight at 5·28g).
d Shapur II: Ag 95·7% ; Au 0·14% (weight normal at 3·84g).
Photographs: courtesy of Dr A A Gordus, University of Michigan, Ann
Arbor, and with the permission of the Royal Numismatic Society, London.

articles has been established using pieces, such as the large head of Shapur II (AD 309–
379) now in the Metropolitan Museum, New York (plate 2). Its gold content of 0·67%
falls squarely in the midst of the coin data in plate 1.

The Hermitage Museum of Leningrad holds an interesting nine-
teenth-century copy of a silver plate, inspired by an original in the Oxus Treasure
bequeathed to the British Museum by Sir Augustus Wollaston Franks in 1897. The
genuine piece is decorated with a scene of a hunter (thought to be Bahram V) who has
captured a lion cub but now has to defend himself against the irate parents. But the
early fifth-century craftsman who produced this cut off the legs of the attacking lions
at the edge of the plate. The fake version bears a faithful transfer of the scene on to a
larger plate, including the omission of the lion's paws. As if this were not adequate
evidence, the Hermitage piece has a gold content of only 0·019%.

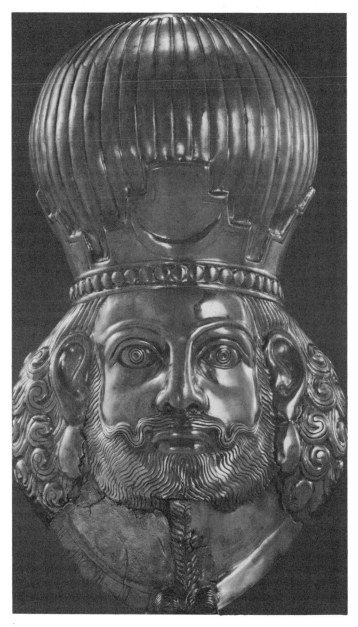

Plate 2/Shapur II/Large silver head, Sassanian (*circa* AD 309–379). Au content, 0·67%. Photograph: courtesy of the Metropolitan Museum of Art, New York; accession number 65.126.

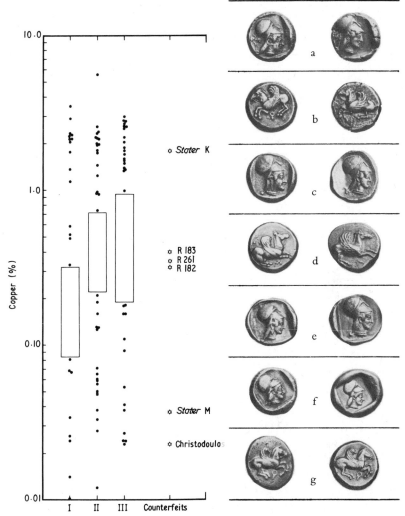

Plate 3 / Copper impurity levels in Corinthian silver coins / Classified according to O Ravel's 'Les Poulains de Corinthe' (reference 'R'): Period I (570–520 BC), Period II (520–460 BC) and Period III (460–430 BC). Other identifiers match those in reference 7. Coins are arranged with each fake coin face (left) alongside a genuine coin with close parallels in design (right).

a R182 (Cu 0·32%): R173 (Cu 1·97%) (obverses).
b R183 (Cu 0·40%): R173 (Cu 1·97%) (reverses).
c R261 (Cu 0·35%): R244 (Cu 2·6%) (obverses)
d Stater M (Cu 0·037%): R244 (Cu 2·6%) (reverses)
e Stater K (Cu 1·8%): R 111, P137 (Cu 2·5%) (obverses).
f Christodoulos (Cu 0·023%): R 158, P99 (Cu 0·95%) (obverses).
g Christodoulos (Cu 0·023%): R 158, P99 (Cu 0·95%) (reverses).
Photographs: courtesy of the Heberden Coin Room, Ashmolean Museum, Oxford.

The rules of ore purity that hold in one part of the world cannot be carried over to other regions as we can see from an examination of Greek silver coins. Analysis of Corinthian silver coinage,† over the period from 570 to 430 BC, indicates that a gold impurity of more than 0·5% would be more the exception than the rule, while more than a third of those sampled contain less than 0.05% gold [7].

But debasement is a much rarer phenomenon here (except amongst counterfeits) so that copper can now act as an effective indicator of the ore source though the mine locations themselves remain unknown. Copper concentrations divide into clear-cut groups, particularly in post-520 BC material. These findings are summarized in plate 3. (The fact that there is no sensible correlation between ore source and gold content, as in the Sassanian material above, may indicate variations of the gold concentration within the mine itself.)

There are wide concentration gaps in all three phases of these Greek coins,

(i) 570–520 BC $0·08\% \leqslant Cu \geqslant 0·33\%$
(ii) 520–460 BC $0·21\% \leqslant Cu \geqslant 0·74\%$
(iii) 460–430 BC $0·18\% \leqslant Cu \geqslant 1·0\%$

which some forgers obligingly set out to fill! Six fake coins are illustrated in plate 3. Three of these appeared in the standard work by O Ravel, 'Les Poulains de Corinthe', as genuine despite their weights being out of keeping with known Greek standards. Their copper contents of 0·32–0·40% confirm suspicions raised on these grounds. Of the other three, one (*f*, *g*), if not all, can be attributed with confidence to the hand of a skilled Greek counterfeiter, C Christodoulos, who began his operations at the turn of this century, selling his products to the National Museum in Athens. Yet chemical analysis would not detect his activities. Perhaps this is an instance of the use of old metal, a trick against which chemistry can offer little protection.

Similar analysis of Athenian coinage shows no such well-defined impurity concentration limits until the introduction of silver *Owls* (head of Athena on the obverse, and an owl on the reverse) sometime close to 525 BC. Their highest copper level, with one exception, is 0·9%, while the gold concentration is restricted between limits of 0·0035% and 0·072%. It is tempting to link this high purity with the initial exploitation of the nearby silver-laden Laurion mines around that time.

We now move on to discuss our second analytical method, x-ray fluorescence analysis. In the words of Victor Hanson of The Henry Francis du Pont Winterthur Museum, this technique offers 'The Curator's Dream Instrument'. Perhaps his feelings were coloured by the speed with which he was able to despatch a new and improved silver tankard, attributed to N and S Richardson of Philadelphia (1771–91), but, in reality, re-built *circa* 1930 using twentieth-century sterling silver [8]. The telltale feature was the absence of gold and lead, plus an excess of copper.

When a material is bombarded with x-rays, electrons are displaced from the innermost shells of the constituent atoms. Electrons from outer shells immediately fall into the vacant levels, shedding energy by the emission of secondary, or

† Mainly *staters*, but some *drachms* and *obols* as well.

fluorescent, x-rays. The important electronic transitions are those known as K(a) and L(a). Figure 2 shows how the energies of K(a) and L(a) transitions depend on the atomic number Z of the element involved. Normal operational voltages of about 4 to 30 keV exclude elements below calcium ($Z = 20$) in the periodic table and allow measurement of only L(a)-lines of the heavier elements of interest to us, such as lead ($Z = 82$) and gold ($Z = 79$).

Figure 2/X-ray fluorescence energies as a function of atomic number, Z/The important electronic transitions are known as K (a) and L (a), where their energies are given by:

$$E_K \text{(KeV)} = \frac{(Z-1)^2}{97} \text{ and } E_L \text{(KeV)} = \frac{(Z-7\cdot4)^2}{523}$$

Because the levels of primary radiation do not need to be high there is no risk of physical damage to the object and there is no residual radioactivity to be worried about. However, x-rays (whether primary or secondary) do not penetrate very deeply into metals and x-ray fluorescence data represent only the first 50 micro-metres or so of the specimen. Just as with 'streak' sampling for neutron activation purposes, care must be taken to remove corroded regions and surface portions which may have suffered elemental depletion or enrichment effects.

 Two main types of detection system are available with x-ray fluorescence equipment. Dispersive units (figure 3) require quite sophisticated control of their operation but offer high resolution of 40 eV [9]. Alternative non-dispersive systems give poorer resolution (about 160 eV) but have the advantage of making a portable system available [10].

 X-ray detection limits are usually somewhat poorer than those quoted for neutron activation analysis, for example 0·05% for gold in a silver matrix

(compared with 0·001%), but for most authenticity problems this is more than adequate. Two factors in particular control the ultimate accuracy of the method:

(i) The intensity of an x-ray spectrum line is influenced by the presence of other impurities as the x-ray penetration will be controlled by the specimen's overall composition. Such 'matrix effects' can be greatly minimized by setting up reference curves to cover the more relevant mixtures of elements but some minor impurities can still be troublesome. For example, an unsuspected lead content of 10% in an alloy with a silver/copper weight ratio of 3/1 leads to an overestimate of the silver content by more than 3% as lead atoms absorb copper x-radiation more readily than that of silver.

(ii) The detection geometry may be upset by irregularities in the specimen's surface (figure 3, detail). The markings on a coin are an obvious problem in this sense. A displacement of only 0·5 mm can cause a 45% fall in the count-rate. This is less of a problem with a binary alloy as each constituent will be affected to much the same degree so that a concentration *ratio* suffices, but more complex alloys require a family of calibration curves. Matrices as complex as brass (which contains zinc, lead and nickel at significant levels, besides the main components of copper and tin) take appreciable time to analyse accurately.

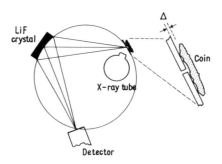

Figure 3/Schematic representation of the dispersive x-ray fluorescence unit known as the 'milliprobe'. Johannsen focusing conditions are used where the crystal is bent to an arc generated by a radius equal to the diameter of the so-called Rowland circle, but ground to an arc generated by the Rowland circle. The detail illustrates the problems that arise when positioning of a coin with an uneven surface is attempted. The measured region lies a distance Δ from the collimator pin-hole. After Schweizer F 1972 *Royal Numism. Soc. Spec. Publ.* **8** 153.

Despite technical difficulties of this nature x-ray fluorescence analysis has repeatedly proved to be 'competitive' with allied scientific techniques in the study of gold and silver coinage [11]. Understandably it is particularly valuable in the study of surface gilding and in the detection of one of the most common operations in counterfeiting of coins, the coating of an inner core of base metal with a thin layer of a precious one [12].

One of the surest traps for a coin forger is his lack of knowledge of the political factors that controlled minting procedures in antiquity. This is well-illustrated by the two Burgundian gold coins, 0.144 and 0.149, in plate 4, which are simply too pure! [13]

To appreciate this point we must look at the historical events affecting the peoples of North and West Europe between the fifth to the seventh centuries AD [14]. The sweeping Germanic invasion of the erstwhile Roman Empire had left these regions in a politically weak and fragmented condition compared with the Byzantine Empire to the East. But there was no lack of wealth in terms of gold as the invaders gathered increasing amounts of coinage in the form of plunder, tribute and subsidies. In areas outside, or at the limits of, the old Roman frontiers (such as Anglo-Saxon Britain and the Frankish Rhineland) these coins were treated as bullion to be hoarded or, occasionally, to be adapted into ornaments. However, in the southern half of Gaul, where the Visigoths and Burgundians had already settled in federation, the economic advantages of an official coinage, properly controlled in value and weight, were fully appreciated. When the Romans abandoned their mints scattered along the length of Rhone, each Kingdom in turn took to issuing its own currency.

These currencies were 'pseudo-imperial' in that the coins still bore representations of contemporary Byzantine Emperors, such as Anastasius, Justin I and Justinian, but they contrast with their prototypes in their inferior style and lower weight. By AD 534, when the Frankish rulers had achieved their long-term ambition of conquering Burgundy, the face of this region of the continent had a quite different complexion as a powerful *Regnum Francorum*.

For more than half a century the coin output of the primary minting centres of Marseilles, Arles and Uzès remained remarkably steady in quality, maintaining gold purity as high as 97·6% though more 'provincial' mints lagged somewhat behind. Military alignment with Byzantium during the attempted Lombard invasion of Italy had resulted in generous gold subsidies which kept the economy of Frankish Gaul buoyant. But the two decades, AD 620–40, saw radical changes in the monetary affairs of the West [15]. Civil strife and renewed Persian aggression drew Imperial forces to other frontiers and absorbed Byzantine resources. Clothaire II, who in AD 615 had gained sufficient independence to renounce allegiance to the Emperor and had decreed that coinage be struck in his own name, now found himself left very much to his own devices in the matter of currency.

A steady devaluation occurred at all levels of minting standard from the highest at Marseilles to the lowest at centres such as Metz and Paris. By AD 630 gold stocks were virtually static but the political situation had stabilized. Dagobert I then sought to solve his economic problems by introducing a controlled debasement of the coinage in an attempt to expand trade without draining his reserves of gold [15].

His actions proved no more than a stop-gap; a complete change-over to a silver currency took place within the subsequent 50 years. The step-wise decline is thought to have followed a reduction in alloy standard in units of sevenths, where the coins were tariffed at 7 *siliquae*, in keeping with Byzantine weight-controls, and the gold/silver ratios follow the sequence 6:1, 5:2, and so on [16]. The 'Two Emperors'

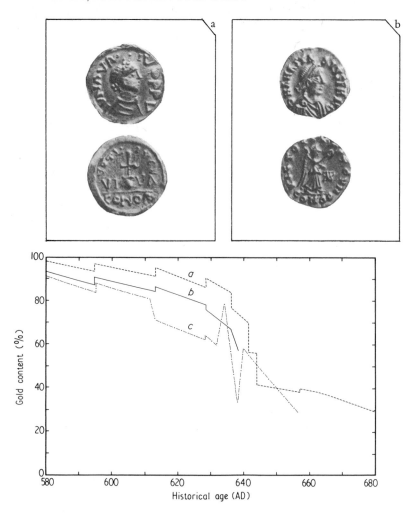

Plate 4/The change in fineness of Frankish gold coinage over the period AD 580–680/
 Inset figure
 a High Provençal standard (including mints at Marseilles, Arles and Uzès).
 b Low Provençal standard (including the Viviers and Vienne mints in
 Burgundy).
 c Standard outside Provence (including Metz and Paris mints).

 Coins (Analysis numbers here match those of references 13, 14).
 a 0.22 *Triens*, Vivier mint. (Au 96%) (obverse and reverse).
 b 0.144 *Triens* in the name of Anastasius attributed to the Burgundian ruler,
 Gondebaud (monogram added in reverse field). (Au ≥ 98·5%)
 (obverse and reverse).

 Figures: courtesy of Dr Kent and the Royal Numismatic Society.
 Photographs: courtesy of the Heberden Coin Room, Ashmolean Museum,
 Oxford.

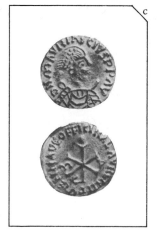
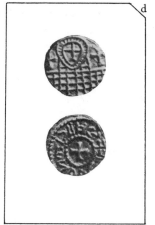
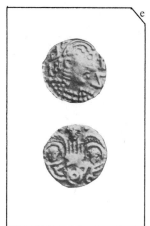

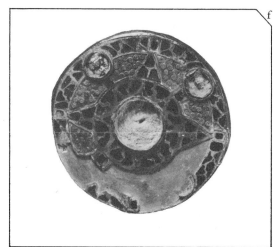
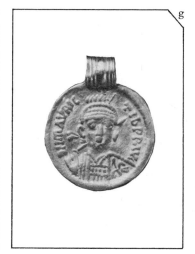

c 0.149 *Triens* in the name of Maurice, mint of Vienne, with the moneyer's name, Laurentius. (Au ⩾ 98·5%) (obverse and reverse).

d 0.10 *Thrymsa*, found at York (obverse and reverse).
 Face: Au 64% ; Ag 34% ; Cu 2%.
 Edge: Au 56% ; Ag 42% ; Cu 2%.
 Interior: Au 46% ; Ag 52% ; Cu 2%.

e 0·11 'Two Emperors' debased *thrymsa* (obverse and reverse).
 Face and edge: Au 33% ; Ag 66% ; Cu 1%.
 Interior: Au 25% ; Ag 70% ; Cu 5%.

f AM20 Jewelled gold disc brooch, in Kentish tradition. (Diameter 6·1 cm) (Ashmolean, 1909.204).
 Edge: Au 45·5% ; Ag 51% ; Cu 3·5%.

g AM29 Coin pendant; a pseudo–imperial solidus of Maurice Tiberius, minted at Marseilles; separate grooved loop. (Diameter 1·9 cm). (Ashmolean, 1942.221).
 Face: Au 97% ; Ag 1% ; Cu 2%.
 Loop: Au 98% ; Ag 1·5% ; Cu 0·5%.

debased *thrymsa* illustrated here (0.11) marks the penultimate stage of decline when the alloying had reached the ratio level of 2:5.

Within this historical framework the gold content of 98·5% in the coin 0.144 is unacceptable. As a *triens* marked in the name of 'Anastasius' it can be attributed to the Burgundian ruler Gondebaud (AD 473–516) (his monogram appears on the coin's reverse). It has a purity 2·5% higher than the best issues of that region (cf coin 0.22, minted at Viviers). A similar argument holds good for the *triens*, 0.149. Its markings, 'Maurice (Tiberius)', mint of Vienne, plus a moneyer's name 'Laurentius', indicate a date AD 590–595 but its exceptionally high purity of better than 98·5% stands more than 2·5% above comparable genuine material of that origin and period.

In contrast, scientific analysis goes a long way to support the authenticity of the controversial *thrymsa*, 0.10, illustrated here. True, its design is unusual. The camp-gate on the reverse recalls late Roman bronze coinage of York (where it was found), and the oval and cross motif above seems to be a fanciful variation on the star with side turrets of such a prototype. But x-ray fluorescence data from the surface regions of the face and edge of the coin differ sharply from that of the interior metal, with gold enrichment quite in keeping with the effects of long-term burial (compare this with the *thrymsa* (0.11) mentioned earlier). We might even cautiously suggest a date *circa* AD 640–650 and link the coin's origins to experiments stimulated by the introduction of gold coinage in England in the London and Canterbury regions [17].

Before leaving this topic I would like to include a brief comment on the use of the debasement curves in analysis of Anglo-Saxon jewellery. We have already noted the early practice of the underdeveloped regions to treat coins less as currency, more as a convenient source of ornaments. Examples of this latter usage can still be found late in the sixth century; the pendant in plate 4 was made from a pseudo-imperial solidus of Maurice Tiberius, minted at Marseilles. But for jewellery made from a melt of various coin stocks we have no knowledge of the standards set.

Despite this doubt a recent survey of English grave finds has provided surprisingly good dating results (at least, for *terminus post diem* estimation) on the basis of comparison with the lowest gold standard operating away from the Lower Rhone minting centres (plate 4, curve *c*) [18]. For example, the composite jewelled brooch, (AM 20), which was found at Faversham in Kent, would date stylistically *circa* AD 630–60. The gold content of 45·5% places the piece in the age bracket AD 639–57.

The only problems in this application are the likely brief time lag between the jewellery's manufacture and its subsequent burial, plus a possible ambiguity around AD 635 when there was a sudden departure from the lower gold standard curve owing to an unexpected windfall of Visigothic *solidi* that Dagobert I acquired some four years earlier.

Coin counterfeiting in the past should not be seen as just a limited activity carried out by anonymous gentlemen working in isolated farms and chateaux. The activity has often reached international proportions, with the motive of economic subversion, setting country against country. Such an incident was reported in a fourteenth-century document when Moorish Granada flooded the Christian state of Aragon with false money [19]. Other instances have much more mundane origins,

such as the Russian government issue of imitation Dutch ducats from 1736 onwards, ostensibly to cover the needs of foreign trade but, in reality, aimed at paying the expenses of the extravagant Imperial household while abroad [20].

Accusations of counterfeiting for political ends crop up again and again and it seems probable that the majority of these complaints were well founded. For example, in 1239 Pope Gregory IX had good grounds to accuse the King of Sicily, Fredrick II of Hofenstaufen, of *denarii* forgery, as his coinage had become little more than a copper disc with a silver coating [21]. Also there is good reason to believe the reports made by Lord Burghley in letters to the Earl of Leicester, that the Dutch were producing vast quantities of imitation, heavily-debased Elizabethan shillings to be passed amongst the English troops in the Netherlands [22]. But the story of the mutilation of Henry I's moneyers is a sad one, as we now know the charges made by the king were falsely laid [23].

Henry must have witnessed with dismay the prevalence of coin forgery during the reign of his brother William II and determined to take a strong line once he was enthroned in AD 1100. Year after year he tried to stamp out false coinage but clearly his threats fell on deaf ears. As the coins moved about in the business community they were ruined by being picked over, bent or even broken as their silver quality was tested. But the year 1124 was a disastrous one. Crops had failed, money was in short supply and a wave of crime swept through England. Meanwhile Henry was using fair means and foul to extort extra revenue to finance his warring in Normandy.

This economic atmosphere would indeed have been ripe for coin debasement and the writings of William of Jumièges seem to provide adequate evidence of its occurrence. He claimed that the English moneyers were adding so much tin that the coinage scarcely bore a third part of silver. Henry no doubt received reports of this nature from various sources but when his soldiers complained that the money they had been sent for wages was quite useless his rage knew no bounds. He sent word to the Bishop of Salisbury to summon all of England's moneyers to Winchester at Christmas time, and duly mutilated them all, cutting off their right hands and their testicles. Rough justice indeed, but the common folk probably approved of Henry's action, seeing these events from a state of near poverty themselves and eager to find scapegoats for the situation.

But were the charges against the moneyers justified? Scientific analysis of the few pennies of this period that have survived till now says they were not. The traditional fineness was set at about 92·5% and this quality would seem to have been adhered to quite well since the period of this control's inception in the middle of the eleventh century, through the Norman Conquest and up to the death of William I in 1087. There were some sub-standard pennies but they are in a minority (plate 5). Coins only about 2% below weight can hardly be regarded as debased as the English mints seemed to have had quite a struggle to attain the correct level and, as often as not, finished up with coins that were silver-rich instead. Then for the period 1087–1125, covering the reign of William II and that of Henry up to the crucial year of the Winchester affair, we find no worsening of coinage quality, certainly nothing like the fall of standards William of Jumièges would have us believe.

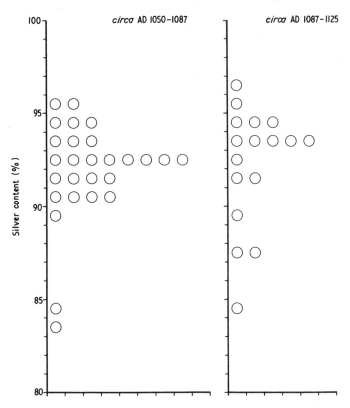

Plate 5 / Histograms of silver contents in English pennies during the reigns of William I and Henry I / Covering the periods AD 1050–1087 and AD 1087–1125.

Coins	Ag%	Cu%	Pb%	Zn%	Au%
a 0.207/William II (1095–98)	93·5–94·0	3·4–3·6	1·1	0·4	0·4
b 0.217/Henry I (1113–1116)	92·5–93·0	4·5–5·0	0·9	0·2	0·5
c 0.219/Henry I (1124–25)	92·0–92·5	4·4–4·6	1·5	0·9	0·5
d 0.246/Henry I (1134–35)	94·0–94·5	3·2–3·5	1·3	<0·2	0·4

Analysis numbers here match those of reference 23.
(No tin detected in any of these analyses, thus Sn \leqslant 0·1%).
Photographs: courtesy of the Heberden Coin Room, Ashmolean Museum, Oxford.

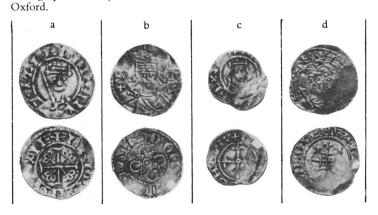

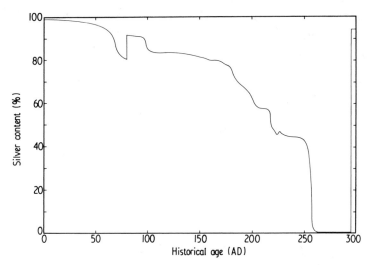

Plate 6/Progressive debasement of Rome's silver coinage from the reign of Augustus to the reign of Diocletian/The decline in silver content, initially slow, accelerated late in the second century and reached bottom midway through the third century. The recovery in AD 294, in a reform instituted by emperor Diocletian, was short-lived and fine silver Roman coins did not appear again until late in the fourth century.

Graphical data generously supplied by Dr G C Haines and Dr G C Boon.

Coins

a Gold *aureus* of Augustus (27 BC–AD 14). (Ashmolean, RIC 267).

b Silver *denarius* of Augustus (27 BC–AD 14). (Ashmolean, RIC 326).

c Silver-dipped official *antoninianus* minted during the reign of Aurelian (AD 270–275). Consistent with this description, x-ray fluorescence analysis detected 30% Ag-content on the coin's surface and only 10% deeper into the coin's body. (Ashmolean, RIC 368).

d A counterfeit *radiate* of the emperor Probus (AD 276–282), probably made shiny by a silver or tin wash and only a fraction of the size of an orthodox coin of that period.

The first *radiate*, the *antoninianus* minted by order of the emperor Caracalla (AD 211–217), his portrait bust appearing of the coin's obverse. The figure on the reverse is Sarapis, a god originally worshipped in Egypt. (National Museum of Wales, number 131.6).

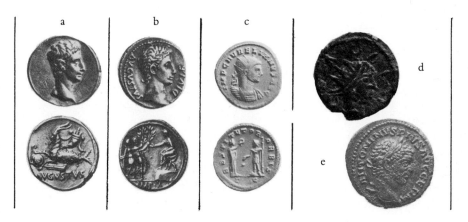

The chronicler was wrong again in his notions of the methods of debasement prevalent in those times. Scarcely a trace of tin is to be found in any of these pennies. If anything the presence of some zinc as well as the expected alloy additive, copper, hints at the inclusion of some melted-down brass. We may even surmise that the English moneyers' plight, in those instances where some lowering of standard is in evidence, was the consequence of the coining practices of their counterparts abroad. Silver was in short supply and the English mints could only maintain output by re-using bullion and old coins, much of which came via the Cinque Ports from foreign merchants.

We have already seen, in the monetary history of the Frankish Empire during the Dark Ages, that economic inflation is by no means a purely modern phenomenon. Before 1200 BC the Hittites used their control over the sources of iron ore in a way which has striking parallels with the economic pressure exerted by the oil-producing Arab states today. The heavy costs incurred by the United States in their recent military presence in Vietnam has a thirteenth-century counterpart in the problems experienced by the Mamluk ruler Qutuz in equipping his expedition against the Mongols. (Qutuz's solution to his financial needs was a sweeping debasement of the silver *dirham* by 10% reduction in precious metal content from a $66\frac{3}{3}$% fineness [24].) But the best-documented history of inflation is amongst the currency issues of the Roman Empire between the first and third century AD (plate 6) [25].

The Romans had already gone through the experience of one radical monetary reform in 15 BC when Augustus tackled the problem of the devaluation of an earlier standard of weight, the *as* (an alloy of copper, tin and lead). The related monetary value of this metal had been slashed, by the impact of the Punic Wars, to almost one thirty-sixth of its status during the early part of the Republican era. The final lightweight *asses* served as little better than loose change. The new coinage of the post-Christian period included the gold *aureus* and the silver *denarius*, (1 *aureus* was equivalent to 25 *denarii*).

The initial decline of the Imperial currency was quite slow; Nero (AD 54–68), debased the *denarius* with only about 7% added copper. Even a century later, at the death of the powerful Marcus Aurelius in AD 180, the silver fineness still stood close to 77%. Then civil strife threatened to tear the central authority apart. But for a strong military grip exerted by Septimus Severus up to AD 211, the subsequent escalation of the *denarius* dilemma might have happened far sooner.

Caracalla (AD 211–17) sought to re-establish the earlier post-Republican gold–silver relationship by the introduction of the *antoninianus* which was half as large again as the current *denarius*. The new coin is now better known as the *radiate*, a name derived from the ray-decorated crown worn by the Emperor in his portrait profile on its obverse. But the tide of events was running against Caracalla and his successors. Decius was killed by the Goths in AD 251; Gaul and much of the rest of western Europe, under the leadership of self-styled emperor Posthumus (an erstwhile Imperial general), declared itself independent of Rome's control. Roman military determination to regain its lands across the Rhine, while holding the Persians at bay to the East, was accompanied by a cataclysmic decline in the value of the relatively new

radiates to a point where this coinage in AD 270, under Claudius II, contained a mere 1% of silver.† An attempt was still made to give this essentially bronze money an aura of greater value by the addition of a silver-dipped coating [26].

Finds at Roman sites give us some insight into the procession of monetary changes the Empire suffered over the centuries [27]. The most commonly lost coin (as opposed to those hoarded) in Augustan times was the copper-based *as,* by the end of the first century it was the bronze *sestertius* (equivalent to 4 *asses*) and a century later still it was the 'silver' *denarius*. But other present-day excavations provide us with a more complex picture, with genuine, albeit low standard, coins often outnumbered by counterfeits.

In view of the inflationary trends of the time the main period of *radiate* forgery is understandably in the decades around AD 260. Britain and the other fringe regions of the Empire, such as the settlements on the Rhine, were most affected, particularly during the temporary Gallic breakaway.

The fakes were usually cast in stacks of individual mould cavities each bearing the impression of genuine coins. This was the case of counterfeiters' hoards unearthed at the fortress of Ristissen in Germany and at Whitchurch in Somerset (colour plate 12). Bronze would generally be the preferred core metal with each piece finished off with a silver or tin plating, but, when the Imperial treasury did much the same at their mints, new tricks had to be thought up. Simple tin coins shone brightly enough shortly after manufacture to pass for a thoroughly-debased *denarius* while the *radiate* suffered the unfortunate fate of being physically shrunk, often to no more than a quarter of its orthodox size. With the lower denominations, the bronze *sestertius* and *as*, either a similar shrinkage tactic was adopted or the plating approach was given a new twist, an iron core now being coated by dipping in molten bronze.

These old forgeries make no great demands on the scientific analysis; a great deal of authenticity information can be obtained by the familiar technique of specific gravity measurement [11]. Errors in weight, size and major metal composition can be readily detected, while precious metal simulation by artificial surface coating can be regarded as tailor-made material for x-ray fluorescence analysis. But several groups of more recent counterfeits require a more sophisticated approach.

This category of coinage includes the output of Giovanni dal Cavino (1500–1570), who, like so many of his Renaissance contemporaries, took a great deal of pride in good simulation of antique prototypes [28]. He and his associates (notably Alexandra Bassiano) made up a group, now known as the 'Paduans', which specialized in copying the rarer Roman *sestertii* like those illustrated in plate 7. R H Lawrence in his book 'The Paduans' of 1883, considered it unjust that these items were treated as forgeries in view of the prevailing atmosphere in the art world at their time of manufacture. However, several other coins with no known prototype (seemingly intended to fill 'gaps' in the Imperial issue) are not so easily defended.

† One of the most drastic steps taken during this period occurred *circa* AD 250 when old *denarii* were overstruck at the mint to become *radiates*, a procedure equivalent to a 30% devaluation.

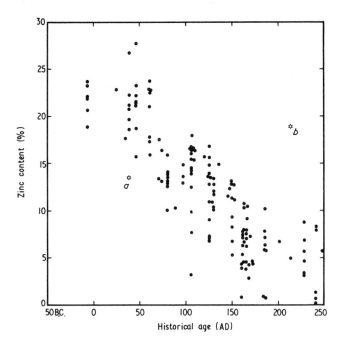

Plate 7/Variation of zinc content with time for Roman Imperial bronze *sestertii* and *dupondii* coins manufactured from orichalcum/Data points for dal Cavino counterfeits are represented by stars.
Dal Cavino coins.
a Sestertius of Caligula (Lawrence number 9). Zn 13·5%.
b Medallion of Caracalla (Lawrence number 70). Zn 18·9%.
Photographs: courtesy of the Koninklijk Penningkabinet, The Hague.

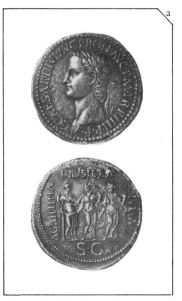

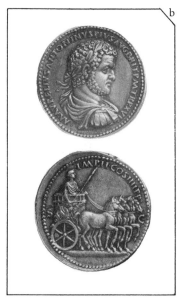

Many of dal Cavino's original dies are preserved in the Bibliothèque National in Paris but even without this reference material most of his products could be identified by virtue of their anomalous zinc contents [29]. The Romans are thought to have learnt how to make the copper-zinc alloy, orichalcum *circa* 45 BC and imposed a state monopoly on its usage of *sestertii* manufacture during the very late stages of the Republican era. For a little over half a century standardization of procedure in the alloy's production excluded use of secondary metal or scrap, so the zinc concentration remains fairly steady at about 22%. But during the reign of Nero (AD 54–68) these restrictions seem to have been relaxed with mints using increasing numbers of re-melted old coins. Each fresh alloy firing and subsequent annealing would have caused a partial loss of zinc through volatilization so the element's concentration in later coinage gradually fell away. Some coins of exceptionally low zinc content in the post-Hadrian period (*circa* AD 150) can be attributed to addition of old bronze to some metal stocks. Clearly the dal Cavino 'Caracalla' medallion has no place in this sequence of events. Its zinc content of 18·9% is far too high to fit in with minting practices of the early second century AD.

The gold *aureus* always stood at the apex of the Roman monetary system and its frequent reforms. Its high intrinsic value meant it was rarely seen in currency circulation, but served more as bullion. During the last decades of the Republican era and the first two centuries that followed this coin's standard was maintained at an exceptionally high level without debasement (the silver content never rose above 2%). Even the *solidus* which replaced it during the early part of the fourth century (at the instigation of Constantine the Great) was somewhat poorer in fineness, containing up to 5% alloying silver in several instances.

Study of the fineness of *aurei* has been attempted using thermal neutron activation analysis but there are conflicting views as to its practicality. The extremely intense [198]Au activity of the coin matrix tends to dominate the gamma spectrum. Earlier research papers are pessimistic [30] but recent analyses of Frankish coins from the Sutton Hoo royal burial appear satisfactory [31]. However, charged-particle irradiation, using 30 MeV protons or 26 MeV deuterons, offers a valuable alternative [32] (figure 4).

Copper activity dominates spectrum analysis carried out within a matter of minutes of a brief radiation exposure (the copper concentration detection limit is as low as 0·005%). For silver determination a longer irradiation of about an hour may be necessary together with a week's delay before gamma-spectrum analysis, but at that stage a detection limit as low as 0·05% has been reported. The cross-section for gold activation at these bombardment energies is only about one sixth of that for silver so interference problems are appreciably reduced. This technique has set quite tight limits of 0·01% to 0·26% for the copper content in *aurei* (plate 8).

The sensitivity of these analyses has made it practical to detect several counterfeits, a number of which have been attributed to a particularly well-known forger, Carl Wilhelm Becker [33]. Becker (1772–1830) developed a fascination for numismatics early in life, deriving far more pleasure from drawing coins than working in his father's wine business or in the drapery trade he subsequently built up for himself in Mannheim. So it is not so surprising that he gravitated to the Munich

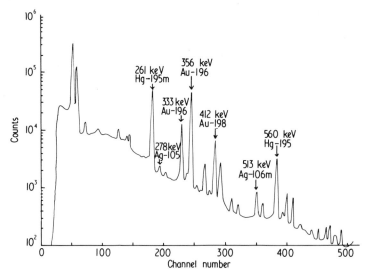

Figure 4/The gamma spectrum obtained from a gold coin after activation with 30 MeV proton
 irradiation/Measurement in this case was delayed several days. After Meyers P
 1969 *Archaeometry* **11** 67.

Royal Mint shortly after the collapse of his commercial interest in 1803. Thereafter he
he became known as 'Antique Becker', trading in fine genuine gold coins with most of
the leading dealers and collectors in Europe.

 It is uncertain when he began passing off his own products as genuine.
We know he paid off a debt to the firm of Meyer Amschel Rothschild & Son with a
spurious coin in 1811. Probably the most stimulating period for him was his sojourn
in 1814 with Prince Carl von Isenburg for whom he worked as a librarian. The Prince's
fine collection of Visigothic coins from the French campaigns in Spain provided
excellent source material for Becker's activities.

 But, quite suddenly Becker's luck ran out, when, in 1819, he tried to
pass off some of his products on C H Haeberlin. Till then, this young law student and
avid coin collector had been Becker's friend but, once cheated, he decided to build up a
case against the forger and put a stop to his activities. Three more years of personal
disaster, including divorce and an unsuccessful re-marriage, reduced Becker to a state
of almost total despair. He offered his dies for sale to the Austrian Emperor and even
went so far as to co-operate in attempts at cataloguing his own forgeries.

 The impact of these forgeries in numismatic circles has only been
partially reduced by such documentation. Becker was a craftsman of great skill, strik-
ing his dies with a sledge hammer to produce the 'double contour' effect often seen on
ancient coins. Even his 'ageing' processes were novel. He developed a method of pack-
ing his coins into a box of iron filings mounted on the axle of his carriage and 'taking
his old men for a drive', as he put it. Fears are still often expressed that his patterns,
which we now know from lead impressions of his dies, refer only to final specimens
and not to any coins struck in between each stage of die correction.

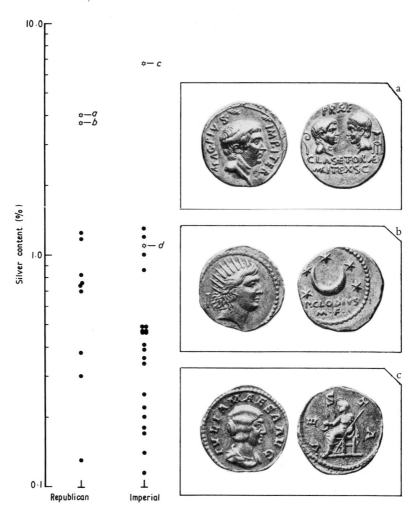

Plate 8/Variation of silver content in gold Roman *aurei* both in Republican and subsequent Imperial times. Data points for C W Becker counterfeits are represented by stars.
Becker coins
a Republican *aureus*. Ag 4·0% ; Cu 1·52%.
b Republican *aureus*. Ag 3·7% ; Cu 0·53%.
c Imperial *aureus* of Julia Maesa. Ag 6·7% ; Cu 0·22%.
d Imperial *aureus* of Julia Maesa (sister-in-law of Septimus Severus). Ag 1·1% ; Cu 0·66% (not illustrated).
Photographs: courtesy of the Koninklijk Penningkabinet, The Hague.

Coin forgery amongst modern currencies has largely died out now that paper money is so much more widely used. But the last few decades have produced some notably unusual case histories. Perhaps the trend was set by José Beraha, a Yugoslav merchant who took advantage of a rising market for gold coins which

developed shortly after the conclusion of World War II, to mint English sovereigns [34]. His counterfeits were unusual in at least two respects: their date of 1926, a year when none was produced officially in London, and a gold content well above any comparable official issues. Even the end of the matter was bizarre as Beraha successfully defended his actions in a Swiss court on the basis that the sovereign was no longer legal tender.

Now we can add to this a remarkable technical example: the skilful production of an English penny bearing the date 1933 (plate 9) [35]. Such a coin would be an important collector's item as only five other examples are thought to be extant and three of those lie firmly buried under the foundations of buildings; the Royal Mint and the British Museum hold the remaining two.

Plate 9/A spurious 1933 English penny, shown in detail in scanning electron micrographs
 a Original '3' digit (magnification × 70).
 b Spurious, added '3' digit (magnification × 70).
 c Close-up of b (magnification × 350) which shows up the exuding solder medium used to attach the digit to the coin base.
 Photographs: courtesy of Dr A Y Nehru and Mr L Green of the Wolfson Institute of Interfacial Technology, and Dr J R Moon of the Department of Metallurgy and Materials Science, Nottingham University.

But scanning electron microscope close-ups of each '3' digit on the new find show that the second one is a spurious addition. It is probable that the forger (perhaps a watchmaker) meticulously filed away the body of another coin while holding the digit he required tightly fixed. Then he soft-soldered this digit onto a mutilated region of a coin of the same decade, but, most surely, of a much less significant year. Perhaps this is one instance where patience can not be considered a virtue.

Our discussion of coin forgeries has led us from the precious metals to bronze, a humbler material perhaps, but one with a long and significant history. The invention of bronze, an alloy of copper and tin, is traditionally placed in the Near East early in the third millennium BC, on the evidence of simple tools and agricultural implements excavated at Ur. It is true that alloys of copper and arsenic were produced more than a thousand years earlier but it seems safe to assume that this was an accidental process depending on the natural presence of arsenic impurity in copper ore seams; it would simply have been known that certain ore sources produced the best results. In contrast the addition of tin must have been deliberate; few tin ore sources lie at all close to copper ones.

Whatever inspired ancient man to mix the two metals together remains one of the principal gaps in our understanding of early metallurgy. However, we can certainly appreciate why the alloy eventually gained worldwide popularity, not only in weaponry and chariot fittings but also for 'personal' items such as ritual vessels and deified statuary (colour plates 14 and 15). Copper on its own tends to shrink heavily on cooling and not pick up the finer detail of any pre-formed model or mould, but tin addition largely overcomes this problem. Additionally, while copper-working calls for a technical ability to produce temperatures approaching that metal's melting point of 1083°C, a copper/tin ratio of 9/1 allows alloy formation at 995°C.

The emergence of true tin bronzes was rather sporadic and partially masked by the fact that the tin's replacement of arsenic as the main impurity was only a gradual process [36]. But, by the end of the third millennium BC, the technology had spread through Syria and Anatolia (as evidenced by the cast animals and vessels at Alaca Huyuk and Mahmatlar) into the Cyclades and along the length of the Persian Gulf to South-East Iran. The 'transmission' lines were probably the firmly-established turquoise, lapis lazuli, bitumen and obsidian trade-routes that covered this area.

In the Mediterranean regions and throughout South-East Asia the principal method of working bronze in ancient times was the *cire perdue* technique of casting molten metal and cold-working from a cast ingot. This involves the construction of a wax model (often over a simple clay core) which is carved to produce the required sculptural detail [37]. Then a series of thin coatings of fine clay is smeared over the surface so that all the nooks and crannies of the decoration are filled. A final coating of coarse clay completes an outer mould of appreciable structural strength. This mould is pierced with strategically-placed vent-holes and some ducts extending across the entire unit so that the metal can flow easily and swiftly into all parts of the casting cavity once the wax has been melted out. Fine examples of *cire perdue* casting include the controversial bronze Horse of the Metropolitan Museum in New York, recently re-instated as authentic with much publicity [38] and the Roman 'Medusa di Nemi' (first century AD) of plate 10.

Plate 10/Medusa di Nemi/Roman bronze (first century AD).
Data at analysis points: a Cu 81·3% ; Sn 16·8% ; Pb 1·9%.
b Cu 76·7% ; Sn 19·5% ; Pb 3·8%.
c Cu 85·3% ; Sn 12·7% ; Pb 2·0%.
d Cu 81·7% ; Sn 15·8% ; Pb 2·5%.
In all cases zinc was not detected (ie Zn ≤ 0·5%).
Photograph: courtesy of Dr R Cesareo, Faculty of Engineering, Rome
University.

The Iranian beaker of plate 11 is an example of cold-working of
bronze [39]. Though the alloy is reasonably malleable, it hardens when hammered and
tends to become brittle if the tin content is high. But occasional red–heat annealing,
which rearranges the metal's crystal structure and re-softens it, allows a bronze ingot to
be gradually reduced to suitable sheet form. As a consequence of these hammering and
annealing treatments the metallographic structure of cold-worked bronze is distinctive.
Polyhedral grains are formed in which the crystal lattice structures of adjacent regions
within a grain develop as mirror images of one another. Designs tooled into the surface
of the metal sheet cause localized grain distortion (plate 12).

It was not until the fourteenth century AD that European technology
began to swing away from *cire perdue* to the *piece-moulding* method of casting (we will
return to the detailed technology of piece-moulding in our discussion of Chinese
bronzes) but the move was extremely slow. Da Vinci, ever the experimenter, recorded
his plans for such an approach to the Sforza equestrian monument in Milan, although
this example is still regarded as unique amongst large Renaissance sculptures [40].
However, piece-moulding became the rule when the monument of Louis XIV was
completed by Keller and Bouchardon.

The details of historical development, fabrication and metal structure
dictate the various methods of scientific analysis that can be used in bronze authentica-

tion. For example, many South-East Asian, Nepalese and Indian bronzes contain a characteristic friable black core, rich in charcoal fragments and quartz, and this is suitable for dating using *thermoluminescence*. Some of these cores, like the one inside the Buddha Figure of colour plate 15 (Gandharan period in India, *circa* fifth century AD), are virtually intact as the original complete metal sealing has only been broached recently by the effects of corrosion or damage. Others, in hollow castings, were either scraped out or have been severely eroded with the passage of time, but even these pieces usually carry sufficient remnants, in the hollow of a head or the crevasses of a lotus-decoration, to permit thermoluminescence analysis.

There are now many inferior bronzes appearing in the Western art market—fakes trafficked within the framework of an illicit export market in genuine, but looted, wares from Thailand and Cambodia. (Sad to say, this activity has been appreciably increased by the recent American military presence in Indochina.) The Deity Figure of plate 13 is a typical forgery and certainly not the product of the Khmer period (from the tenth to the twelfth century AD) that it purports to be.

For non-cored castings we must seek evidence of natural ageing processes or call upon our knowledge of ancient metallurgy to point up anachronisms in the forger's manufacturing methods.

Patination falls into the former category, representing the gradual formation of corrosion products as the metal is attacked by active agents such as sulphur in the atmosphere or water in burial media. Bronze corrosion begins with copper migrating to crystal surfaces where it is oxidized to form amorphous red cuprite $\{Cu_2O\}$. The crystalline mineral, malachite $\{Cu\,CO_3.Cu\,(OH)_2\}$, will then encrust the bronze surface as percolating ground waters or condensed dew react with the cuprite products. The presence of sulphur will produce a purple tarnish due to formation of bornite $\{Cu_3FeS_3\}$ while chlorination creates either a bright green coating of atacamite $\{CuCl_2.3Cu(OH)_2\}$ or a greyish layer of nantokite $\{CuCl\}$.

Corrosion in cast pieces shows up particularly well in a cross-section of the metal (plate 12c) [41]. Here the tree-like structures (called, reasonably enough, *dendrites*), now eaten away, were originally tin-depleted cores of the first crystals to solidify as the metal cooled. The remaining sound metal, a quite distinct phase known as the *eutectoid*, is tin-rich and consequently resists corrosion much more effectively.

Attempts to simulate patination show varying degrees of ingenuity. 'Pickling', designed to accelerate the rate of the corrosion process, was thought by many old authorities to be a highly prevalent activity amongst forgers, but certain anomalies in their technical descriptions suggest that their knowledge was no better than second hand. However, many of the recipes reported, such as burial in dung and fermenting juices or heating of vinegar-sprinkled metal, would have the desired surface effect. Usually the only hope of detecting such treatment is by the lack of gradation in corrosion penetration that they often produce.

Less ambitious patina imitation may involve no more than the application of a spurious surface coating. Sometimes crushed malachite is used (colour plate 13) [42] and this at least is one of the natural corrosion products, but it is just as common for one to find only ground-up artificial pigments such as emerald green $\{Cu(C_2H_3O_2)_2.3Cu(AsO_2)_2\}$ and even Prussian blue $\{Fe_4[Fe(CN)_6]_3\}$. Simple micro-

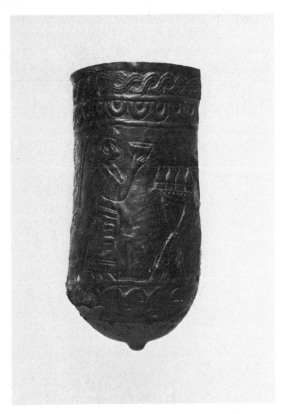

Plate 11/Iranian bronze beaker/Photograph: courtesy of the Metropolitan Museum of Art, New York; accession number 54.5.

chemical spot tests for arsenic and iron would promptly distinguish these recent materials from natural copper carbonates.

 In application corrosion studies have rarely proved more valuable than in the authentication of the Iranian beaker of plate 11, as this piece faced severe criticism on stylistic grounds [39]. No less than fifteen points of weakness and error in drawing have been suggested, including the absence of ears or feet on the figures and the lack of the usual vertical support for the table (the one depicted here seems to be about to fall over). Yet the kind of intergranular corrosion (selective cuprite build-up along the metal's grain boundaries) in evidence in a polished section of the vessel's metal (plate 12a) may be regarded as a natural phenomenon no faker could possibly simulate. Additionally, an uninterrupted corrosion band following close to the contour of the traced line of the design itself contradicts any notion that the vessel's scene is a late addition on old metal (plate 12b).

 In matters of *composition analysis* zinc emerges once again as the most important bronze additive for authenticity judgement. In the Mediterranean region the Roman development of orichalcum as a medium for *sestertius* coinage can be regarded as the first deliberate alloying of copper and zinc to produce *brass*. But the State mono-

Plate 12/*a* Photomicrograph of a cross-section of the Iranian beaker illustrated in plate 11 showing extensive intergranular corrosion (sample taken from the border of a large hole near the base of the vessel). (Magnification × 75 bright field of illumination, not etched).

b Photomicrograph of a cross-section of the Iranian beaker illustrated in plate 11, showing how the corrosion follows the contour of a trace line in the design (sample taken from the border of a large hole near the base of the vessel). (Magnification × 75, bright field, not etched).
Photographs: courtesy of Dr P Meyers, Metropolitan Museum of Art, New York.

c Photomicrograph of a cross-section from a bronze Ibex figure, showing the preferential attack of corroding media on the dendritic cast metal structure. (Corrosion products were identified as nantokite, cuprite and malachite). (Magnification × 25, not etched).
Photograph: courtesy of Dr A E Werner, The British Museum, London.

poly that set the standards of metal available to mints seems, at the same time, to have prevented the use of orichalcum for other items, at least until the middle of the first century AD. Even then significant zinc levels are only to be found amongst smaller items, such as fibulae and domestic utensils, quite possibly fabricated from old coinage which was melted down.

Plate 13/Bronze figure of a Deity/Height 0·72 m, in the style of the Khmer period in Cambodia, tenth–twelfth century AD.
Thermoluminescence data (casting core)
Archaeological dose ⩽ 34 rad
R_i, 0·32 rad/year
R_e, 0·11 rad/year
Age ⩽ 80 years.

So it is reasonable to be suspicious of any early Roman bronze statuary and similar large-scale objects if there is evidence of appreciable quantities of zinc. There is one recognized exception to this, a statue's dedication plate which contains 10·6% zinc, but the inscription it bears, 'To the invincible God an orichalcum figure of Sol', explains this anomaly [43]. Apart from this piece, no documented analysis has yet turned up a zinc level of more than 2·2%, and that in the somewhat later Vittoria di Brescia of the second century AD. This low concentration is a typical upper limit for the amount of natural zinc impurity which would survive normal copper smelting, even if far greater concentrations occurred in the original copper ore seams.

Much the same rules hold amongst Classical and Hellenistic bronzes and coins, but further east still the use of zinc in prehistoric times seems to be much more complicated. Isolated instances of brass crop up at a number of sites, including Gezer in Palestine in a level dated to the Semitic III period (*circa* 1400 BC) [44] while several small items from Gordion and Altintepe, in Anatolia, provide evidence of the alloy's more general usage as early as the seventh century BC. One ancient source even

documents the discovery of brass by the Mossynoeci who lived in the zinc-rich region of Turkey south of Trebizond early in the first millennium BC. Despite this, extensive analyses of Achaemenian metal wares and of grave goods from the Luristan area of the Zagros Mountains in Western Iran provide only a couple of examples of the presence of zinc above a level of 2·0%, and those items are now regarded as dubious [45].

A somewhat clearer picture emerges in South-East Asia, with a steady growth in the use of zinc from the fifteenth century onwards, except in the Gujarat and Kashmir regions where the principal ancient settlements were strung out along the length of the Indus river (figure 5) [46]. In those regions, even by the time the Gupta Dynasty's control of North-West India had faded away, at the beginning of the seventh century AD brass technology must have been well established; zinc levels in copper alloys are as high as 16%. It is a pity that we lack any comparable data from the preceding Gupta period (*circa* AD 320–600) when the first bronzes that can be regarded as wholly Indian in style make their appearance.

Compared with zinc other alloy constituents and additives play a secondary role, except in many cases to underline the transition from bronze to brass. This is well illustrated by the South-East Asian material of figure 5 where the upward trend in zinc content is fully matched by a downward one in tin and lead. These same two elements can be used to check the authenticity of any Roman casting with a high zinc content (it might, just by chance, have been a by-product of the orichalcum industry). It is not until after the end of the first century AD that this alloy became sufficiently adulterated by bronze scrap additives to an extent where (tin + lead) content altogether exceeded 2% in concentration. In constrast, later copies, particularly Renaissance attempts at antique simulation, carry at least 6% (tin + lead), sometimes as much as 15%.

Lead on its own has been considered as a means of distinguishing Roman copies from their Greek prototypes, as the latter seem to carry no more than trace levels of this element until after the third century BC (roughly the watershed between Classical and Hellenistic art). The Roman bronze industry, running parallel to that of coin-brass, made extensive use of lead at concentrations of 2% and above (plate 10) [47]. However, research in this subject is not without its difficulties. The passage of time has made stylistic attribution of some bronzes from both the cultures extremely hazardous and it is even possible that some of the reference material could be misplaced in time.

Chinese bronzes stand out in quite striking contrast to their counterparts in the West for a variety of reasons, one of the most obvious being the way in which use of the piece-moulding casting technique *pre*-dates the introduction of *cire perdue*. Little can be said about the origins of the Bronze Age in China to account for this difference; there is no evidence of a preceding Copper Age and where signs of similarity with other cultures are recognizable (notably in the style of socket axes found in western Siberia) all the indications, at present, are that the Chinese craftsmen were the innovators. Also, by Western standards, the emergence of bronze in China, sometime around the eighteenth century BC, is remarkably late. Yet within a few centuries there had grown up a lively and highly creative metal industry which was to remain supreme in the Far East for more than a millennium (colour plate 14).

Figure 5/Summary of chronological variation of copper alloy elements in India and South-East Asian bronzes

Origin	Age range (century AD)	Element concentrations (%)		
		Sn	Pb	Zn
a West and North-	7–12	0·4	4·0	14·8
West India	18–19	1·5	2·6	21·3
b South India	10–15	12·9	5·2	0·3
	15–17	3·4	4·9	15·8
	17–20	2·1	4·2	8·8
c North India	8–15	6·8	2·0	3·4
	15–17	2·2	2·0	11·6
	17–20	0·3	1·6	21·8
d Burma	12–15	9·6	6·8	0·1
	15–17	4·1	8·7	1·8
	17–20	0·4	1·2	30·2
e Java	9–15	11·7	6·9	0·4
	15–17	8·5	2·8	10·0
	17–20	3·6	3·2	35·6
f Thailand/Cambodia	9–15	8·9	7·0	1·1
	15–17	5·8	5·8	5·8
	17–20	2·1	2·9	20·8

Concentrations quoted are mean values. The number of Burmese bronzes analysed is very small: 5, 3 and 2 in each age bracket.
(After Werner O 1972 *Spektralanalytische und Metallurgische Untersuchungen und Indischen Bronzen* (Leiden: Brill) p 140.

The principles of piece-mould casting involve covering a clay model with thin slabs of clay each trimmed and rubbed with a releasing agent to keep it free from its neighbour. Once sun-baked to near dryness each mould unit can be dismantled and decorated on the inner concave surface with incised patterns, punched motifs and even some repetitive features made with prefabricated ceramic stamps. There are now a great number of excavated mould fragments that attest this means of design and casting (plate 14) [48].

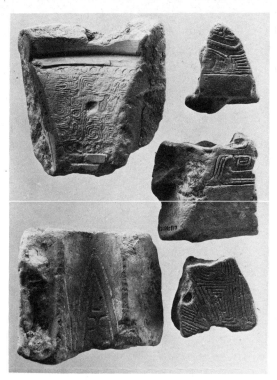

Plate 14/Fragments of Late Shang Dynasty clay mould sections/*Circa* fourteenth–eleventh century BC from Anyang, Honan province in China. Photograph: courtesy of the Museum of Far Eastern Antiquities, Stockholm.

The original model was probably scraped down to act as a central core of slightly smaller dimensions than the mould cavity. Space for the metal was made by inserting small rectangular chaplets between the core and the re-assembled outer mould unit. The metal was finally poured into the mould cavity, probably with the mould unit itself kept hot to drive off volatile matter and prevent premature hardening of the bronze. Construction features, such as mould-join seams, casting flaws (and their repairs) and chaplets show up clearly enough in an x-radiograph (plate 15) [49].

The earliest example of *cire perdue* casting in China (and the only one prior to the fifth century BC that has so far been recognized) is thought to be the caps mounted on the rim of a Late Shang Dynasty *chia* vessel of the twelfth century BC. In that case x-radiography revealed pin-chaplets which would have served to hold the model clear of the outer mould while the wax was drained out.

But the bizarre events of the past millennium in China make a unique contribution to the history of fake manufacture. It was during the Sung Dynasty (eleventh and twelfth centuries AD) that a vogue for collecting early Chinese bronzes first got under way. Chance discovery of genuine ancient material became progressively rarer and the gentry, ever anxious to ingratiate themselves with the Emperor,

Plate 15/X-radiograph of a Chinese bronze food vessel (*kuei*) of the Chou Dynasty. Three chaplets are clearly visible in the vessel's bottom: one is crossed on the front by strokes of an inscription character and on the back by raised criss-cross lines. Photograph: courtesy of the Freer Gallery of Art, Washington DC; catalogue number 11.38.

sent their underlings out into the country with instructions to loot any tombs they could find. The story of magistrate Wu Chüeh indicates the mood of the times [50]. In the province he administered for Emperor Hsüan-ho (AD 1119–25) he often set aside sentences passed by the courts in return for 'gifts' of archaic vessels. By the time he retired the wily old gentleman had accrued more than fifty bronzes.

We have no way of knowing whether criminals due to come before his court recognized his predilection and catered for it by commissioning fakes in advance. Certainly there was no lack of such fraudulent activity at that time. Catalogues (fully illustrated with block-engravings) provided a convenient source of information for the Sung artisans. Even these catalogues began to contain an increasing number of fakes, as fresh editions were issued to keep pace with the growth of collections.

Though the subsequent six centuries or so were marked by only passing scholarly interest in archaic bronzes the forgers continued to ply their wares with success. Several sixteenth-century writers of the Ming period offered descriptions of elaborate artificial ageing processes and one, Kao Lien (AD 1591) reported the use of reproduction casting moulds, a notion that seems to have been overlooked by earlier operators. It was he who also commented on the barbarous custom of fusing together fragments of old damaged vessels ('helterskelter', as he put it) and the careful obliteration of join lines with patches of local *loess* clay. Incredible as it may seem, Kao Lien states that other forgers attempted to give their work an 'archaic aura' by adding such remnants to the melting pot!

The *p'ou* vessel of plate 16 illustrates the extremes to which modern forgery has been taken [51]. Now in the study collection of the Art Museum of Princeton University, its 'pedigree' reaches back to about 1920 when it was bought in Hong Kong in a seemingly pristine condition. The vessel's great reputation took a sudden knock when, a few years ago, a fracture at the base exposed a layer of recently-worked copper, covered with traces of sealing wax and daubs of soft solder.

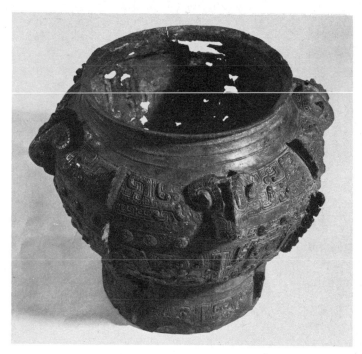

Plate 16/Early Chou Dynasty *p'ou*. Photograph: courtesy of the Art Museum, Princeton University; accession number 68.110.

Deeper exploration revealed that almost the entire vessel was a spurious superstructure fabricated around a flimsy, but genuine, skeletal ruin. A molten compound of earth pigments, sand and a vehicle of shellac had been applied in thin films until the new body was some 4 millimetres thick. Once the surface had cooled and hardened it was carved and incised to re-assert the underlying designs. Finally, to tone down the freshness of the piece, a sand and shellac mixture was applied to simulate encrustations while some coloured stippling provided a patina.

The more conventional technical treatments of Chinese bronzes follow much the same paths as those described in the last section. Thermoluminescence dating is again applicable to casting cores, but these are now derived from the quartz-rich loess beds through which the Yellow River flows from its source in the Tibetan Highlands to the coast. (The major early kiln sites of Cheng-chou and Anyang are clustered about the river's path through the province of Honan.) Many Sung, and later,

fakes are distinctive in that their cores are extremely similar in texture to the South-East Asian black friable type already described. (The Sung founders used the *cire perdue* casting method exclusively so there may be some obvious practical reason for the core-type change of which I am unaware.) The loess cores are usually readily accessible inside handles, like those of the ritual *kuei* vessel illustrated in colour plate 14, and in knobs and legs now opened up by corrosion.

Corrosion products and consequent patination are important here too as the loess used for casting is also the most common burial medium for these bronzes. It is rich in carbonate of lime and highly porous, so metal attack is swift, sometimes completely destructive. But it is essential to realize that Sung fakes will have ample time to build up a good patina in such an environment without help from outside human agencies.

The presence of zinc impurity above the 1% concentration level seems to be a particularly reliable authenticity criterion amongst Chinese bronzes; our present evidence is that brass technology only developed in that region sometime between the eleventh and fifteenth century AD [52]. But any such analysis should be backed up by x-radiography as vessels composed of ancient metal, such as a Kao Lien 'helterskelter' example, would pass chemical tests without trouble.

The last word on this material should go to the conservator, Stephen Guglielmi, who undertook the task of 'unravelling' the Princeton *p'ou*: 'Perhaps it will be necessary to reverse the basic premise applied in human courts of law. An art object will first have to be proved genuine, rather than be accepted on dangerous optimistic assumptions.'

[1] Reith A 1970 *Archaeological Fakes* (London: Barrie and Jenkins) p 117
 or Jeppson L 1970 *Fabulous Frauds* (London: Arlington Books) p 23
[2] Destrée J 1927 *The Connoisseur* **79** 138
 Evans J 1941 *Burlington Mag.* **78** 196
[3] See for example Stolow N, Hanlan J F and Boyer R 1969 *Studies in Conservation* **14** 139
 Cesareo R, Frazzoli F V, Mancini C, Sciuti S, Marabelli M, Mora P, Rotandi P and Urbani G 1972 *Archaeometry* **14** 65
[4] Gordus A A 1973 *Application of Science in Examination of Works of Art* (Boston: Museum of Fine Arts) vol II p 9
[5] Meyers P 1972 *Royal Numismatic Society, Special Publication* **8** 183
 Meyers P, van Zelst L and Sayre E V 1972 *Proc. Conf. Modern Trends in Activation Analysis* (Saclay, France)
 Caley E R and McBride H D 1956 *The Ohio Journal of Science* **56** 285
[6] The figure is derived from Keisch B 1972 *The Atomic Fingerprint: Neutron Activation Analysis* (USAEC, World of the Atom Series) p 37
[7] Kraay C M and Emeleus V M 1962 *The Composition of Greek Silver Coins: Analysis by Neutron Activation* (Oxford: Ashmolean Museum)
 Svoronos J N 1922 *Synopsis de Mille Coins Faux du Faussaire, C Christodoulos* (Athens)
 Robinson E S G 1956 *Numismatic Chronicle* **16** 15
 and Fischer T 1968 *Numismatic Chronicle* **8** 267
[8] Hanson V F 1973 *Application of Science in Examination of Works of Art* (Boston: Museum of Fine Arts) vol II p 9
[9] Schweizer F 1972 *Royal Numismatic Society, Special Publication* **8** 153
[10] Hall E T, Schweizer F and Toller P A 1973 *Archaeometry* **15** 53

McKerrell H and Stevenson R B K 1972 *Royal Numismatic Society, Special Publication* **8** 195

[11] Oddy W A and Schweizer F 1972 *Royal Numismatic Society, Special Publication* **8** 171

and Schweizer F and Friedman A M 1972 *Archaeometry* **14** 103

[12] Cope L H 1967 *Metallurgia* **75** 15

Deana Salmeron A 1961 *Monedas* **3** 299

[13] Merrick J M and Metcalf D M 1969 *Archaeometry* **11** 61

[14] Hawkes S C, Merrick J M and Metcalf D M 1966 *Archaeometry* **9** 98

Metcalf D M, Merrick J M and Hamblin L K 1968 *Minerva Numismatic Handbook* **3** 14

[15] Kent J P C 1972 *Royal Numismatic Society, Special Publication* **8** 69

Metcalf D M and Schweizer F 1970 *Archaeometry* **12** 173

[16] Metcalf D M, Merrick J M 1967 *Numismatic Chronicle* **7** 167

Kent J P C 1967 *Cunobelin* **8** 24

[17] Grierson P 1962 *British Numismatic Journal* **31** 8

Rigold S E 1965 *British Numismatic Journal* **34**

[18] Brown P D C and Schweizer F 1973 *Archaeometry* **15** 175

[19] Lluis y Navas J 1953 *Numario Hispánico* **2** 219

Ives H E 1941 *Numismatic Notes and Monographs* **93** (New York: American Numismatic Society)

Thompson J D A 1956 *British Numismatic Journal* **25** 282

Lavanchy C 1955 *Schweizer Münzblatter* **5** 85

[20] Razanov S A 1945 *Musée de l'Ermitage. Trauvaux de Départment Numismatique* **1** 145

[21] Kowalski H 1972 *Eurospectra* **11** 47

[22] Thompson A 1947 *Spink's Numismatic Circular* **12** Collection 607–608

[23] Metcalf D M and Schweizer F 1971 *Archaeometry* **13** 177

[24] Bacharach J L and Gordus A A 1968 *J. Economic and Social History of The Orient* **11** 298

[25] Boon G C 1974 *Scientific American* **231** 120

[26] King C E and Hedges R E M 1974 *Archaeometry* **16** 189

[27] Reece R 1975 *World Archaeology* **6** 298

[28] Seeger J A 1970 *SAN: J. Society for Ancient Numismatics* **1** 42

[29] Caley E R 1964 *Numismatic Notes and Monographs* **151** (New York: American Numismatic Society)

and Meyers P 1969 *Archaeometry* **11** 85

[30] Emeleus V M 1958 *Archaeometry* **1** 3

Das H A and Zonderhuis J 1964 *Archaeometry* **7** 90

[31] Tables presented in the *Royal Numismatic Society, Special Publication* **8** 96

[32] Meyers P 1969 *Archaeometry* **11** 85

[33] Hill G F 1924, 1925 *Becker, the Counterfeiter, Parts I & II* (London: Spink)

Franke P R 1958 *Schweizer Münzblätter* **30** 33

[34] Bloom M T 1957 *Money of Their Own. The Great Counterfeiters* (New York: Scribner's)

[35] Green L and Moon J R 1972 *J. Microscopy* **96** 381

[36] Wertime T A 1973 *Science* **182** 875

Wertime T A 1973 *American Scientist* **61** 670

[37] Steinberg A 1967 *Master Bronzes from the Classical World* (Cambridge, Mass: Fogg Art Museum) p 9

Griswold A B 1954 *Bulletin de l'École Française d'Extrême-Orient* **46** 635

Hill D K 1958 *Hesperia* **27** 311

[38] Zimmerman D W 1974 *Archaeometry* **16** 19

see also *The New York Times* December 24 1972

[39] Muscarella O W 1974 *American Journal of Archaeology* **78** 239

[40] Bearni B 1970 *Commentari* **21** 3

[41] Cushing D 1965 *Application of Science in Examination of Works of Art* (Boston: Museum of Fine Arts) vol I p 53

[42] Gettens R 1969 *The Freer Chinese Bronzes, Volume II: Technical Studies* (Washington DC: Freer Gallery) fig 290

[43] Caley E R 1964 *Numismatic Notes and Monographs* **151** 107
[44] Macalister R A S 1912 *The Excavations of Gezer* (London) vol II p 265
[45] Moorey P R S 1969 *Iran* **7** 131
[46] Werner O 1972 *Spektralanalytishe und Metallurgische Untersuchungen an Indischen Bronzen* (Leiden: Brill) p 140 and tables 1–7
[47] Cesareo R, Sciuti S and Marabelli M 1973 *Studies in Conservation* **18** 64
 Caley E R 1970 *Art and Technology, A Symposium on Classical Bronzes* ed
 S Doeringer, D G Mitten and A Steinberg (Cambridge Mass: MIT Press) p 37
[48] Karlbeck O 1935 *Bulletin Museum of Far Eastern Antiquities* **7** 39
[49] Gettens R 1969 *The Freer Chinese Bronzes, Volume II: Technical Studies* (Washington DC: Freer Gallery) fig 192
[50] Barnard N 1968 *Monumenta Serica* **27** 91
[51] Guglielmi S 1968 *Record of The Art Museum, Princeton University* **27** 3
[52] See tables 1 A and B of reference 49 and table 7 of reference 46

Appendix
Bibliography
Index

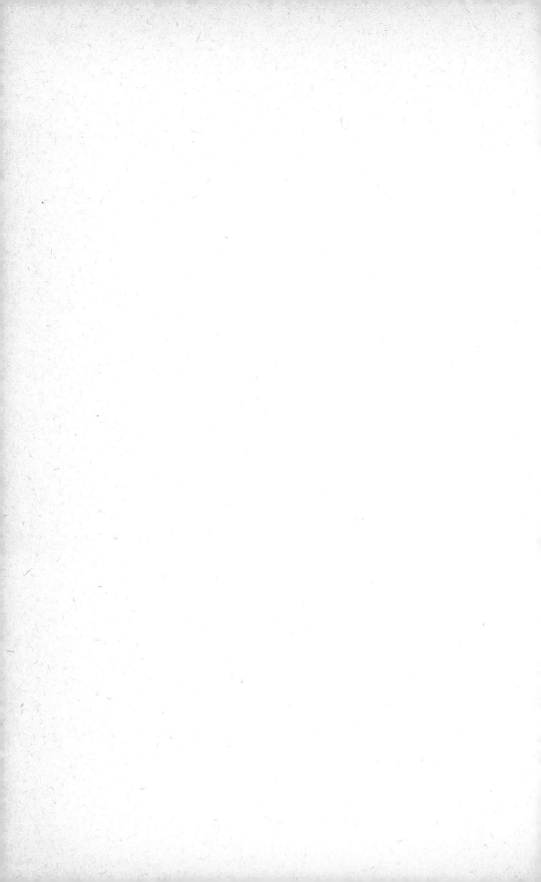

Appendix

X-ray fluorescence of Chinese blue-and-white
porcelain/Radiocarbon analysis/Lead isotype
analysis of ancient objects

X-RAY FLUORESCENCE OF CHINESE BLUE-AND-WHITE PORCELAIN

During the first millennium AD Chinese ceramic technology
developed rapidly to include a mastery of high-firing kiln techniques with an ever-
increasing production of stoneware. However, it was only during the Sung Dynasty,
around the beginning of the tenth century, that porcelain became at all common.
Throughout the eleventh century specialized manufacturing centres flourished;
Chien-tzǔ Ts'un in the northern province of Hopei produced white-glazed 'Ting'
porcelain while, further to the west at Yao chou in Shensi province, olive-green
glazed ware was made.

At the end of the thirteenth century the long-established mono-
chrome tradition was broken, probably to satisfy the demand of the new Mongol
rulers of the Yüan Dynasty for decorated wares. Sung porcelain now became a
collectors' item and the first rash of imitations emerged to supplement the limited
genuine stock. This imitation culminated in the Imperial factory of Yung Chêng
(1723–1735), which specialized in copies of the antiques in the Palace collection,
affixing the Emperor's reign-mark to its products.

By the middle of the eighteenth century a strong popular taste had
grown up for blue-and-white decorated porcelain, first developed in China early in
the fourteenth century (see colour plate 16). Any lack of inspiration on the part of these
later potters was compensated by their advanced technique so that many Yung Chêng
pieces are quite indistinguishable from their prototypes.

This blue-and-white ware had found its way to Europe as early as
1338, but early in the sixteenth century Italian merchants, familiar with Oriental
styles by way of sea-trade with the Levant, began to supplement the rare, genuine
imports with small batches of imitations. However, one chance event was to transform
the desultory European interest in this material into a near obsession [1]. In 1604 the
Dutch captured a Portuguese carrier, the *Catharina*, yielding close on one hundred
thousand pieces of blue-and-white porcelain as part of the booty. Subsequent local
demand was so great that even a vast new import traffic could not cope and the factories

of Delft found themselves fully employed in the production of homespun copies of every size and shape.

From then on each fresh Chinese style that arrived was promptly translated into a Delft or Meissen equivalent. It is unlikely that many of these pieces were intended to deceive, except for a few produced soon after the introduction of a new fashion, at a time when 'reference' material was in short supply. To present-day eyes most of these imitations are quite obvious if only by their comparatively heavy pottery fabric.

During the Ch'ing era (1644–1908) a new phenomenon emerged; the Chinese began to copy their own Imperial porcelain in order to supply the ever-increasing demand of the European export market. In due course European manufacturers set about copying these export wares, any inferiority to genuine Imperial articles being of secondary importance to the economic threat posed by the Chinese export material. Industrial espionage was rife following the introduction of china to the West, some manufacturers even going so far as to keep their craftsmen as virtual prisoners. An atmosphere of intrigue pervaded the industry with recipes and styles pirated and peddled the length and breadth of Europe.

Despite, or perhaps because of, this state of affairs a few deceptively fine imitations reached the stage of being accepted as of genuine Chinese origin. A case in point was a group of peacocks from the Royal Palace in Munich which would have been on display at the 1929 Berlin Exhibition of Chinese Art had not an obscured Meissen mark been spotted at the last moment [2].

Detailed scientific analysis (specifically the technique of x-ray fluorescence) only entered the complex world of Chinese porcelain imitation some twenty years ago, largely in an attempt to explain the wide variation in hue of the cobalt blue in blue-and-white ware. For some time the broad colour range, anything from near-black to an almost pure ultramarine, had been attributed to the exploitation of different cobalt ore sources, some local and some in Persia. But this notion had been taken one step further with the suggestion that the imported ores were used only for the more refined porcelains while the Chinese ores were restricted to local wares. There were far too many anomalies for the latter generalization to be acceptable, notably the occurrence of quite different shades in obvious porcelain pairs.

X-ray fluorescence analysis has confirmed that this explanation was too simple-minded and has managed to introduce some chronological order to this subject (figure 1) [3]. The important element here is manganese as it is abundant in only one of the natural cobalt ore-types, that found in China and known as *asbolite*. Persian and Middle-Eastern sources, while distinctly rich in arsenic, are virtually manganese free. So we see that all early porcelains prior to the Hsüan Tê period (1425–1436) used imported ores exclusively: the Mn/Co ratio is always less than 0·05. From then on addition of local ore becomes more and more common until, by the middle of the seventeenth century it probably contributes the lion's share of any glaze mixture. It is particularly significant that during the Yung Chêng period (1723–1735), when the imitations were so exceptionally good, the Mn/Co ratio is distinctive, being in excess of 2·0 in every case. The early fifteenth-century gourd flask and the elegant Yung Chêng bowl illustrated here provided typical data in this research.

Figure 1 / Variation with time of the ratio of manganese and cobalt content in Chinese blue-and-white porcelains / The particular group of nine porcelains dated *circa* AD 1675 and found in Tanganyika all show high amounts of manganese indicating no special care was taken in the manufacture of these export wares. After Garner H and Young S 1956 *Oriental Art* **2** 43. See also Banks M S and Merrick J M 1967 *Archaeometry* **10** 101.

Perhaps the most convincing confirmation of this trend from imported to local ore had been supplied by a group of dishes delicately painted with sages in landscapes and marked with a Hung Wu reign-mark (1368–1398) [4]. As the design is now regarded as typically sixteenth century, certainly no earlier, it is comforting to record that the one piece so far scientifically studied carried a Mn/Co ratio of 5·0, a level an order of magnitude greater than any late fourteenth-century equivalent.

The original question as to what controls the glaze's colour remains largely unresolved. Many early blues contain appreciable amounts of iron impurity and we know that the Chinese developed means of getting rid of this so that the brighter hues are predominant amongst later pieces. However, there are sufficient exceptions to this generality to make us believe that other factors, such as firing conditions, play an equally important role.

Modern fakers have one additional device in their technical repertoire which is of major commercial significance. Over the past decade early pieces have only commanded top prices if they are completely undamaged; a single crack can lower values by a factor of three or more. It is now rumoured that some Oriental repairs are so meticulous that they defy visual inspection and, with a specialized spray-on after treatment can even escape detection by ultraviolet light. If this is true, it provides an interesting new battleground between the scientist and the forger with the latter at present in control.

[1] Le Corbeiller C 1968 *Art Forgery* (New York: Metropolitan Museum of Art) p 269
[2] Kümmel O 1968 *Z. bildende Kunst* **62** 263
[3] Banks M S and Merrick J M 1967 *Archaeometry* **10** 101
[4] Garner H 1956 *Oriental Art* **2** 43

RADIOCARBON ANALYSIS

Although radiocarbon dating has had a vital impact in archaeological chronology its use in authentication of art works has been muted. In part this can be explained by the comparatively heavy sampling requirements of several grams of carbon for accurate age determination, a demand imposed by the naturally low concentration of the radioactive isotope, ^{14}C, even in modern carbon-rich materials. To appreciate this point it is necessary to understand the theory of the method in some detail.

^{14}C-manufacture takes place in the Earth's upper atmosphere as cosmic radiation gives up some of its energy in neutron production. Though the neutron energies are initially very high, after a few atomic collisions they soon slow down to the 'thermal' region around 1 eV and less where they react efficiently with nitrogen:

$$^{14}N + n \rightarrow {}^{14}C + H.$$

No other neutron reaction in the atmosphere has a comparable likelihood of occurrence so virtually every cosmic neutron creates a ^{14}C-atom [1].

Initially the distribution of these atoms is non-uniform: the Earth's magnetic field deflects the electrically-charged cosmic rays so that the neutron flux in the stratosphere is more intense near the poles than at the equator. But 10 km above the Earth's surface, once the carbon has been converted into carbon dioxide, circulating air currents soon completely homogenize the ^{14}C-distribution. In this way some 7.5 kg of ^{14}C are injected into the world's carbon 'reservoir' each year to be distributed through it by a variety of mechanisms.

The major uptake of the atmosphere's carbon dioxide occurs at the ocean's surface as dissolved bicarbonates are formed in the water. On land the gas is taken up by plant life in foodstuff manufactured by photosynthesis so that the carbon becomes organically bound in a living organism. In turn, plants are food for animals so the ^{14}C moves steadily onwards through the various elements of the biosphere. Death of the vegetation or the animal eventually allows the carbon cycle to be completed as material decomposition releases carbon dioxide back to the atmosphere.

But even while an organism is still alive and its carbon content is constantly being replenished from new stocks in the atmosphere via the reservoir supply lines, the ^{14}C-concentration is still extremely small: the isotope's abundance is only $1 \cdot 5 \times 10^{-12}$. Most of the carbon is in the lighter isotopic forms of $^{13}C(1 \cdot 1\%)$ and stable $^{12}C(98 \cdot 9\%)$. In terms of radioactivity such a low ^{14}C-abundance gives rise to a mere fifteen nuclear disintegrations per minute (dpm) for every gram of carbon present, following the reaction:

$$^{14}C \rightarrow {}^{14}N + \beta.$$

When a tree is chopped down to provide timber for sculpture or paper-making it stops taking in carbon from its surroundings. In the same way the death of a mammoth that supplies ivory for a carving or the harvesting of flax to be used in linen manufacture each sets a time-zero for ^{14}C decay. Whatever the material, its

subsequent ageing is matched by a gradual loss of radioactive content through the reaction recorded above, following an exponential decay law:

$$N = N_0 \exp(-t/\tau).$$

It is usual to talk in terms of the radioactive half-life, $t_{\frac{1}{2}} = 0.693\tau$, which is a measure of the time required to halve the number of atoms of a radioisotope present. For $^{14}$C, $t_{\frac{1}{2}} = 5568$ years, conventionally [2]†.

Let us consider how this data would limit authentication of a 500-year-old statue if less than a gram of wood was available, enough to yield 0.1 gram of carbon for analysis, after chemical treatment. This sample's radioactivity would be equivalent to 1.41 dpm in counting, a measurement taken in the presence of a typical background close to 1 dpm, at least partly due to residual levels of radioactivity within the detection equipment itself. Without going into the statistics of counting in detail [3] it can be reckoned that more than *twenty days* of measurement time would be involved in establishing authenticity beyond reasonable doubt, if one chance in a thousand of error can be so regarded. In contrast, with one gram of carbon available the same level of confidence in authenticity judgement becomes practical with only about six hours analysis, as the background count is driven into relative insignificance.

Interpretation of a radiocarbon date is a separate matter altogether and one fraught with pitfalls. Taking a simple example, the dating of a Japanese wooden Guardian figure (plate 1) of the Kamakura period (AD 1185–1334), gave a conventional radiocarbon result of 560 ± 80 years BP, where BP is an abbreviation for 'Before Present'. The word 'conventional' here carries several overtones.‡ To begin with, the reader might be tempted to regard 'present day' as the year 1975, but, by convention, all radiocarbon dates are quoted with reference to the *year 1950*. Second, it is now generally recognized that the conventional half-life is a little low: the most up-to-date evaluation suggests 5730 years [5] in other words our date should be multiplied by 1.030. Thus our 'age' of 560 years translates into AD 1370.

The error term of ±80 years is more difficult to interpret. It refers to no more than the statistical errors involved in counting the $^{14}$C-decay of the sample (after allowance for similar errors in background activity) and is quoted to only one standard deviation. Figure 2 indicates the meaning of this quantity, σ: there is more than one chance in three that the true age for this statue lies outside the $\pm 1\sigma$-range (AD 1290–1450), even one chance in fifty it pre-dates the Kamakura period altogether. So, within the scope of these error considerations we can be quite satisfied that the radiocarbon date is consistent with the stylistically attributed age of this piece while, at the other end of the scale, there is only about one chance in a million that the wood of this statue is of twentieth-century origin.

† It is a useful rule of thumb to remember that the half-life of 5568 years is equivalent to a $^{14}$C-activity decrease of close to 1% every eighty years.

‡ The conventional age will probably already contain one correction factor, that of $^{13}$C/$^{12}$C isotopic fractionation (see chapter 2, figure 1 and associated text). With wood it may be necessary to make allowance for the greater antiquity of its inner growth rings. Sampling in pith-wood, if accessible, could produce a systematic error in age-determination of a century, perhaps more.

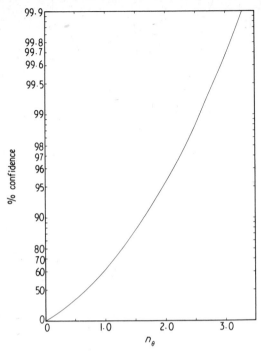

Figure 2/The link between the error quantity known as the standard deviation σ and the percentage confidence in a single analysis/Note the connection between '% confidence' and the logarithmic vertical scale which begins with the origin as 1. For example, when a result's probability is 1 in 20 the confidence is 95% and so on. This graph may be used to assess error limits in various other data presented in this book.

Here again, wording is all-important as the radiocarbon result is by no means proof against a forgery carved from old wood†, perhaps a genuine art work given a 'face-lift'. There are several instances where the wood of a piece clearly pre-dates its period of carving, such as the lacquered wooden statue (Freer Gallery of Art, catalogue number 44.46) with a conventional radiocarbon age of 1440 ± 50 BP, but, stylistically, certainly of the Sung Dynasty (AD 960–1269) [6]. Additionally many ivories appear to have been carved out of fossil mammoth tusks rather than con-temporary ones.

Another radiocarbon problem emerges when dating is attempted over more recent centuries: that of ambiguity. One $^{14}$C-activity may match more than one historical age [7]. It appears that the rate of $^{14}$C-production in the upper atmosphere is susceptible to sharp, short-term fluctuations each of which is partially reflected, year-by-year, by the isotopic composition of the carbon uptake of a tree's annual growth ring. The fluctuations may arise from a variety of effects: variations in the strength of the non-dipole component of the Earth's magnetic field, changes in

† I hasten to add that I have no reason to suggest the Guardian figure illustrated here has been a victim of such treatment.

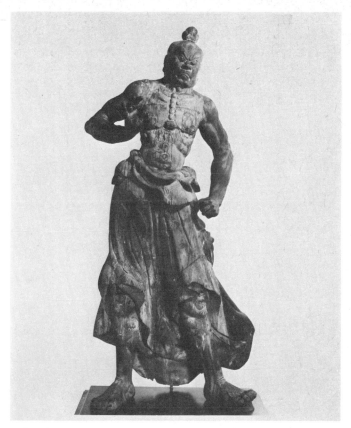

Plate 1 / Wooden Guardian figure / Japanese, Kamakura period (AD 1185–1334).
Radiocarbon date: 560 ± 80 years BP {I(FG)—240}. Photograph: courtesy of
Dr J Winter, Freer Gallery of Art, Washington, DC; accession number 49.20.

interplanetary field caused by solar activity and climatic changes are all regarded as possible contributing factors. Whatever the causes, the matching of the calendar age of tree-rings in living timber (such as the giant sequoias and bristlecone pines of America together with oaks from Europe) with their ^{14}C-content has provided a calibration curve (figure 3).

The dating of the land lease document (plate 2) illustrates how the calibration curve can wander. A conventional radiocarbon date of 245 ± 50 years BP converts to AD 1700 after half-life correction [8], but when calibrated this moves to AD 1620. At the ± 1σ limits we can read off tree-ring ages of AD 1650 at the younger extreme and *either* AD 1600 *or* AD 1520 at the older extreme. At the ± 2σ limits the age range spreads to AD 1770–1470 as extra crossings in regions of ambiguity are encountered. Yet almost all this correction is required to accommodate the document's historical date of '30 October, 1495'. This result amply underlines how naive it would be to accept a quoted radiocarbon age and its error without recognition of its limitations.

After 1850 the normal mode of application of radiocarbon dating is virtually ruled out. Apart from the difficulty of distinguishing the only slightly reduced ¹⁴C-activity of such youthful material from the undecayed level of a modern standard, we now face the effects of two forms of carbon contamination [9].

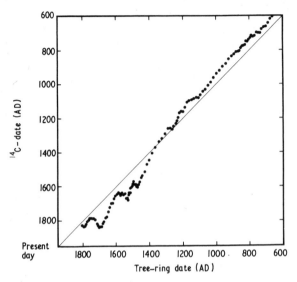

Figure 3 / Variation of predicted ¹⁴C date ($t_{\frac{1}{2}} = 5730$ years) for wood samples given an accurate calendar age by tree-ring analysis / After Ralph E K, Michael H N and Han M C 1973 *MASCA Newsletter* **9** 1.

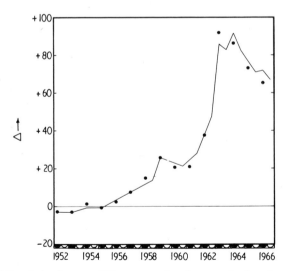

Figure 4 / Correlation between ¹⁴C concentrations in atmospheric carbon dioxide (solid line) and in vintage wines (dots) between 1952 and 1966 / Each of the latter is only recorded for the plant growth season of each year. After L'Orange R and Zimen K E 1968 *Naturwiss.* **55** 35.

Plate 2/Parchment land lease at Sandford/From William Thawmire of Drumlochy to Stephen Duddingstone at Sandford. The lease, in Latin, is witnessed by Robert Brown of Binnon, John Gourlay, Edward Bruce, John Carver, William Strange, Thomas Scougall and James Young, the public notary. The document is dated 30 October 1495.
Radiocarbon date 245 ± 50 years BP (UCLA–A1445). Photograph: courtesy of Professor R Berger, Institute of Geophysics and Planetary Physics, Berkeley, California.

The first source of contamination comes from the injection into the atmosphere of *inactive* $^{12}$C as a consequence of the industrial revolution. Oil and carbon combustion has brought back into play carbon that had settled out of the main cycle of the $^{14}$C-reservoir many millions of years ago. This *fossil-fuel effect* has caused sufficient dilution of the natural $^{14}$C-concentrations to give wood growing in the mid-1950's a $^{14}$C-content already as much as 2% below the expected uncontaminated level, that is to say, it creates a false antiquity for recent material of about 160 years.

Since 1952 this human-assisted artificial 'ageing' mechanism has been heavily offset, indeed overwhelmed, by a second source of contamination, that of extra *active* $^{14}$C produced in the northern stratosphere by neutrons created in thermo-nuclear explosions. Plant life in the biosphere has immediately taken up the $^{14}$C-enrichment in the atmosphere. This is evidenced by the correlation between $^{14}$C-concentrations in atmospheric carbon dioxide and in post-1952 vintage wines illustrated here in figure 4 [10]. By 1963 the air of the troposphere was recording a $^{14}$C-content twice as high as the normal cosmic-ray-induced level, as the radiocarbon input rate far outstripped the ability of the exchange processes at the oceans' surface to spread the fresh material throughout the carbon reservoir. Only with the inter-national moratorium introduced at that time has the normal carbon cycle begun to re-establish its equilibrium.

This bomb-fallout effect could well have a strong impact amongst modern-day authenticity problems. A modern faker bent on production of a pre-World War II painting could hope to arrange his pigment palette correctly: many paints popular at that time are still available from colour merchants. But carbon-rich linseed and other drying oils have a fairly short shelf-life so that the forger would be

obliged to use a modern source of these pigment-vehicles. Analysis of as little as 100 mg of paint would allow detection of this fallout-induced radioactivity [11].

Recently another 'art medium' has begun to appear in the salerooms; fine wines and spirits. Here again radiocarbon dating has a useful application in detecting spurious products. If the recent allegations of port adulteration with inferior alcohol are upheld we can recognize a serious threat to this market. Following reports that the Portuguese state alcohol monopoly had introduced synthetic spirit ($^{14}$C-free oil and coal by-products) instead of vegetable-based ($^{14}$C-rich) alcohol during a shortage of the latter, the West German government banned port importation until such time as analysis can prove or disprove these allegations. While, as the *Evening Post* of February 17th (1975) jokingly put it, this problem 'sets boffins a tasty poser' it should be noted that a £2 million a year business arrangement hinges on the outcome of this investigation.

[1] Libby W F 1946 *Phys. Rev.* **69** 671
[2] Engelkeimer A G, Hammil W H, Inghram M G and Libby W F 1949 *Phys. Rev.* **75** 1825
[3] Note that, taking sample and background count-rates S and B over a counting period t, the net count-rate due to $^{14}$C is given by $(S - B)t$. The standard deviation σ on this count is given by $\{(S + B)t\}^{\frac{1}{2}}$.
[4] Isotopes Inc. 1962 *Radiocarbon* **4** 41
[5] Hughes E E and Mann W B 1964 *Int. J. Applied Radiation Isotopes* **15** 97
[6] Private communication, Dr J Winter, Freer Gallery of Art
[7] Ralph E K, Michael H N and Han M C 1973 *MASCA Newsletter* **9** 1. See also De Vries H 1958 *Koninljke Nederlandse Akademie van Wetensschappen* B**61** 1
[8] Berger R, Evans N, Abell J M and Resnik M A 1972 *Nature* **235** 160
[9] Baxter M S and Walton A 1971 *Proc. R. Soc.* A**321** 105
[10] L'Orange R and Ziman K E 1968 *Naturwiss.* **55** 35
[11] Keisch B and Miller H M 1972 *Nature* **240** 491

LEAD ISOTOPE ANALYSIS OF ANCIENT OBJECTS

The use of isotope analysis in pigment research was briefly outlined in chapter 2, particularly in connection with the origins of lead white in European easel paintings. The point was made there that ore source identification based on particular elements in chemical composition can often be criticized on the grounds of modifications caused by variation of refining and smelting procedures, even on a day-to-day basis. The same can be said of chemical analyses of a metal as every chemical step in its history from the time when the parent ore is mined to when it is excavated from the ground as an artefact, can have some effect. Cupellation roasting of argentiferous lead in silver refinement typifies these reactions, with elements such as tin and zinc surviving at any level between 0·001 and 0·1% (but rarely more) in the bulk of the silver, whatever their original concentration [1].

Coins carry some special problems such as casting defects, segregations and mechanical working effects which all tend to occur in radial directions in the striking of a horizontally oriented alloy droplet. Additionally it is now known that many later Roman coin blanks were cast vertically so that the original structure

became non-radial in distribution with segregates concentrated around the pouring lip [2]. Factors like these, plus corrosion attack during burial, all add up to quite a severe indictment of chemical analyses in several practical applications.

In contrast to whatever variations may occur in the absolute concentration of lead when it is included in an alloy stock to make bronze, we can safely assume that the element's isotopic make-up will remain virtually unaltered. A typical ore containing isotope abundances of $1\cdot40\%(^{204}\text{Pb})$, $25\cdot1\%(^{206}\text{Pb})$, $21\cdot7\%(^{207}\text{Pb})$ and $52\cdot3\%(^{208}\text{Pb})$ will retain that composition in the final object. Expressed as isotope ratios, we have $^{204}\text{Pb}/^{206}\text{Pb} = 0\cdot0558$, and so on.

However, galena ores from different mining regions throughout the ancient world provide quite different sets of isotope ratios [3]. For example, for an ore sample recently collected from the most famous ancient lead-mining district of Laurion (some 40 kilometres from Athens) gives, on analysis: $^{204}\text{Pb}/^{206}\text{Pb} = 0\cdot0530$, $^{208}\text{Pb}/^{206}\text{Pb} = 2\cdot0599$ and $^{207}\text{Pb}/^{206}\text{Pb} = 0\cdot8307$. (Quotation of these figures to a fourth decimal place may seem extreme, yet this precision level is now within the scope of modern-day mass spectroscopy.) Plate 3 incorporates some of the important sources of galena in Europe and the Mediterranean region in the past and illustrates how distinctly different they are from the Laurion material [4].

Isotope data for Athenian bronze coinage covering the time 330 BC to *circa* 50 BC (with lead content between 3 and 21%) agrees admirably with this singular Laurion ore analysis, as we might expect, but so, too, does coinage from Egypt, Syria and Rome of such an early date [5]. (The illustrated coin of Ptolemy VIII struck in (or for) Cyprus, *circa* 146–127 BC is one such instance.) What little scatter there is in the isotope results probably reflects slight variations of source material within the mine itself. The Laurion mines were eventually deserted in the second century AD but their rundown had started long before, possibly in the middle of the fourth century BC. With appreciable inertia, coin analysis only reflects a choice of ore source round about the beginning of the Christian era.

Roman Imperial issues, *circa* AD 110–310, also conform to a sensible lead isotope pattern, though we can only hazard a guess that the ore source was somewhere in northern Italy. Certainly this isotope data permits no linkage to any of the better known Roman mining regions around the Mediterranean, either at Rio Tinto in southern Spain or several Levantine possibilities including Trabzon on the Black Sea coast recorded here. There is also no match to be made to a region of Etruscan mine exploitation around Campiglia Marittima (then called Populonia) in Italy even though this region lies less than one hundred miles to the north of Rome.

There are similar difficulties in pinpointing the origins of galena used in the western regions of the Empire at mints such as London at the same time. Though analysis has so far been limited to only four coins of this type they group tightly together and stand well apart from lead ratios obtained from several Romano-British lead pigs from various find-spots in this country.

One coin struck in the name of Maxentius (son of Emperor Maximiam who ruled between AD 286–305, as Diocletian's colleague) is of particular interest. L H Cope has expressed an opinion that this is a contemporary forgery [6]. Certainly lead isotope analysis goes a long way to substantiate his claim as it is far

away from the main stream of coinage struck at Rome at that time even though, stylistically, the capital would be its mint source.

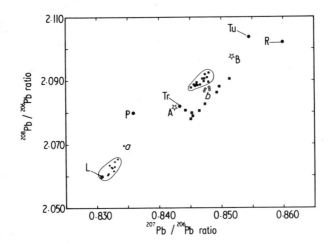

I1 I2

Plate 3 /Isotope ratios for lead extracted from various types of early materials /
Galena ore sources: L Laurion, Greece; P Populonia (now Campiglia Marittima, Italy); Tr Trabzon, Black Sea Coast; Tu Bottino, Tuscany; R Rio Tinto, Spain.
Bronze coinage: Greek (330–32 BC), circles; Roman AD 111–308, small squares.
a Imperial coin of Athens, 27 BC–AD 14, with a bust of Athena on the obverse.
b (Small 'starred' group) Four provincial Roman coins minted at London *circa* AD 307–296.
Lead pigs from Roman-British sites: large squares.
A isotope data from Julia Domna bronze portrait bust, plate 1.
B coin of Maxentius struck in Rome *circa* AD 307 but a suspected contemporaneous forgery.
Illustrated coins
I1 Coin of Ptolemy VIII struck in (or for) Cyprus 146–127 BC
I2 Coin of Severus struck in London *circa* AD 307

Isotope data	I1	I2
$^{208}Pb/^{206}Pb$	2·0604	2·0872
$^{207}Pb/^{206}Pb$	0·8317	0·8475
$^{204}Pb/^{206}Pb$	0·05307	0·05419

After Brill R H and Shields W R 1972 *R. Numismatic Soc. Spec. Publ.* **8** 279

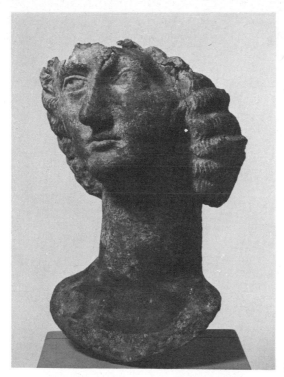

Plate 4/Julia Domna/Bronze portrait bust, height 36·5 cm, Syrian (third century AD). Photograph: courtesy of the Fogg Art Museum, Harvard University, Cambridge, Massachusetts: Gift of C Ruxton Love, Jr; accession number 1956.19.

The lead from the bronze portrait of Julia Domna (illustrated in plate 4) provides a good example of the application of lead isotope analysis amongst larger objects [4]. This lady was Empress to Septimus Severus (AD 192–211) and bore him two sons, Caracalla and Geta, both of whom were destined to don the Imperial robes. Her native city was Emesa in Syria. The protrait itself has been given an 'eastern' attribution not only on its find-spot (Selimiyeh in Syria) but also on stylistic and historical grounds. Scientific analysis substantiates this attribution with isotope ratios that match those found amongst various materials from several sites along the eastern Mediterranean and Black Sea coastline from Trabzon to Alexandria.

Glass is another medium which is amenable to isotope analysis as two important types extensively used in ancient times, red and yellow opaques, often contain appreciable quantities of lead as an additive [7]. The red opaques owe their colour to the presence of cuprite crystallites precipitated in the glass under reducing (oxygen-starving) heating conditions and use of more than 5% lead oxide encourages this chemical reaction. A yellow coloration is obtained more directly by addition of one of two opacifiers, lead diantimonate ($Pb_2Sb_2O_7$) or lead stannate ($PbSnO_3$). The earliest examples are contemporary with the first Egyptian and Mesopotamian cored glass vessels of *circa* fifteenth century BC.

Indeed the Egyptian glass stands out by virtue of its exceptionally low isotope ratios ($^{208}Pb/^{206}Pb$, about 2·025, $^{207}Pb/^{206}Pb$ about 0·811), which lie outside the graphical limits of plate 4. This data has been used to substantiate the authenticity of a cored glass fish now in the Brooklyn Museum (New York) (catalogue number 37.316E). This piece was regarded as unusual being for the most part made of transparent glass, a scarcity in early Egypt. But analysis of yellow coloration on the fish's lip provided isotope ratios that differed by only 0·001 from the typical levels quoted here, in each case.

The potential of lead isotope analysis is truly exciting as that element is to be found commonly enough in silverwares, as a consequence of poor separation of the precious metal out of its parent galena ore in ancient times. Thus there is the possibility of classifying early silvers according to their geographical origins, as is done with the bronzes and glasses. Gold coins, surprisingly often contain appreciable quantities of lead though it is not clear how the impurity came to be there.

But on the debit side we must occasionally fear confusion because of lead recycling, allowing some contamination from discarded metal. This 'mixing' problem will probably prove more serious amongst silvers as the melt could contain material hoarded for many decades and carried over long distances, perhaps for business transactions.

[1] McKerrell H and Stevenson B K 1972 *R. Numismatic Soc. Spec. Publ.* **8** 195
[2] Cope L H 1972 *R. Numismatic Soc. Spec Publ.* **8** 3
[3] Brill R H 1970 *Phil. Trans. R. Soc.* A**269** 143
[4] Brill R H, Shields W R and Wampler J M 1973 *Application of Science in Examination of Works of Art* (Boston: Museum of Fine Arts) vol II p 73
[5] Brill R H and Shields W R 1972 *R. Numismatic Soc. Spec. Publ.* **8** 279
[6] Cope L H and Billingham H N 1968 *Bulletin Historical Metallurgy Group* **11** 51
[7] Brill R H, Barnes I L and Adams B 1974 *Recent Advances in Science and Technology of Materials* ed A Bishay (New York: Plenum) vol III p 9
 Oxygen isotope analysis provides a quite separate tool for glass analysis as it refers to the principal silica-bearing ingredient rather than to an additive. By convention a sample's isotope ratio ($^{18}O/^{16}O$) is quoted as a δ-value relative to that of ocean water; positive values of the parameter indicate ^{18}O excess over the standard. Some typical δ-values of important glass sources include:
 Egypt (XVIIth Dynasty *circa* 1350 BC) δ = 16·1‰
 Jelemie, West Galilee (4th century AD) δ = 14·1‰
 Nimrud, Mesopotamia (8–7th century BC) δ = 22·0‰

Additional Bibliography

Stylistic detection of fakes: general/Modern art/
Paper, parchment and inks/Marble and stone/
Miscellaneous

STYLISTIC DETECTION OF FAKES: GENERAL

Arnau F 1961 *Three Thousand Years of Deception in Art and Antiques* (London: Jonathan Cape)
Jeppson L 1971 *Fabulous Frauds* (London: Arlington)
Kurz O 1967 *Fakes* (New York: Dover)
MacDougall C D 1958 *Hoaxes* (New York: Dover)
Mendax F 1955 *Art Fakes and Forgeries* (London: Laurie)
Mills J M 1971 *How to Detect Fake Antiquities* (London: Arlington)
Reith A 1970 *Archaeological Fakes* (London: Barrie and Jenkins)
Savage G 1965 *Forgeries, Fakes and Reproductions* (New York: Praeger)
Also see the catalogue, *Fakes and Forgeries*, of the July 1973 exhibition at the Minneapolis Institute of Arts

MODERN ART

Hess T B 1962 *Art News* **61** 42, 64. The unmasking of the Paris forgery ring, headed by the young Jean-Pierre Schecroun, which specialized in minor peripheral works of Léger (under whom Schecroun studied), Miró, Braque and many others.
Irving C 1969 *Fake!* (London: Heinemann) The life and activities of Elmyr de Hory are described in detail. One important point made in this book is that de Hory deliberately hunted out stocks of pre-war paper to use in his Picasso fakes.
Rewald J 1953 *Art News* **52** 17 illustrates pastiches of a Van Gogh and a Seurat.
Stolow N 1964 *Canadian Art* **94** 5.

PAPER, PARCHMENT AND INKS

Batigne R and Bellinger L 1953 *The significance and technical analysis of ancient textiles and historical documents, Proc. Am. Phil. Soc.* **97** 670
Boutaine J L, Irigoin J and Lemonnier A 1972 *Radiography in the study of manuscripts, Colloques Internationaux CNRS Rep.* **548**
Burton D, Poole J B and Reed R 1959 *A new approach to the dating of the Dead Sea Scrolls, Nature* **184** 533. Age determination of about 2000 years based on natural shrinkage characteristics of parchment.
Demus O 1967 *Colour of Byzantine book illustration, Palette* **26** 2

Krummel D W 1974 *Guide for Dating Early Published Music* (New Jersey: J Boonin)

Landolt R R and Tyler V E 1970 *Thermal neutron activation analysis of counterfeit and genuine Japanese postage stamps, Radiochemical and Radio-analytical Letters* **5** 365

Lizardi Ramos C 1959 *Another Maya falsification, American Antiquity* **25** 120

Longo L and Bozzacchi B 1955 *Boll. 1st Patalogia Libro* **1** 152 discusses a fake document on which several lines of text had been hidden under a purpurin film. The paper became transparent when immersed in a mixture of benzol and carbon sulphide so that the covered words turned out on the unwritten side of the document.

Macris C G and Riganezis M D 1955 *Characterization of writing inks by paper chromatography for criminological purposes, Analytica Chimica Acta* **13** 129

Pollock H C, Bridgman C F and Splettstosser H R 1955 *The x-ray investigation of postage stamps, Medical Radiography and Photography* **31** 73

Reed R 1965 *The examination of ancient skin writing materials in ultraviolet light, Proc. Leeds Philosophical and Literary Soc.* **9** 257

Reed R 1972 *Ancient Skins, Parchments and Leathers* (London: Seminar Press) In addition to parchment shrinkage and uv studies an extensive discussion of collagen fibre breakdown with ageing is included. This is illustrated with several excellent scanning electron micrographs.

Schroeder G L, Kramer H W, Evans R D and Brydges T 1966 *Lithium-drifted germanium detectors: applications to neutron activation analysis, Science* **151** 815. Documents discussed in this paper include: (i) *Civitas Dei*, by St Augustine, printed by Sweyn-heym and Pannartz (Rome, *circa* AD 1470) (ii) *The Nuremburg Chronicle* printed by A Koberger (AD 1493) (iii) *Cicero's Orations* printed by Aldus (Venice 1519).

Sen N K and Ghosh P C 1971 *Dating iron-based ink writings on documents, Journal of Forensic Science* **16** 511

Stevenson A 1968 *Maps, missals and watermarks, Nature* **218** 620 Identification of watermarks using beta-radiography allowed precise dating of (i) the manuscript accompanying the *Vinland Map* (*circa* AD 1450 from the Piedmontese town of Caselle) (ii) the *Constance Missal* AD 1473, and not printed at Gutenburg as originally thought and (iii) Caxton print-ings of *Recuyell of the Histories of Troie* and *The Game and Play of Chess* (AD 1474)

Tholl J 1967 *Shortwave UV radiation. Its use in the questioned document laboratory, Police* **11** 21

Vaultier R 1957 *The history of china ink, Papetier* **11** 444

MARBLE AND STONE

Anonymous 1967 *Stone fingerprints, Chemical Engineering News* **45** 100. Micro-scope identification of limestone sources used in a group of T'ang Dynasty (AD 618–906) Buddhist sculptures.

Ashmole B and Toynbee J 1965 *Ancient or modern? The case for and against the St Albans head's antiquity, Illustrated London News* **226** 1062

Bromer F 1963 *False heads, Archaeolog. Anz.* **3** 439 presents evidence that the head of a *kouros* in the Metropolitan Museum of Art (New York) is a fake, no doubt inspired by the *kouros* of Volo-mandra in Athens.

Černohouz J and Šolc I 1966 *Use of sandstone wanes and weathered basaltic crust in absolute chronology, Nature* **212** 806

Craig H and Craig V 1972 *Greek marbles: determination of provenance by isotope analysis, Science* **176** 410

Dixon K A 1967 *The first Tikal-inspired fake, Expedition* **10** 36

Rybach L and Nissen H U 1964 *Neutron activation of Mn and Na traces in marbles worked by the ancient Greeks, Radiochemical Methods of Analysis: Proceedings, Salzburg Symposium* p 105

MISCELLANEOUS

Bieber M 1964 *History of copying in the Roman period, American Philosophical Society Yearbook* p 449

Bradbury F 1973 *British and Irish Silver Assay Office Marks* (Sheffield: J W Northend)

Carroll D L 1970 *Drawn wire and identification of forgeries in ancient jewellery, American Journal of Archaeology* **74** 401

Cescinsky H 1913 *The Gentle Art of Faking Furniture* (London: Chapman and Hall)

Feldhaus F M 1954 *Imitation emerald problems in the 16th century, The Gemmologist* **23** 175

Forbes J S 1971 *Hallmarking gold and silver, Chemistry in Britain* **7** 98

Gaines A M and Handy J L 1975 *Mineralogical alteration of Chinese tomb jades, Nature* **253** 433

Kleinert T N 1972 *Ageing of cellulose VI. Natural ageing of linen over long periods of time, Holzforschung* **26** 46

Masschelein-Kleiner L 1967 *Microanalysis of hydroquinones in red lake pigments, Microchimica Acta* **6** 1080. Illustrates thin-layer chromatography with madder dye identification in the red wool of a 16th century Brussels tapestry.

Richter G M A 1958 *Ancient plaster casts of Greek metalware, Am. J. Archaeology* **62** 369

Schedelmann H 1965 *Waffen-und Kostumkunde* **7** 124

Schedelmann H 1966 *Waffen-und Kostumkunde* **8** 53 illustrates fake dress, arms, armour and helmets with examples from several famous collections. Products of Konrad, who worked undetected for about 30 years before his exposure early in this century, are highlighted.

Staccioli G and Tamburini U 1973 *Ageing of wood: Preliminary studies of panel paintings, Application of Science in Examination of Works of Art,* (Boston: Museum of Fine Arts) vol II 235. Study of increase in the acetyl/hemicellulose ratio with time as observed in Black Poplar used in panels over the past 800 years.

Symonds R W 1923 *The Present State of Old English Furniture* (London: Duckworth)

Taxay D 1964 *Counterfeit, Mis-struck and Unofficial US Coins* (New York: Arco)

Webster R 1973 *Photographic techniques in forensic gemmology, Forensic Photography* **2** 2

Whitworth H F 1954 *A faked fossil, Museums Journal* **53** 319 describes the insertion of an insect's wing into a crystal of selenite.

Index†

italic figures indicate that subject is illustrated
bold figures indicate colour illustrations

†Note: (i) For individual painters and sculptors, see *artists*
 (ii) Individual forgers, their accomplices and art copyists are grouped under *forgers*
 (iii) Individual painting colours, with the exception of lead white, are grouped under
 pigments